THE NORTHMAN

A CALL TO THE GODS

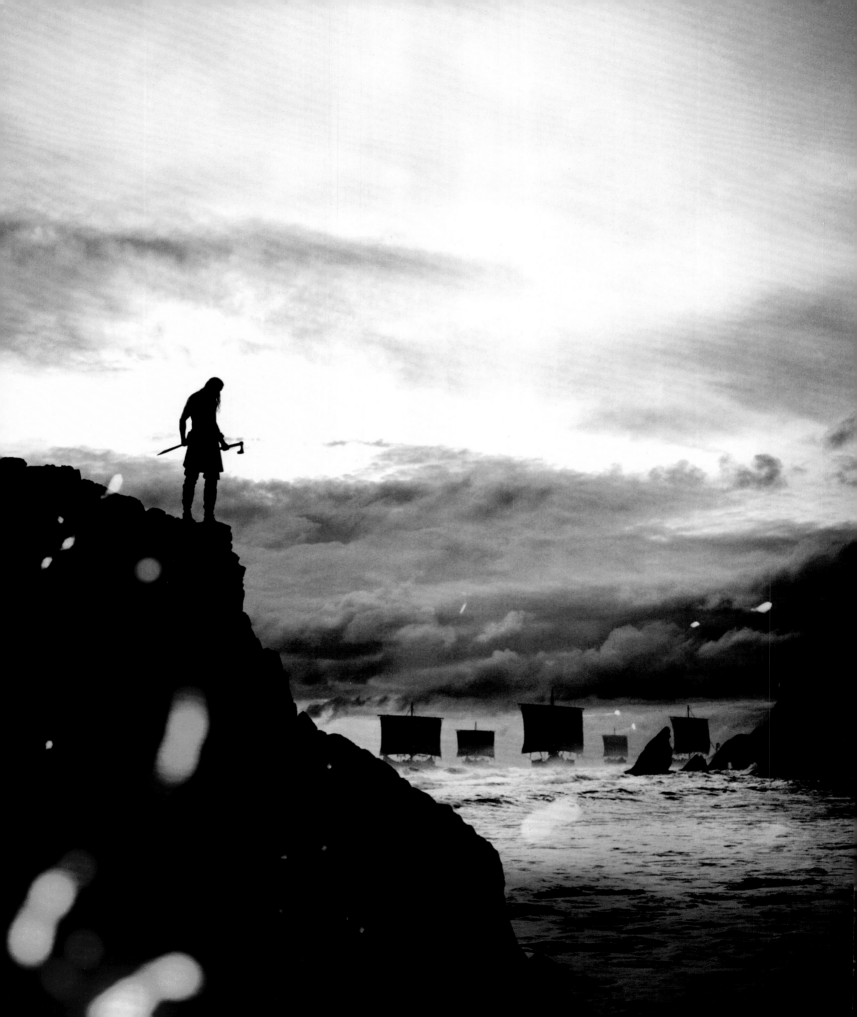

THE NORTHMAN

A CALL TO THE GODS

INSIDE ROBERT EGGERS' EPIC
VIKING REVENGE THRILLER

FOREWORD BY ALEXANDER SKARSGÅRD
PREFACE BY ETHAN HAWKE
INTRODUCTION BY ROBERT EGGERS AND SJÓN

SIMON ABRAMS

INSIGHT
EDITIONS

San Rafael • Los Angeles • London

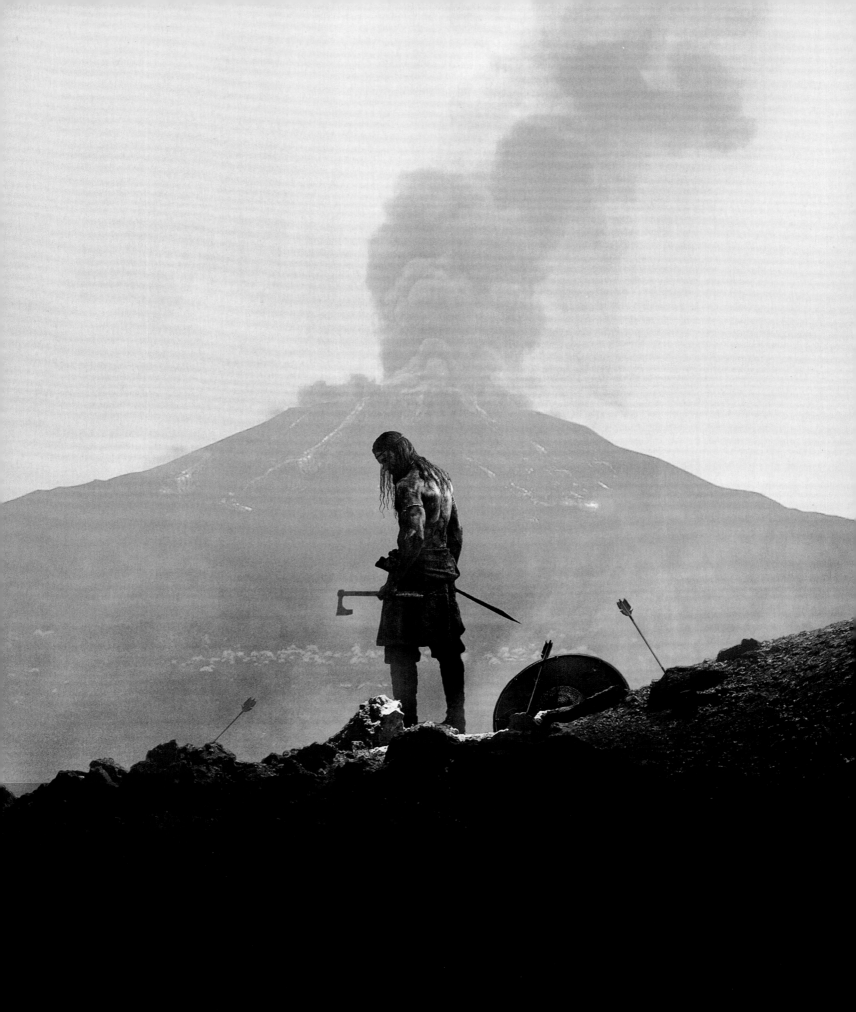

CONTENTS

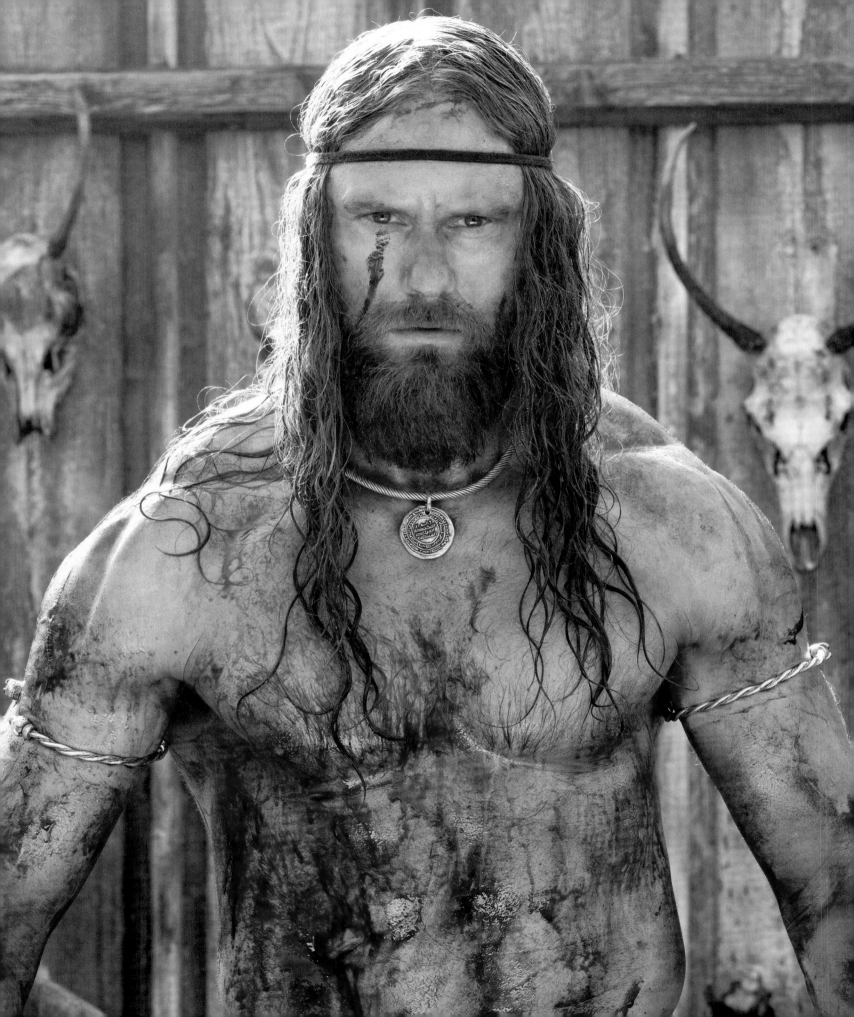

FOREWORD BY
ALEXANDER SKARSGÅRD

On the island of Öland in the middle of the Baltic Sea lies one of the most famous runestones in Scandinavia named the Karlevi Runestone. It was raised in memory of the sea-warrior Sibbi the Good, who was Fuldarr's son. In the 1920s my great-grandfather built a simple wooden house on Öland, not too far from the Karlevi Runestone, which has been in our family ever since. As a child I would spend every summer on Öland, and this eighty-five-mile-long limestone island was—and still is—my favorite place on earth. When I was seven years old my grandfather, who was an enthusiastic hiker, took me for a walk on Stora Alvaret, a barren limestone plateau that stretches the length of almost the entire island and which is a UNESCO World Heritage Site. (I highly recommend a visit to this magical place.) On our way home, grandpa asked if I wanted to see a runestone. I had absolutely no idea what a runestone was, so of course I said yes. When we arrived to the Karlevi Runestone my first impression was that it looked nothing more than a massive boulder. However, as we approached, its engraved epigraph appeared to be slithering like a snake across the stone. Grandpa urged me to run my finger along the inscription and to imagine that I was standing next to the Viking who carved and erected the runestone a millennia ago. Perhaps an ancestor of ours, since Skarsgård is derived from Skare's gård (Skare was a Viking chieftain from the southern part of the island and *gård* means "farm"). It was the first time I ever felt the dizzying sensation of existing in both the past and the present simultaneously.

When we returned home we spent the evening in front of the fireplace, and Grandpa recounted stories of famous Vikings and their expeditions. He told me about Ingvar the Far-Traveled, who in 1041 set sail from Sweden with twenty-six langskips—only one would return—and led the last Viking campaign in the Caspian Sea. He narrated the legend of the Varangians, who with just a few ships tried to conquer Constantinople—the most powerful and heavily fortified city in the world at the time—and a suicide mission so insane that the Byzantine emperor later hired the Varangians as his personal bodyguards.

As we drank tea from the ridiculously oversized mugs Grandpa loved, he narrated fascinating and outlandish tales from Norse mythology about the Norns—three women who sit under the Yggdrasill tree and weave the Fates of man and who are the most powerful entities in the cosmos. And about the wolf Fenrir, who the Vikings believed would be chained until *Ragnarök*, the apocalypse, at which point he would then be able to break his shackles, swallow Ódinn, and devour the entire sun! At midnight, as the last embers glowed in the fireplace, Grandpa put me to bed. The man who leaned over to kiss me goodnight was no longer a retired mid-level administrative controller from Kalmar, but instead a battle-hardened Viking chieftain. I drifted off to sleep, and with every heartbeat I could feel his blood pumping through my veins.

PREFACE BY
ETHAN HAWKE

When I arrived in Belfast to begin filming *The Northman* the global pandemic was in full force. There was no vaccine yet. I was tested before I left home and when I arrived, I had to quarantine in my hotel room, and I was only allowed contact with a select group of people in the production staff. The transportation crew had one colored vest, hair and makeup another color, and the camera department their own so that they could remain isolated as much as possible within their respective groups. In addition, each department stayed within its own circle. Colors were *not* allowed to mix. And yet . . . there was something inspiring about it all.

Hundreds of cast and crew were performing extraordinary efforts for the gift of being able to make a film together. There was a sense of gratitude I had never experienced in a film production. I was escorted through the offices and witnessed some of the most remarkable preparations for film-making I'd ever seen: period-specific Viking langskips being handmade, with elaborate research drawings covering every wall; armor meticulously crafted; and Alexander Skarsgård working out with a stuntman in a homemade gym—he looked like a cross between Hamlet and Conan. I was given a tour through the massive sets, which were all being built with a level of authenticity that was breathtaking. Cinematographer Jarin Blaschke's intricate lighting plans were already being worked out, like the incantation of a spell. It was clear this swirling team of craftsmen were unified in one ambitious goal: the aspiration for excellence.

When I was introduced to Robert Eggers for rehearsal, we were all masked. Willem Dafoe and I began crawling on all fours—shirtless in Robert's office—pretending to initiate our future King Aurvandil War-Raven through pagan rituals, barking and howling like dogs and shouting our Icelandic verse through our cloth masks. It was at once both ridiculous and the most hard-earned rehearsal of my life. No one present on this film project was going to go down without a fight.

Movies, at their best, are built on the power of harnessing a collective imagination. The underlying question is, can the director and the producing staff organize a team of artisans around a story so that everyone's sweat, passion, intelligence, research, humor, love, and effort somehow form a cocoon around the script—eventually releasing a film that flies away in some new, confident, wondrous incarnation? I've been acting for over thirty years, and I've only witnessed it actually happen a handful of times. But when it *does* happen, it's inspiring in a way that goes beyond filmmaking. As tough, and cruel, and bitter as the world can be, humanity cannot be completely lost if a company this large can discover a unity of purpose for the simple goal of making something beautiful.

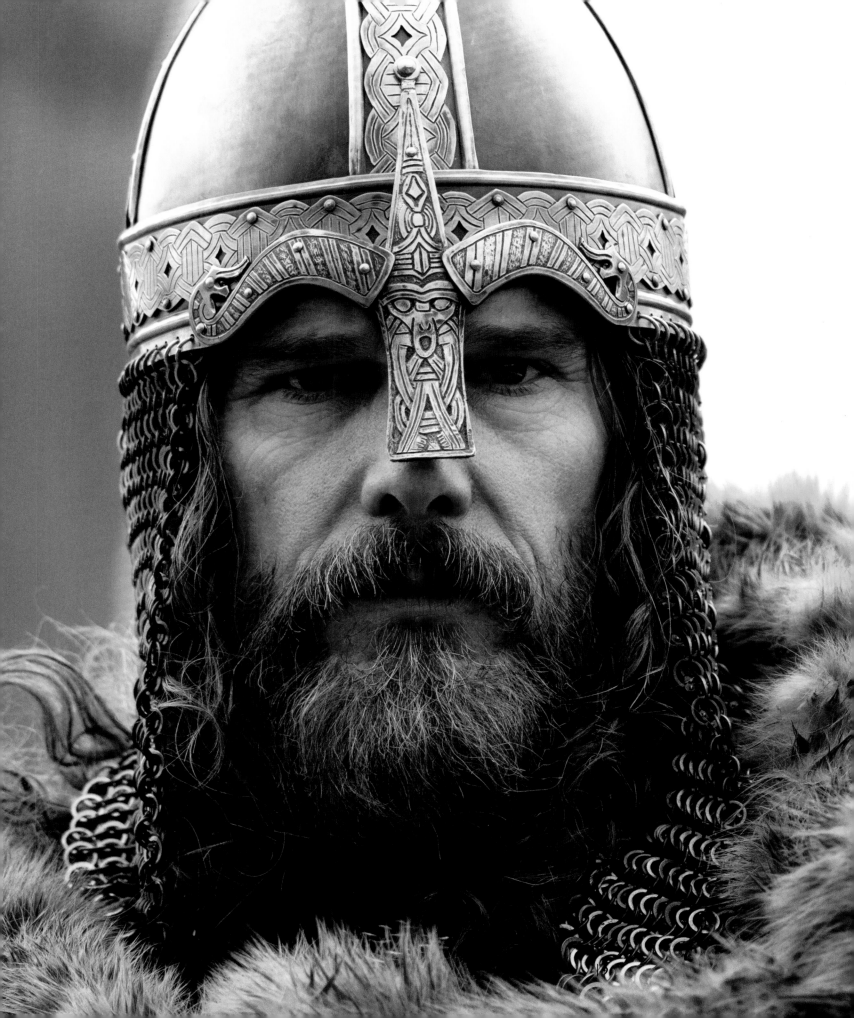

INTRODUCTION BY
ROBERT EGGERS AND SJÓN

"Hljóðs bið ég allar helgar kindir"

"Silence, all who hear my story" so speaks the Seeress of the epic poem "Völuspá," as she begins reciting her tale and prophesy of the creation of the world and its final destruction. Her poetic utterances create the world in a string of stanzas that stretch from the great nothing, or *Ginnungagap* in Norse mythology, until the Nordic apocalypse, *Ragnarök*. It is a story that plays out on a stage made from the body of a slain primeval giant: the World. The earth, oceans, sky, and clouds are all made from his bones, blood, and brain. And onto this grandest of stages, the Seeress introduces the key players of the greatest story ever told: the Æsir gods, led by Ódinn and Freyja; the Valkyries; the giants and dwarfs; dísir; dragons; and finally human beings, ourselves. Together, all these elements make the world tree Yggdrasill, a magnificent arboreal structure that fosters within its branches all there is and ever will be—the nine worlds of the Viking cosmos—while its own roots are fed by the water from the spring of Fate, which is the fuel that runs through the veins of every being in this mythical world. "No one can 'scape it," as the Three Norns who guard the spring are wont to remind both gods and men.

The Northman is a re-creation of the Viking Age. The film attempts to articulate the material side of that world as it was experienced by its inhabitants and to give an experience of the inner workings of the Viking societies, their belief systems, and the social mores that guided them throughout their everyday lives. Similar to how belief in fate ran through the veins of the early medieval Nordic cultures, the "words of wisdom" that ran through the entire production of *The Northman* was the quest for "historical accuracy." It meant that everyone who took part in the years, months, days, and hours that went into the creation of the film had to be aware of what *really* had existed in the first decades of tenth-century Scandinavia and, at the same time, be alert to the reinterpretations and inaccurate elements that had been projected onto the Viking culture in the millennia that followed.

Therefore, in every workshop and office of the film's production, people were reading the Icelandic sagas, watching archeological documentaries, consulting massive art books, and devouring obscure scholarly pamphlets. It also meant that everyone who was occupied with transforming the body of our particular slain giant into a motion picture about Prince Amleth of Hrafnsey, the man who never cries—the camera crew, costume weavers, stunt coordinators, actors, carpenters, animal handlers—were all aware that they were a part of a unified team busy with creating one coherent world.

The English word *world* shares its roots with the Old Norse *veröld*, which is comprised of two words that can be translated as "time" and "being," and it implies that the universe is a transient state rather than a fixed place. After the final battle in "Völuspá" has been fought and the world, filled with both beauty and cruelty and so carefully brought into being, is lost and rises again, the main players of the epic poem return to remember it. But the final day is yet to come . . . or will it ever? As long as there remains an audience for epic poems, that world will live. Now that the film is done, let's paraphrase the Seeress:

"Lower the lights, all who see our story . . ."

A CALL
TO THE GODS

It's 895 AD and Iceland's Mount Hekla volcano is smoldering, and its imminent eruption signals the beginning of the end for the Viking Age in *The Northman*, a new action-drama from acclaimed director Robert Eggers (*The Witch*, *The Lighthouse*). Conceived by Eggers and his co-writer, the Icelandic novelist Sjón, the film is a new kind of Viking saga that, like the director's last two movies, plays with our expectations of its historic narrative. The script is loosely based on the legend of Prince Amleth by the thirteenth-century Danish historian Saxo Grammaticus, itself a major inspiration for Shakespeare's *Hamlet*. In the original text, the protagonist, Prince Amleth, seeks to kill his uncle Feng, who is responsible for murdering Amleth's father, King Horvendill, in addition to seemingly kidnapping his mother, Gerutha. Eggers' version of this archetypal revenge narrative reflects the socioeconomic instability and general fear of retaliation from vindictive and power-hungry rivals that loomed over the Scandinavian settlers who, by the late ninth and early mid-tenth centuries, had moved to Iceland to start a new, post-Viking life with their families.

The Northman's main character, also named Amleth, is played by Alexander Skarsgård, the versatile Swedish actor known for his memorable performances in TV series such as *Big Little Lies*, *Generation Kill*, and *True Blood*. Eggers' film follows Young Amleth (played by Oscar Novak) living innocently in the fictitious Scottish kingdom of Hrafnsey, continues to the Land of the Rus

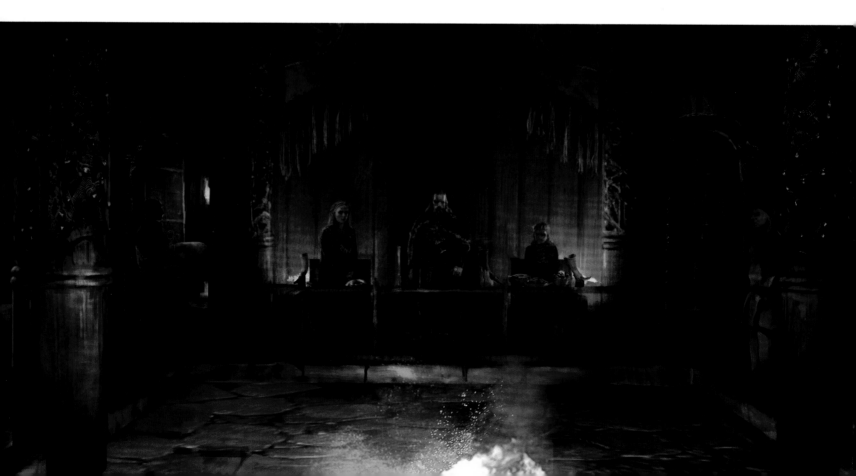

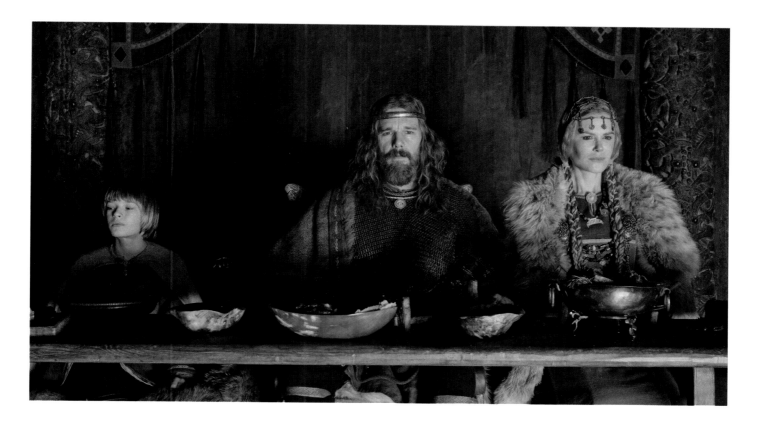

(modern-day Ukraine) with Amleth as an adult, then to Freysdalur, a prosperous farmstead in Iceland, and concludes on Mount Hekla. Skarsgård is part of an award-winning ensemble cast known for their complex and nuanced character roles that includes Ethan Hawke, who plays Amleth's father, King Aurvandil War-Raven; Nicole Kidman, who delivers a ferocious performance as Amleth's mother, Queen Gudrún; *Dracula* (2020) miniseries star Claes Bang, who, as King Aurvandil's treacherous brother Fjölnir the Brotherless, betrays Amleth's father and absconds with his mother; Anya Taylor-Joy as Amleth's love interest, Olga of the Birch Forest; Willem Dafoe as Heimir the Fool, King Aurvandil's court jester; and Icelandic singer-songwriter and actress Björk as a soothsayer Seeress.

With *The Northman*, Eggers takes an ambitious leap forward from his two modestly scaled prior features. The project was originally conceived by Skarsgård, who had tried for years to put together an authentic Viking movie and was particularly impressed by Eggers' *The Witch*. After some discussions with producer Lars Knudsen, Skarsgård started talking with Eggers about collaborating on a modern Viking saga. As in his two previous features, Eggers attracts viewers with the sort of period-specific details that immerses viewers into his characters' covert motivations. By highlighting the sheer normalcy of life apart from Amleth and his monomaniacal quest, Eggers and Sjón's script encourages viewers to see *The Northman* as more than just a straightforward revenge drama.

Despite initial plans to shoot a few key scenes in Iceland, the film was primarily shot in Northern Ireland over the course of eighty-nine days in 2020. Relocating several of the movie's originally planned shooting locations from Iceland to Northern Ireland due to COVID-19 lockdown logistics was a practical necessity given that the film was mostly shot during the global outbreak. Still, despite the production's bad timing, Eggers and Sjón's vision was realized with the sort of attention to detail that has come to define all of Eggers' movies, right down to production designer Craig Lathrop's quest to find just the right color of sulfuric black sand in Northern Ireland to double for the volcanic sand of Mount Hekla in Iceland.

In addition to Saxo Grammaticus's Prince Amleth legend, Eggers took particular inspiration from a wealth of period studies conducted by Viking experts like Neil Price as a research consultant, in

ABOVE (from left to right) Young Amleth (Oscar Novak), King Aurvandil (Ethan Hawke), and Queen Gudrún (Nicole Kidman) enjoying King Aurvandil's welcome banquet. **OPPOSITE** The Great Hall in Hfrasney's longhouse with King Aurvandil, Queen Gudrún, and Young Amleth seated at the head table. Concept illustration by Ioan Dumitscu.

addition to fellow consultants Terry Gunnell and Jóhanna Katrín Friðriksdóttir. The movie's choreography and unique design also speak to the thrilling impact of Eggers and cinematographer Jarin Blaschke's unique one-camera approach to shooting. Most productions of this size would use multiple cameras at once, but Eggers and Blaschke's signature style—along with the director's exhaustive catalog of cinematic knowledge and historical references that serve as inspiration—contribute to and enhance the movie's drama. And while Eggers features some popular staples of *The Northman*'s chosen genre, like Viking Berserkers, langskips, and raids, the movie also frequently acknowledges its protagonists' dual identities as both violent slave-owners and family-oriented, gods-fearing people.

Eggers and his team succeed in creating a new, visual saga, one that is grounded by, but not beholden to, the cultural touchstones that serve as its foundation. In a recent interview, costume designer Linda Muir used the phrase "a call to the gods" to describe intricate embroidery patterns that served as petitions to the gods. As Muir argues, the intricacy, effort, and creativity that went into this embroidery says a lot about the identity of the people who made and identified themselves by their clothing. Like the embroidery, Eggers weaves emotional layers into his characters using threads of betrayal, retaliation, and complete faith in the supernatural to create a nuanced story. It is in these finespun details that *The Northman* reveals itself to be both a historic genre movie about revenge as well as a complex and inverted understanding of a brutally violent bygone era that history has romanticized.

RIGHT The Kingdom of Hfrasney approached by langskips and knörrs. Concept illustration by Ioan Dumitscu. **OPPOSITE TOP** King Aurvandil's homecoming procession. Concept illustration by Ioan Dumitscu.

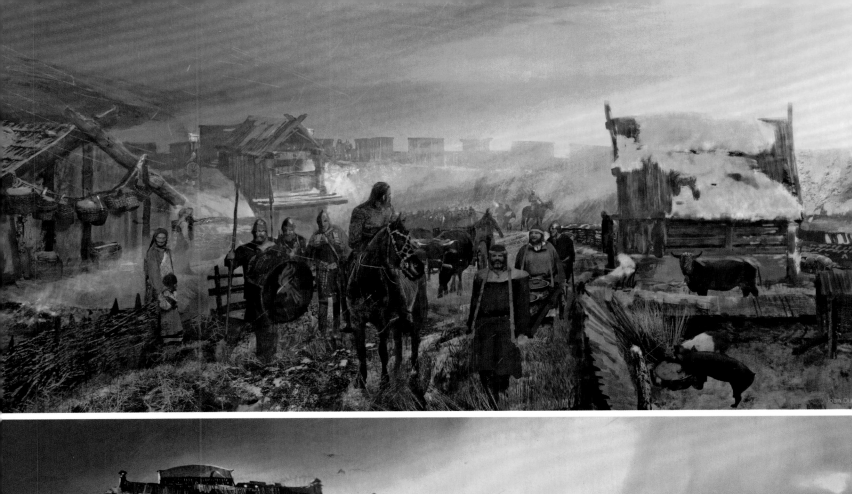
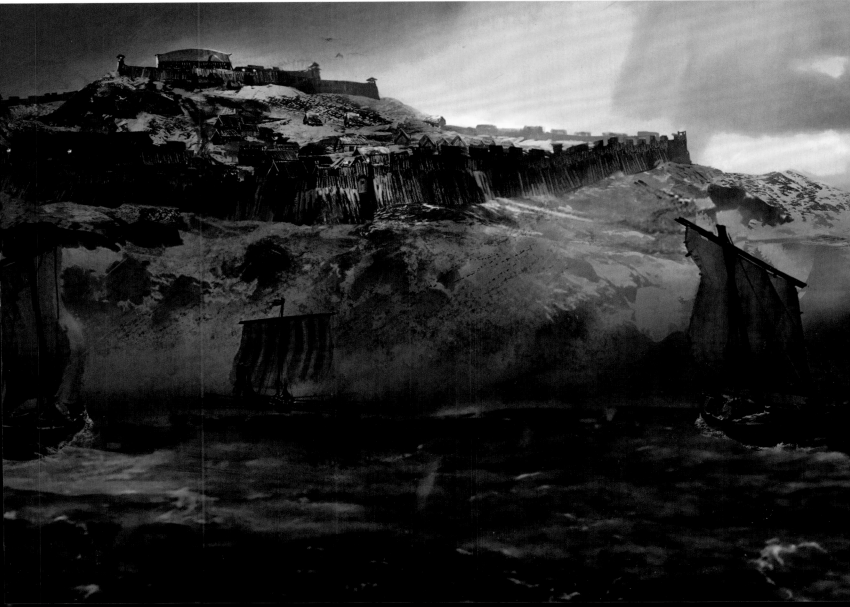

THE NORTHMAN SAGA RETOLD

After witnessing his father, King Aurvandil, being killed by his uncle Fjölnir and his mother being dragged away, Young Amleth swears to avenge his father's killing after barely escaping from his small kingdom of Hrafnsey, Scotland, with his life. We rejoin an adult Amleth nineteen years later, in 914 AD, who is now a member of a raiding party of animalistic, Óðinn-worshipping Berserker warriors that form an elite group among Viking raiders whose sole job is to kill opponents while their counterparts pillage and plunder a Slav village in the Land of the Rus. At this point, Amleth's not yet committed to what may, or may not, be his predestined revenge narrative, but he has already surpassed his youthful innocence. After a prefatory (and maybe perception-altering) ritual, Amleth and his fellow Berserkers mercilessly cut through an unprepared group of Slavic villagers, many of whom are murdered while the survivors are sold into slavery.

After the raid, an exhausted Amleth stumbles onto the Seeress (Björk), who reminds Amleth of his childhood oath to avenge his father. The Seer-

ess's cryptic warning recalls his father's earlier advice to Amleth when he was a child: "Never seek the secrets of women, but heed them always." But while the supernatural is very real to Amleth, it doesn't necessarily mean that we have to share his faith. Immediately after his encounter with the Seeress, Amleth meets a Slavic captive, Olga, on a slave ship bound for his uncle Fjölnir's farmstead, Freysdalur, in Iceland. Amleth quickly disguises (and brands) himself as a slave and stows away on board the ship. Amleth and Olga's bond develops intuitively as he presses onward to his vengeful goal. However, while Amleth and Olga are united by a mutual desire to avenge themselves against Fjölnir, Olga is also aware of Amleth's role in the destruction of her family and village.

Upon arriving to Freysdalur, we join Amleth as he's guided by a combination of mitigating circumstances and supernatural forces beyond his, or our, understanding. He heeds the prophecy of the He-Witch (Ingvar Sigurðsson), who, with the help of a severed human head, tells Amleth where he will find the king-slaying magic

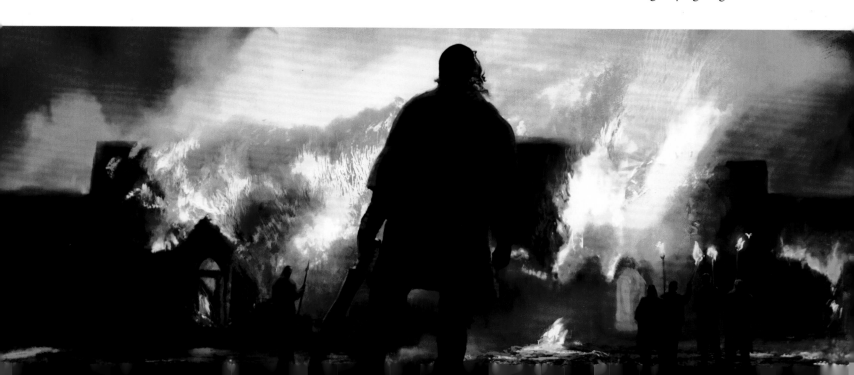

sword Draugr—along with its undead owner, The Mound Dweller (Ian Whyte). Amleth's circumstances are consistently shown to be beyond his control. He chooses his fate, but his path is also often seemingly determined by external forces, like when he plays a brutal game of Knattleikr, a rugby-like sport that also serves as an arena for courtly intrigue. The Knattleikr match is interrupted by the bloodthirsty Thórfinnr Tooth-Gnasher (Hafþór Júlíus Björnsson), who tries to bludgeon Gunnar (Elliott Rose), one of Fjölnir and Queen Gudrún's two sons—and Amleth's half-brother.

Rescuing Gunnar from Thórfinnr not only brings Amleth a few steps closer to Fjölnir—who doesn't recognize his adult nephew—but also gives us a fuller picture of Fjölnir and Queen Gudrún's post-Hrafnsey family life in Iceland. Scenes where Amleth's mother conspires with and dotes on his father's killer only further complicate our understanding of Amleth's destined

foe. In a revealing exchange, Fjölnir warns his son Gunnar, "No man knows if he will celebrate next Yuletide as a king or a slave. It is best to be prepared for both." Fjölnir's admonition not only mirrors Amleth and his father's rite of passage at the beginning of the story but also confounds our sympathetic understanding of Amleth and his defining need for revenge. Soon after the Knattleikr match, Amleth ambushes Thórir the Proud (Gustav Lindh), Fjölnir's other son, and kills him with his sword Draugr. Thórir's death only further tests our ever-shifting sympathies, particularly when he's buried during an elaborate Viking funeral that includes a slave joining her master to be buried alongside him inside a Viking knörr.

From here, Amleth's saga only grows more surreal and treacherous. He's rescued by a conspiracy of Ódinnic ravens and carried away by a Valkyrja (Ineta Sliuzaite) after a failed strike on Fjölnir and his new family. Amleth is then nursed back to health by Olga, although

ABOVE Slaves working on Fjölnir's farm. Concept illustration by Philipp Scherer. **OPPOSITE** Amleth watches Fjölnir's longhouse burn. Concept illustration by Ioan Dumitscu.

it's still unclear whether what we're seeing is real or just a figment of Amleth's imagination. Olga may be Amleth's strongest connection to the movie's reality, but it poses more questions than it answers. As they prepare to sail away together from Freysdalur, a pregnant Olga presents Amleth with a choice: He can continue his legacy by running away with her and starting a new family together elsewhere, or he can return to Freysdalur to confront Fjölnir. Amleth's decision only further opens his narrative to viewers' interpretation. As with any scene that revolves around Fjölnir and Queen Gudrún's post-Hrafnsey home, Olga reminds Amleth of life beyond the fate that's been prescribed to him by his father. She also shows us the world beyond Amleth's perspective and pokes holes in our preconceptions about a woman's limited sphere of influence within the Vikings' otherwise male-dominated society.

Amleth's relationship with Queen Gudrún only grows more complicated as he gets closer to his mother and begins to see her as more than just the distant provider that he swore to protect when he was a boy. In an emotionally devastating scene, Amleth sneaks into Gudrún's bedchamber to reveal his identity as her son, expecting to be welcomed with gratitude. But after Amleth announces his intentions to rescue Gudrún, she insists that she never really loved his father and reveals a scar above her breast, which suggests that she was kidnapped and enslaved by his father (it's the same branding mark Amleth gave himself in the Land of the Rus). This discovery proves to be too much for Amleth, who stumbles out of Gudrún's chamber and seeks out his uncle's men.

The final climax brings us to the fiery and angry volcano of Mount Hekla, where Amleth confronts his uncle and seals his fate. Amleth's nightmarish duel with Fjölnir suggests a world on the verge of collapse, one where the formally common influence of higher powers on day-to-day life may, or may not, be a projection of a peo-ple in spiritual crisis. It is easy to see why Amleth and Fjölnir's naked volcano sword fight was the scene that convinced Eggers that he *needed* to make *The Northman*. It's the kind of set piece that you might not believe exists in a real movie if you were to have read it in Eggers and Sjón's original screenplay. The concluding Mount Hekla set is especially impressive because so much care and effort went into its creation, especially given that this scene was not, in fact, shot at, or near, the real Mount Hekla in Iceland, but rather at Hightown Quarry in Northern Ireland. By getting a closer view of these small, below-the-line details, viewers will hopefully get a better sense of what makes *The Northman* such a unique testament to its creators' sustained vision and collaborative ingenuity.

LEFT Amleth follows the ominous fox with Fjölnir's farmstead in the distance. Concept illustration by Ioan Dumitscu. **BELOW** The climatic fight between Amleth and Fjölnir at Mount Hekla. Concept illustration by Kirill Barybin.

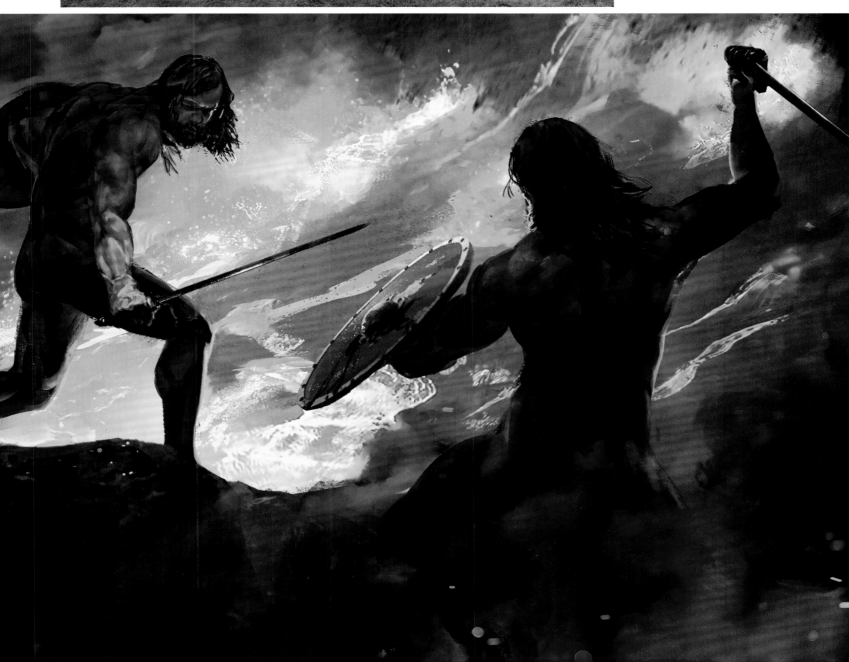

THESE PAGES Young Amleth's vision of his royal kinsmen on the Tree of Kings. Concept Illustrations by Šimon Gočál.

"NOW, LIVE ALWAYS WITHOUT FEAR—FOR YOUR FATE IS SET AND YOU CANNOT 'SCAPE IT. THIS IS THE LAST TEAR YOU WILL SHED IN WEAKNESS. IT WILL BE GIVEN BACK WHEN MOST YOU NEED IT."

—HEIMIR THE FOOL

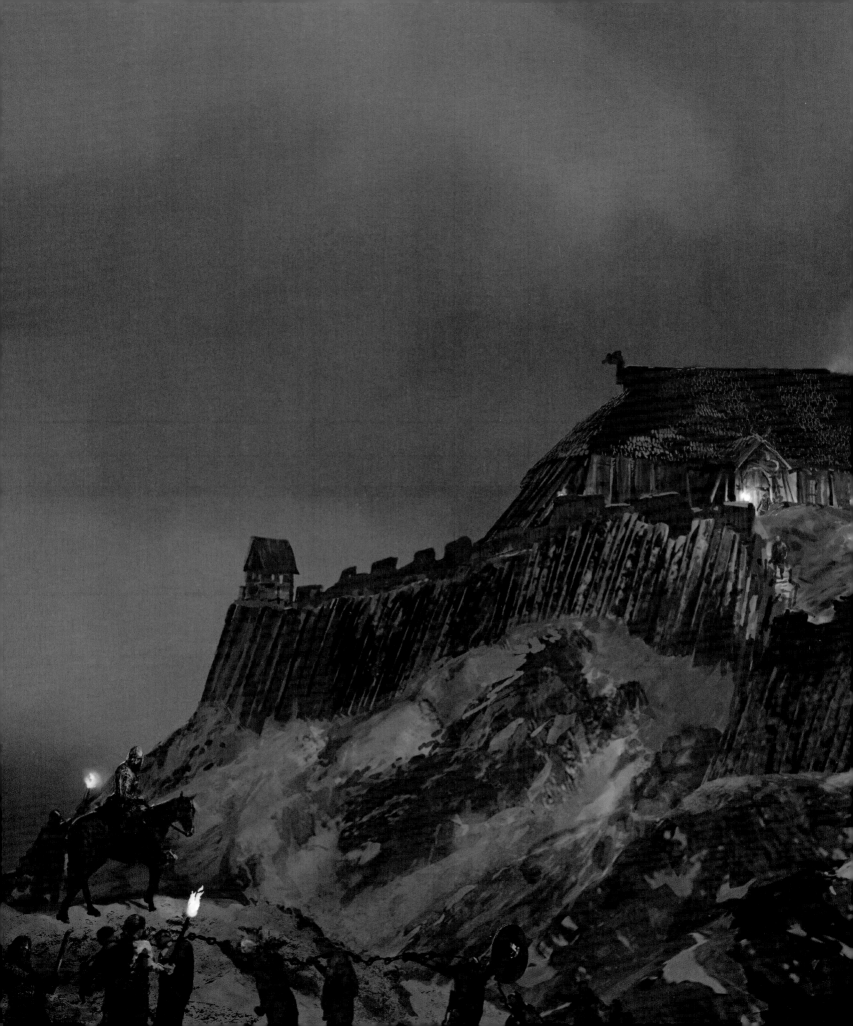

PART I

THE SAGA BEGINS

The Northman features a wealth of historically and dramatically revealing details. Eggers co-wrote his loose adaptation of Saxo Grammaticus's legend of Prince Amleth with Icelandic novelist Sjón. The two were introduced to each other at a dinner party hosted by Björk. The co-writers outlined a new story that depicted Viking culture as "not just a militarist culture," as Sjón says, "but also a culture of great poetry." At the same time, producers Lars Knudsen and Alexander Skarsgård had been looking to make a modern Viking movie.

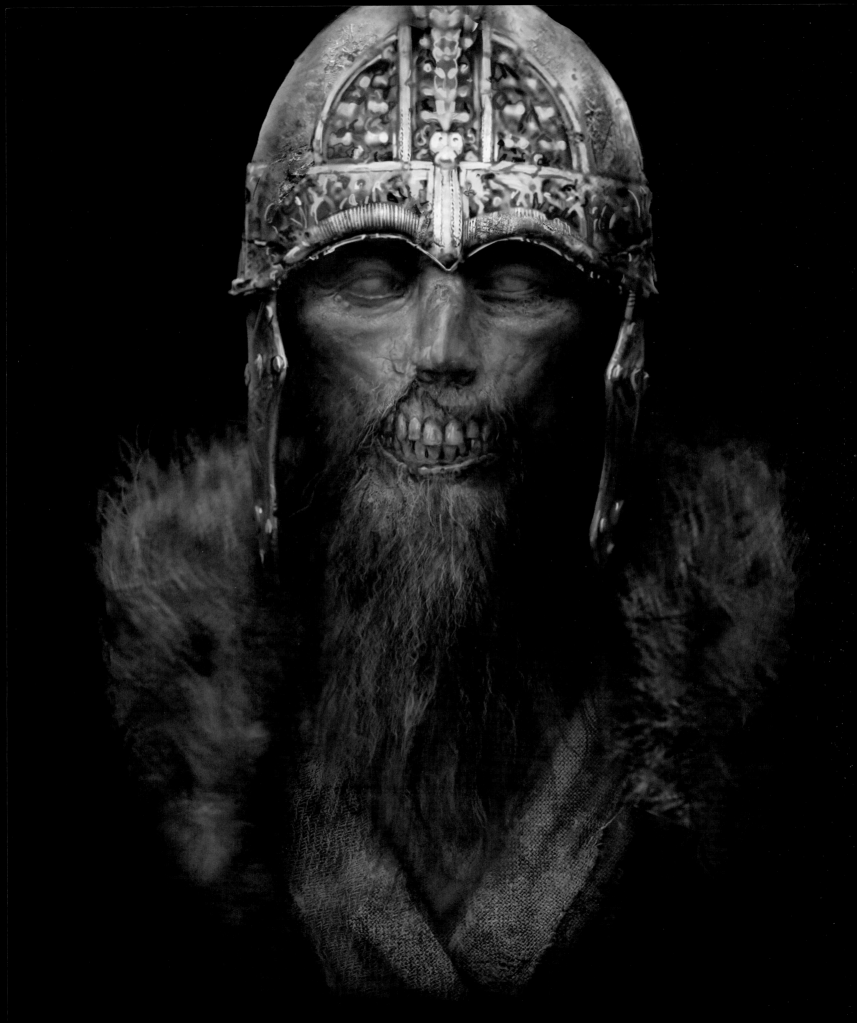

ROBERT EGGERS

Robert Eggers didn't have a Viking movie in him until he met Alexander Skarsgård and they discussed their mutual fascination with Viking culture as well as Skarsgård's ambition to make a great Viking movie. Eggers recalls, "I said [to Alex], 'Well, I have [an idea for] a Viking movie.' [But,] I didn't *really* have a Viking movie. I was excited about the idea of making a Viking movie." Although Eggers had previously visited Iceland with his wife Ali—who was well read in Old Norse literature—he wasn't really interested in Vikings. "I thought that they were testosterone-crazed maniacs; I preferred medieval knights who beat themselves and cry and pray. And the right-wing misappropriation of Viking culture turned me off even more." But Eggers found inspiration after rewatching the 2013 American neo-noir *Blue Ruin*: "Man, sometimes a good revenge story just works!" Armed with Ali's notes, anecdotes, and research, he and co-writer Sjón fleshed out the initial story outline over the course of three days. "Our thinking was that *The Northman* could have a very simple, very clear narrative—though that's not so easy for me to do." He modestly jokes that following *The Lighthouse* and *The Witch*, a relative mega-production like *The Northman* was not an intuitive step forward, given that it was "way too big" compared with his earlier projects. But in talking with Eggers about his vision, one gets a clearer sense of what he means when he says that "it's exponentially massive in every possible way, from the number of characters to the length of the movie."

It seems like your movie's elevator pitch could have been the Viking Hamlet.

It literally was. Also, "it's *Conan the Barbarian* meets *Andrei Rublev*." At a meeting, I was asked by a studio executive to say that *The Northman* was "*The Revenant* meets *Gladiator*." There's a lot of *Conan* in this movie. Too much *Conan*, probably. Fun fact: In *Conan*, when Conan gets his sword from a skeleton in a burial chamber, the effect was done by Richard Conway, the father of Sam Conway, our special effects guy. Sam did the effects during the scene where the dead Mound Dweller collapses and Amleth gets his sword, so that's kind of cool. That's a very deep cut right there.

You mentioned your inspiration started with Saxo Grammaticus's legend of Prince Amleth, which inspired William Shakespeare's character of Prince Hamlet. What were your impressions of Saxo's narrative, and how did that help to inform what you wanted to do with The Northman?

Saxo's Amleth is pretty good, but it's not totally mind-blowing. I prefer the Icelandic sagas to Saxo, but Saxo is a good storyteller, and his Amleth is clearly a story that works. Some people think that Saxo must have read some Icelandic version of Amleth that now no longer exists. We kind of only pulled what we wanted from Saxo, though I remember thinking, *This needs to be the Viking movie, so it has to have all*

PREVIOUS PAGE Hrafnsey's Great Hall. Concept illustration by Ioan Dumitscu. **ABOVE** Director and co-writer Robert Eggers. Photograph by Dave J. Hogan/Getty Images. **OPPOSITE** The Mound Dweller. Concept illustration by Šimon Gočál.

BELOW Alexander Skarsgård practices fight choreography before shooting Amleth's sword fight with The Mound Dweller (Ian Whyte). **BOTTOM** (from left to right) Whyte and Skarsgård review film shots; Amleth delivers a fatal blow to The Mound Dweller; Skarsgård rehearses the death shot with a dummy. **OPPOSITE** Amleth enters The Mound Dweller's burial chamber to take his sword. Concept illustration by Šimon Gočál.

the iconic Viking set pieces in it. Saxo's Amleth doesn't have all that stuff that our version does, like a Viking raid, for example. That said, something that's more pronounced in Saxo's version than *The Northman* [is that] Amleth literally plays the fool in Saxo's story. We had Amleth play the part of a dullard, as a slave on Fjölnir's farm to disguise himself, but that's as far as we went. In Saxo's Amleth, there's a scene where Amleth rides a horse backward and everyone laughs at him. We wanted to have that scene in the movie, but as the writing progressed, we saw that there was no room for it. [However,] unlike Hamlet, Amleth doesn't hesitate to pursue revenge. Our Amleth takes his time;

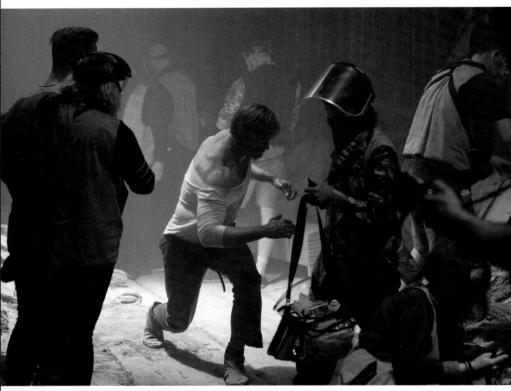

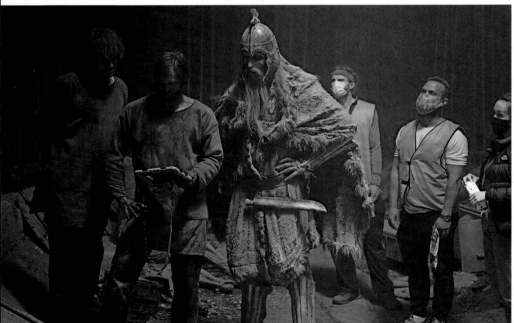

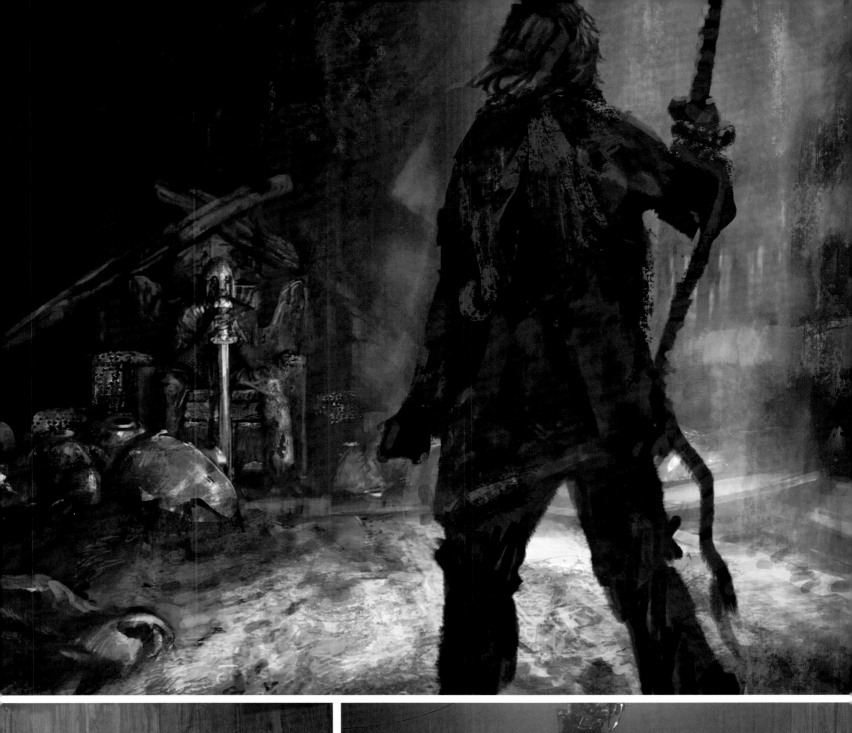
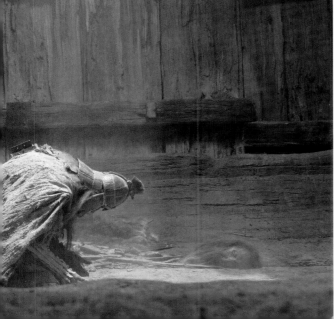

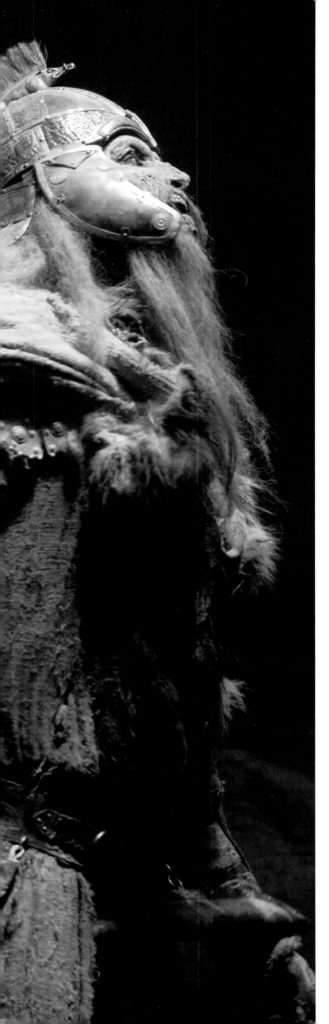

he enjoys toying with Fjölnir. I came across a Viking proverb yesterday while I was doing some research for poster taglines [that said] something like, "Revenge is better when you take your time," [and it was a theme] we also retained from Saxo.

You and Sjón met at a dinner party, where he told you about his research and writing on Icelandic witchcraft. Were there any particular images or concepts from your early conversations with Sjón that either hooked you or helped you to see The Northman's potential?

When we first met, Sjón and I immediately got along. We mostly talked about witchcraft—the "Viking movie" was nowhere on either of our radars. I just liked him, and we shared some of our interests. Everyone in Iceland is friends with everyone, and Sjón was friends with the guy who ran an Icelandic witchcraft museum in the Westfjords [region] that my wife and I had visited. I read Sjón's work after an early trip to Iceland and was completely blown away by it. The first of his books that I read is a very lean book called *The Blue Fox*. It's a masterpiece. Then I read *From the Mouth of the Whale*. I was steeped in Arthurian legend at the time, and I thought, *This guy is like Merlin—he's everywhere at once; his mind is so huge.* Later on, when the idea of doing a Viking movie became more real after having lunch with Alex, I thought, *I have to work with Sjón.* I also thought it would be good to work with an Icelander because, while there are plenty of Icelanders who don't care about Vikings—and are probably sick of Iceland being associated with Vikings—every

LEFT The Mound Dweller (Ian Whyte) collapses in his death throes.

"IN *CONAN*, WHEN CONAN GETS HIS SWORD FROM A SKELETON IN A BURIAL CHAMBER, THE EFFECT WAS DONE BY RICHARD CONWAY, THE FATHER OF SAM CONWAY, OUR SPECIAL EFFECTS GUY. SAM DID THE EFFECTS DURING THE SCENE WHERE THE DEAD MOUND DWELLER COLLAPSES AND AMLETH GETS HIS SWORD."

—ROBERT EGGERS

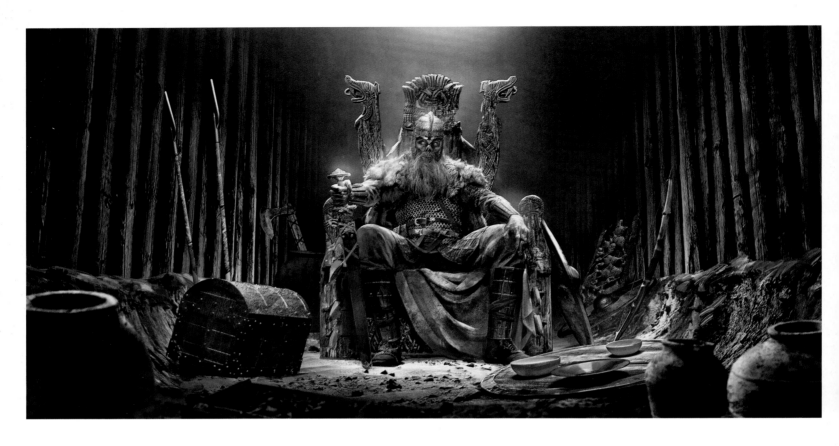

ABOVE The Mound Dweller, the undead warrior king that Amleth must fight to earn his sword Draugr. Concept illustration by Aaron Sims Creative. **RIGHT** Amleth attempting to pry away The Mound Dweller's sword. Storyboards by William Simpson. **OPPOSITE** Ian Whyte, in costume and full makeup, sits on his subterranean burial throne.

Icelander can tell you which Viking saga characters they're directly related to. And from my outsider's perspective, I can tell you that when my wife and I went to Iceland, you feel that you are among Vikings. It's not the same in Denmark or Sweden. Iceland feels more extreme; everyone is named Thor and Gísli and Gudrún. That's how it is there.

In the script there's a kind of ambiguity to Amleth's quest for revenge. You and Sjón go out of your way to suggest that your supporting characters all have personalities, experiences, and inner lives that don't neatly extend from Amleth's story, or perspective, such as how Fjölnir and Queen Gudrún both have genuine affection for their post-Amleth family, and also an autonomy that extends beyond how they're treated by Amleth.

Well, that's partly just to make the story more human and interesting. We're used to gangster movies about Italian mob bosses who are family men, because even mob bosses who love their families can be protagonists in crime movies. Even the villains in those stories like their families. Parts of those mafia stories are not too different from post-tribal Viking sagas. In the Icelandic sagas, you have these very rich, multidimensional characters who are not entirely good or evil. There are a lot of famous Vikings who show up in multiple sagas, and they might be a bad guy in one saga, but more of

a hero in another. So, we tried to honor that literary tradition where not everything's black-and-white. It's also more like life. Really bad theater and bad cinema tend to reduce characters to two dimensions, or one.

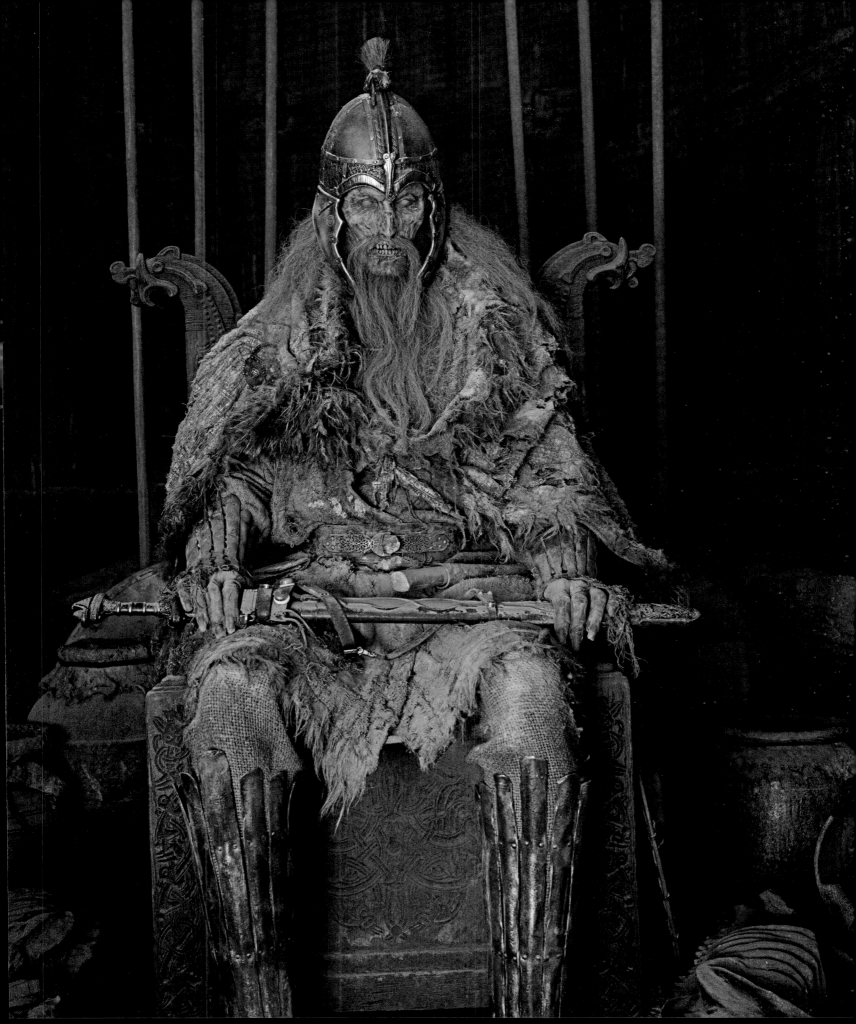

Were you interested in adding a sort of psychological, or emotional, complexity to these saga characters for general moviegoing audiences?

Well, *The Lighthouse* is *The Lighthouse*, but with *The Witch*, it was supposed to be you think you know what a witch is—from Disney's *Hocus Pocus*, ubiquitous Halloween decorations, etc.—but [I wanted to show] *this* is what a witch was like in the English early modern period, when evil fairy-tale witches were thought to be real. That said, some of the stereotypes about Vikings exist in the source materials. There's a famous drinking scene in [the Icelandic saga] *Egil's Saga*, where a farmer, Egil Skallagrímsson, gets so smashed that he pukes in his host's face, so [it is] a lowbrow comedy, with puking. [This] kind of stereotypical Viking behavior probably existed. We also have a scene of tough Vikings partying in that way. But when we first see the Viking world [in the movie], we're with a king in his court, and it's very mannered and the culture is sophisticated in a way that viewers might not expect. That was something that I was more interested in. So, to your point, subverting viewers' expectations with facts is enjoyable.

Olga, obviously, has a different Viking Age experience than Amleth, because she's a slave, which understandably informs a lot of her behavior. How did you develop and conceive of Olga's character?

Olga was initially more earthbound before we turned her into something of a white witch. She was always a partner for Amleth, part of his journey and someone who could bring vulnerability out in him, but also someone with her own agency and goals. She also became another way to get us into the female experience of the period. We already had Gudrún, a queen and a chieftain's wife, but so much of the female world, especially in the Icelandic chapters of the film, was about enslavement. Olga is our window into that world. That's also why we built the weavers' huts. Think of all of the women making the sails for the Viking ships, day in and day out. Even if the plot of the story is about male warriors, we wanted to show a nuanced view of women's experience in the period.

BELOW Amleth spies his uncle Fjölnir (Claes Bang) and mother Gudrún (Nicole Kidman) through a crack in their bedroom door. **OPPOSITE TOP** Olga (Anya Taylor-Joy) weaves a basket while waiting to hear more from Amleth about the plot to kill Fjölnir. **OPPOSITE BOTTOM** Olga stands among her fellow slaves.

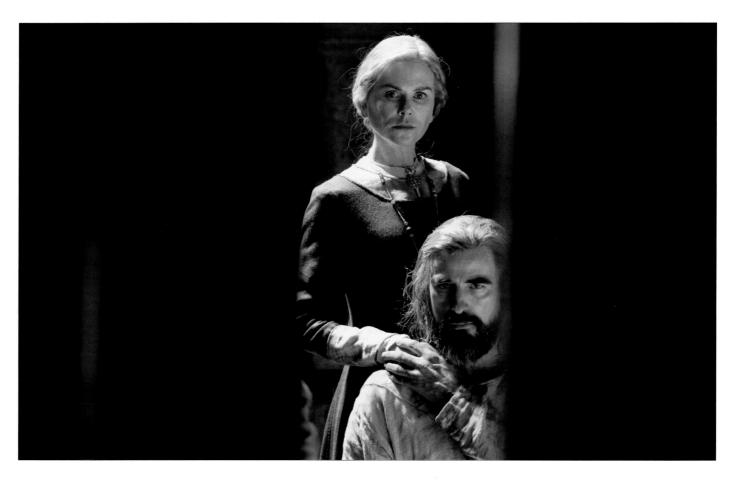

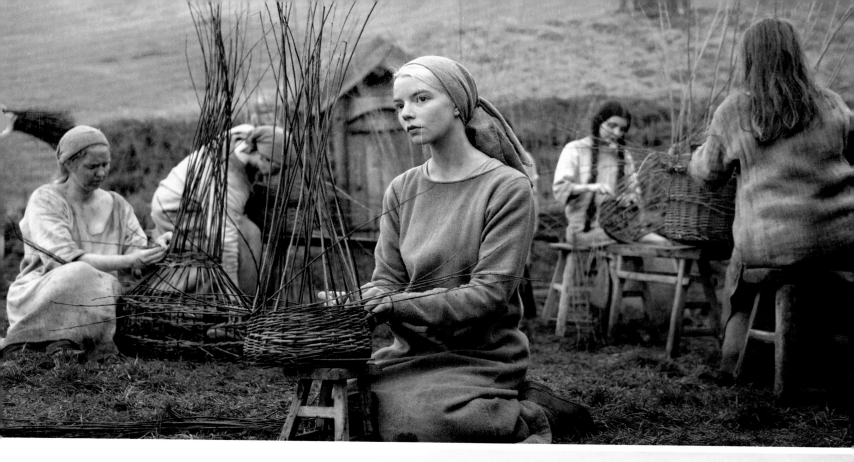

Your use of imagery based on the Norse god Óðinn stands out, like when we see that Amleth's right eye has swollen over when he's bound by his wrists in the shed scene, as well as in the earlier village raid scene when there's a trickle of blood from his right eye.

Óðinn was the god of a lot of things. He was the god of poetry and the male god of sorcery, which is an interesting taboo, because men who practiced sorcery were considered to be "other." That's why Ingvar Sigurðsson—who plays the He-Witch, a male witch that Amleth meets in a cave—is dressed in women's clothing, which may not be immediately clear to modern audiences. There's evidence in the Viking sagas, and potentially in some archaeology, which suggests that Óðinn sometimes dressed like a woman. That's also why we show a big, stone idol of Óðinn dressed like a woman in the early temple scene. Because if you're the god of war and the number-one god, you do whatever you want. Aurvandil, being a king and warlord, would worship Óðinn. But that means that his half-brother, Fjölnir, [who feels he] has to be different, would worship [the god] Freyr, who was Óðinn's brother-in-law—especially because Fjölnir doesn't like his half-brother. Later, Amleth gets taken in by Berserkers, these wolf and bear warriors, and Óðinn is their god. So Amleth's got a lot of Óðinn around him. That's just how it is for him.

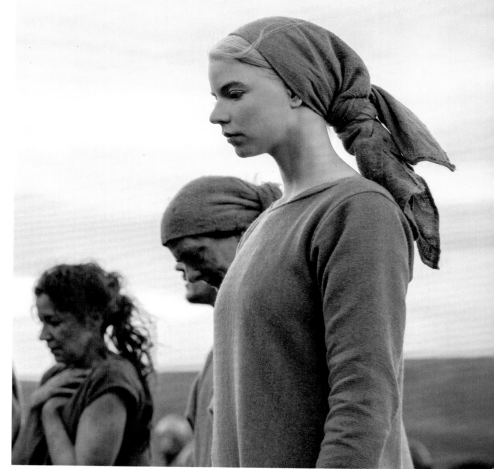

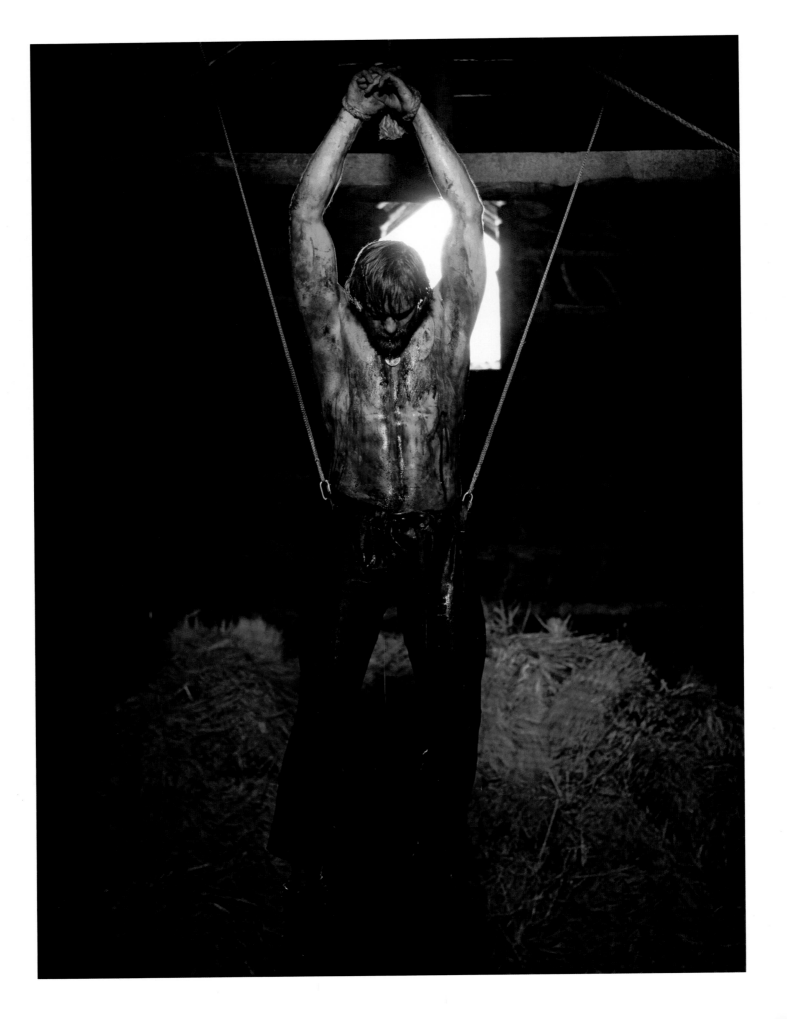

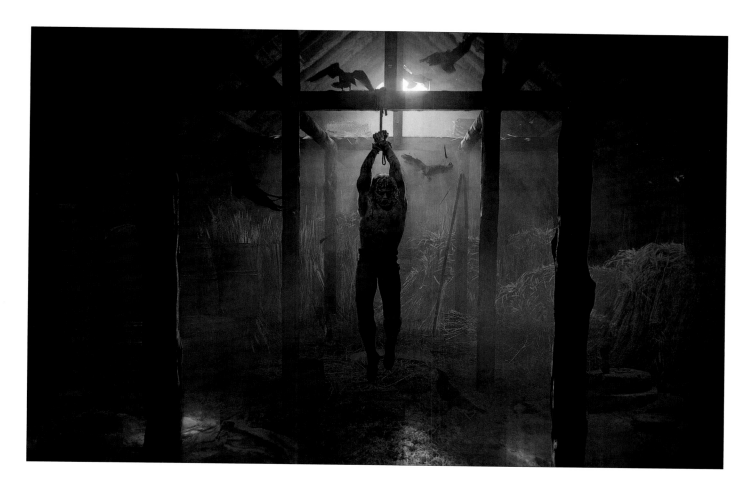

When you worked on the screenplay, were you interested in putting these Viking characters and their environment within the context of how later scholars and historians, who were Christian, interpreted the Vikings and the sagas?

As you read the Christian-tinged sagas, you start to wonder, *What was going on here? What were people trying to hide? What were people embarrassed about?* In addition to talking with [Viking expert] Neil Price, we also worked with [Icelandic] historian Jóhanna Katrín Friðriksdóttir, and she told us, "[The goddess] Freyja really needs to be a bigger presence in your film. She's not in there enough." That was at odds with research I had found that hypothesized that Freyja was more popular with proto-Vikings in Germanic tribes, who were practicing their religious rituals outdoors. As life for these tribes became more militarized, Freyja sort of fell into the background and Óðinn took center stage. However, Jóhanna explained that she disagreed with that. [She said,] "The thing is that all of the people who wrote about Vikings during the Viking Age were Christian, and they didn't want these female gods. So, the Christians worked hard to bury Freyja. Later, most

of the scholars of the nineteenth and twentieth centuries were male scholars who also weren't interested in the goddesses. But there are examples of poetry where half of the slain Vikings go to Valhöll (or Valhalla, as we know it in English), and half of them go to Freyja's hall. So, I believe that she was a big war goddess." Again, I'm paraphrasing [our conversation]. We then incorporated Freyja more into the film. She is mostly present in iconography that only Viking history nerds can appreciate. There was originally a big Freyja-centric scene with Queen Gudrún that was unfortunately cut.

Queen Gudrún is a bit of a femme fatale, which maybe also speaks to the way that the Christians retrospectively depicted Freyja. Was that on your mind?

Queen Gudrún is based on what I believe [Danish historian and expert on medieval women] Jenny Jochens called a "whetting woman," a female saga character who goads her man into seeking vengeance and therefore serves as the whetstone for his fighting rage. Jochens wrote that the whetting woman is a male author's vision of a certain female archetype. In one

ABOVE Amleth tied up and surrounded by ravens. Concept illustration by Philipp Scherer. **OPPOSITE** Amleth (Alexander Skarsgård) is beaten and strung up by his wrists after surrendering to Fjölnir's men.

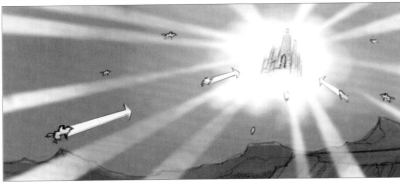

also consult with their wives about the communities that they're going to conquer—because women are fucking smart and part of the world. Even though there were certain laws that limited their power, you see their strength through these saga characters.

Nicole Kidman's performance is stunning. Can you give an example of how she changed, or really defined her character, in a way that you didn't expect when you originally conceived of Queen Gudrún?

Queen Gudrún is fairly consistent with how I conceived her, but Nicole made Gudrún a much richer character by asking questions. She gave me two rounds of notes to enhance and clarify her character, and I have to say, they were really excellent notes.

Olga's ferocity is treated matter-of-factly, even during the scene where she wards off Fjölnir when he tries to force himself on her. How did that scene come together?

We initially wrote that Fjölnir owned a sort of brothel, but Jóhanna set us straight [and said], "No, wherever the women were, they would just be raped. There would be no brothel." Maybe King Aurvandil would have had a brothel in his Viking city, but at Fjölnir's Icelandic farm setting, he'd just go into his cowshed, where the enslaved women slept. That's much more disturbing. That scene was originally kind of uncertain of itself. In an earlier version, Olga shows Fjölnir her menstrual blood and he leaves. Here's where we get into some sticky territory. [When discussing the scene], Claes said, "Well, wouldn't Fjölnir rape her anyway. This is unrealistic—he is a Viking. [I'm] sorry." I told Claes, "Yes, but we still have to care about your character a little bit in order to make this drama work, and if you rape her, it's done. It's done." I also didn't really want to film a rape scene either. There are already plenty of allusions to rape in the film, and while I don't want to whitewash history, we've already seen enough horrible sexual abuse and rapes in cinema. We can be effectively dramatic in other ways in this film. So, I asked Jóhanna if there was a taboo about menstruation during the Viking Age. She consulted with her fellow Viking scholars and experts and said, "Claes is unfortunately right. There isn't a taboo about menstruation," which frustrated me. Then Anya suggested, "What if I reach down, grab a bunch of menstrual blood, and slap him in the face with it?" I said, "*That* is how to do the scene."

story [for example], a character like this convinces her reluctant husband to avenge their son by showing him a bloody cloak that belonged to their dead child. At the same time, so-called whetting women exemplified how women could have power in a male-dominated society. In the sagas, Vikings consult with their wives about how to arrange their daughter's marriage. They

Your actors' movements must be very precise when filming with your and Jarin's one-camera approach. What kind of direction did you give to your cast so that it kept their performances down-to-earth?

I said to everyone, "Be the Terminator. Don't blink. Don't move. Just say your lines. And then within that we can find the different shades of expression."

Can you talk about the folk song performance during the slave camp site? Björk's daughter, Ísadóra Bjarkardóttir Barney, sings part of the song. How did the scene come together?

The change of seasons in the Icelandic chapters of the film are not very well visualized or articulated in the movie, but at that point in the film it is the end of October [and] it's *Vetrnætr*, the Viking holiday that falls near when we celebrate Halloween. We came up with this separate celebration for the slaves as a way to make Olga and Amleth get together. There is no direct evidence that the slaves would have been able to celebrate on their own in this way. But for the Christian slaves of our movie, this would be their Samhain, the Celtic Halloween holiday, so there would be reason to celebrate. Irish Christians were a little more pagan during this period.

We were looking for a bawdy song, and Sjón suggested a passage from the *Bósa Saga*. We went back and forth when deciding whether to subtitle it or not. Our songwriters, Robin Carolan and Seb Gainsborough, worked with our vocalist Karin Ericsson Back. She's an expert in *kulning*, a Scandinavian herding call that's kind of like yodeling to call the cows in. The experts seem to think that in Norse cultures of this period *kulning* is what female singing would probably have been like. There's singing like that even today in a lot of Baltic and Slavic folk cultures, which you might recognize from Bulgarian folk singing because of the Bulgarian State Television Female Vocal Choir—their albums were so influential globally.

Our scene came from all that, but Ísadóra Bjarkardóttir Barney [who plays the slave Melkorka] and Jonas K. Lorentzen [who plays the slave Eysteinn] really made it their own [when performing the campfire duet]. That was the most enjoyable scene to shoot because it was the most lighthearted. It was difficult to shoot, too, because the whole movie is gloomy, cold, hard, violent, sad, tragic, and vengeful. But this scene was light. We were all around a fire, and while I don't know if it's quite captured on film, the sensual qualities of that song and dance had an electrifying impact.

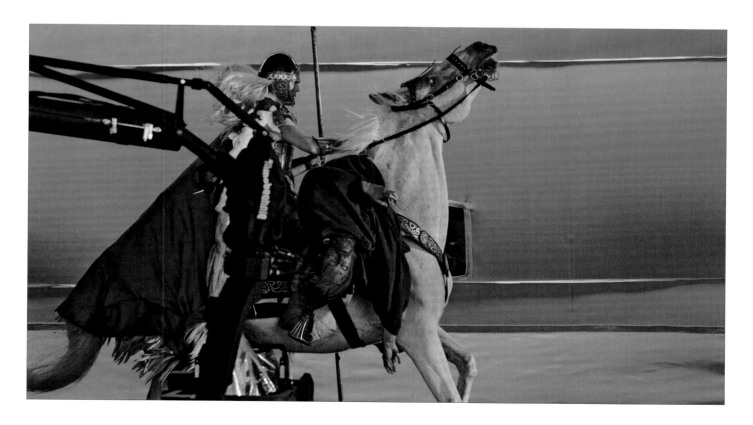

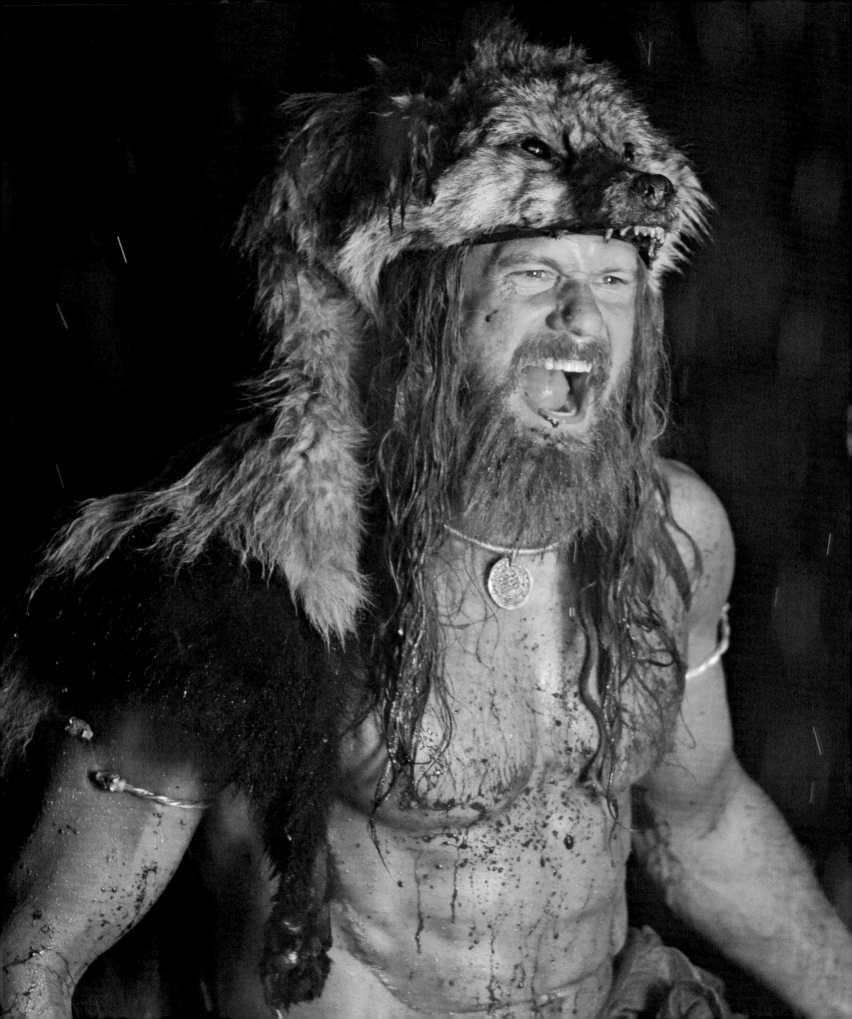

How did you devise the choreography for the Berserkers' dance scene?

Well, some [viewers may] think that they're doing mushrooms or tripping out off camera before the ritual begins, which was not my intention. My thinking was that through this dance these Vikings would be able to go into a trance and transform into beasts. My impression is that Old Norse religions were not necessarily shamanistic, but had shamanistic elements. So, for inspiration, choreographer Marie-Gabrielle Rotie and I looked at lots of different Native American animal transformation rituals and powwows, as well as different war dances from all over the world, including Africa and Polynesia, and used that to interpret the few images we have which historians think may have been ancient Germanic war dances. We worked all of that into the Berserker dance sequence. Some of the actors who played our Vikings could move really well, but other guys could move less well, because we were looking for people who were potentially larger than Alex—and he's six foot four. Some of these seven-foot-tall bodybuilders couldn't move like trained dancers, so we needed to find different movements that they could do. Those guys were awesome, by the way. They were so cool and so creative, and they were like a band of brothers—at the end of the shoot, they got matching tattoos.

I imagine that there must have been some overlap between the cast members as Berserker warriors and players in the Knattleikr game scene?

The Knattleikr game was the last scene to be shot-listed—as in, while we were shooting the movie. Every other demanding scene was already storyboarded or shot-listed *before* we shot the movie, but we were still choreographing the Knattleikr game while we were shooting the movie. I didn't really want the Knattleikr game in the screenplay because I don't really care about sports. But Sjón was very adamant about it, and any time I tried to find a way to get rid of the Knattleikr game, he found a way to keep it. So, I said to myself, *Look, Knattleikr is in a whole lot of sagas. It's a sport that you would play at this time of the year and for this particular holiday, where they're celebrating with this other chieftain. So, we'll do it; it'll be great.* Jarin was also resistant to the idea of filming the Knattleikr scene, but I put my foot down and said, "Look I don't care that we both got bullied by jocks in high school, we've got to figure it out."

That said, I was totally exhausted when we were planning the scene. I'd show up to watch stunt coordinator C. C. Smiff and his team rehearse. I was miserable and barely sane. We were originally supposed to shoot the Knattleikr match in Iceland, and there was a lot of pressure from the line producer to shoot it in a quarry

ABOVE Amleth as a Berserker warrior. Concept illustration by Dan Luvisi.
OPPOSITE Amleth (Alexander Skarsgård) prepares for battle by entering a Berserker trance.

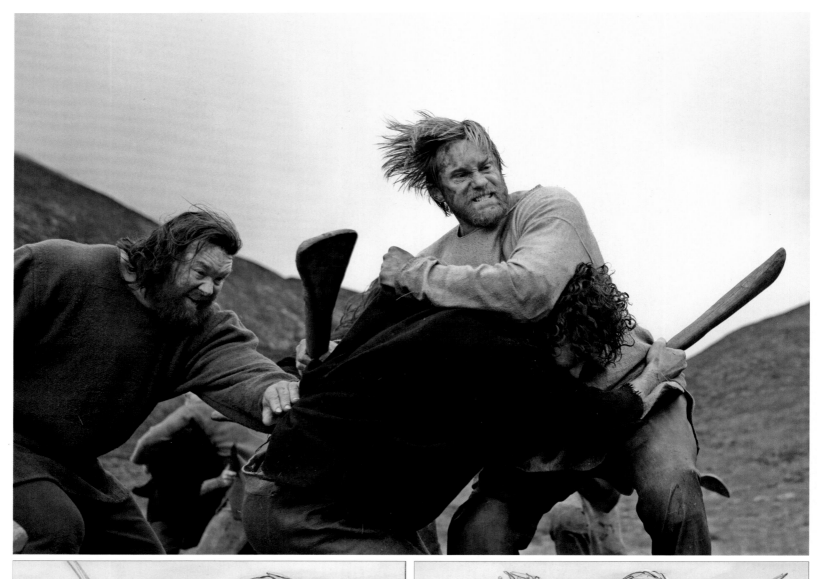

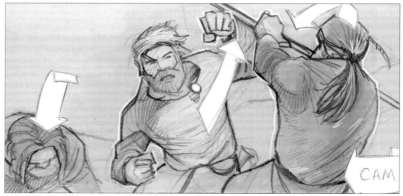

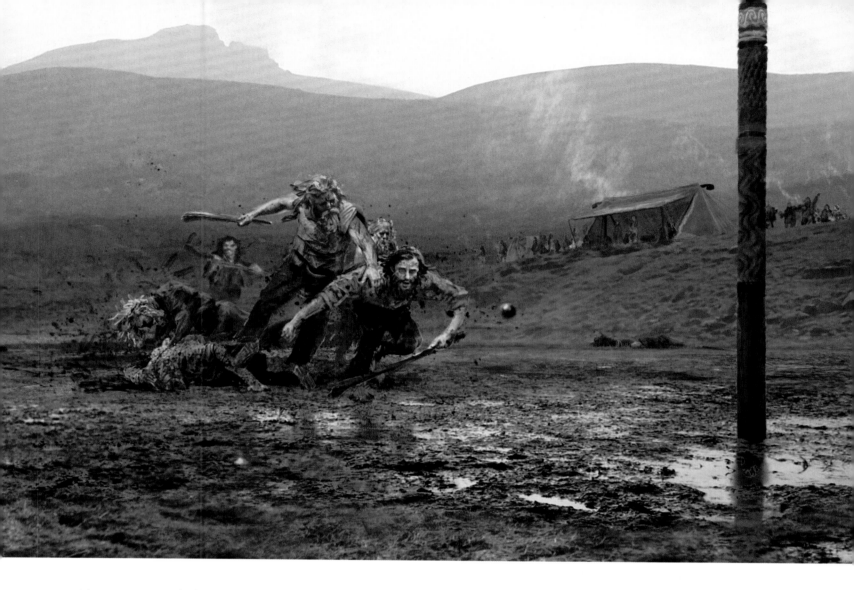

with a green screen, which we would then project footage of Iceland onto. Thankfully, we found a place in Northern Ireland's Mourne Mountains that looked Icelandic and dramatic. That sequence was really difficult, more than any other scene and much to everyone's horror, because the shots were developing a lot as we shot them. So that scene changed a lot with the choreography getting tighter, and it kind of drove everyone crazy.

Did representing blood or nudity pose any unique challenges for you for this project?

There is gore in the movie, but I think that the goriest stuff happens off-screen—or at least, that's my intention. I don't like super-gratuitous gore. I think the only thing that's sort of gratuitous, to my mind, is when [Fjölnir's proxy] Hallgrímr Half-Troll's guts spill out. I feel like we earned everything else. Same thing with the nudity, which needs to not only serve the story, but also not be objectifying. [Nudity] needs to express whatever the story needs it to. Like when I shot the

climax of *The Witch*, where [teenage antiheroine] Thomasin is walking into the woods. Even though we're at a distance from the character, it still needed to feel like her experience of being *free* and expressing freedom in her nudity—and not like we are objectifying a naked young woman. The same philosophy applies here to *The Northman*. Though, we do show off Alex's body—he made it into a work of art—and let's not deny it. That can't be helped.

Can you talk a little about the full-frontal nudity for the Mount Hekla sword fight?

I did want to have male frontal nudity in the movie. I would have only wished for tiny glimpses of penises. We have glimpses of testicles in the final fight, which is fine and keeps the illusion that they're really naked. But where I particularly would have liked full male nudity is in the village raid with the Berserkers. As scary as it is to see a six-foot-eight jacked guy in a loincloth running at you, one who's entirely naked is even scarier.

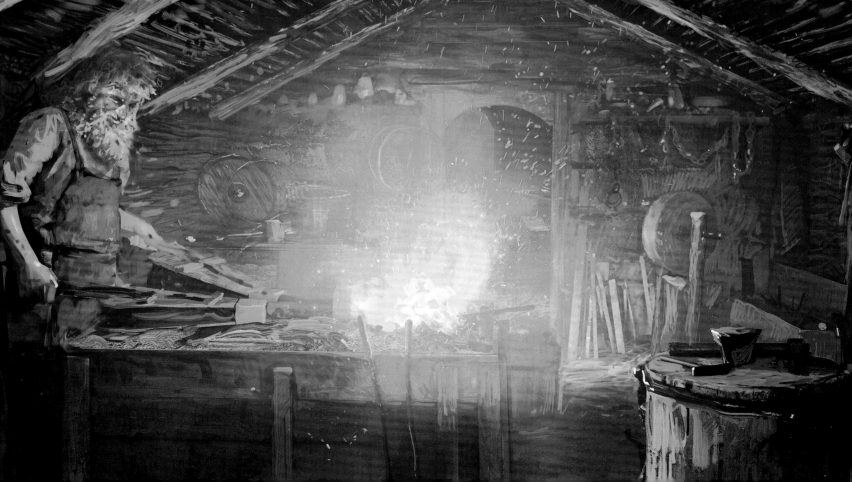

CO-WRITER
SJÓN

Even before they met, Icelandic novelist and poet Sjón had been impressed with Eggers after watching *The Witch*, especially with how deep Eggers had gone into the "contemporary mind-set" of his characters. And Eggers was particularly taken with Sjón's novel *From the Mouth of the Whale*, which Sjón describes as a "pre-Enlightenment story" that follows a character who has been "sentenced to death for spreading the knowledge of witchcraft." Eggers emailed Sjón about the potential possibility of working together on his upcoming film and said: "I'm planning to do this Viking story, and I'm looking for a co-writer. I would love to do it with you because I would like to do the same thing that you are doing in *From the Mouth of the Whale*. That is, to step completely into this world and never question what it is, but rather to take it for granted, just as people living in that world would have." Sjón accepted his offer and then helped Eggers to incorporate historic details from various Icelandic saga tropes. And although Sjón was excited to work with Eggers, adapting a Viking Age saga gave him pause. "It's a bit tricky for an Icelandic writer to work with this material," Sjón says. "It has been done before so many times throughout our literary history—and badly. It's such an easy thing to fail miserably at, really. Still, I said to Robert, 'I'm ready to fail with you.'"

Given your familiarity with the Icelandic sagas and how they've been represented and adapted over the centuries, what sort of tropes did you want to avoid when you co-wrote The Northman?

Here, in Iceland, the sagas are part of a heritage that has never left us, so we never had to rediscover it. The world discovered the sagas probably in the mid-eighteenth century, when Goethe and his group of German writers established the idea of world literature. They said something like, "This is a prime example of high-quality world literature that sprang up in a place beyond the cultural center." Of Europe, that is. I'd promised myself to never touch the sagas because of how much they had been abused by the Nazis, and also because of all the clichés that became tied into the topic—[those] that stem from high culture, like Wagner's operas and, of course, the Nazi clichés of the blond-haired, blue-eyed master race. People tend to weigh down the sagas with all of that baggage, so there are many things for an Icelander to be wary of, really. Icelanders have also been taught to revere the sagas, so I felt like I had to bring something new to that material. Many of our authors have already rewritten the sagas, or written episodes based on minor characters, so I didn't want to just pick up where so many other people left off. That said, something that Robert and I agreed on from the beginning was that we would try to represent these characters' cultural background. Everybody knows why Viking stories are exciting: There are raids, lesser people are taken into slavery, and so on. All that macho stuff is there in our story, but it's so easy to forget that the Vikings were not just a militarist culture, but also a culture of great poetry. They were a culture of great designers and great engineering, and we wanted to bring that alive somehow in our story.

ABOVE Co-writer Sjón. Photography by Kamba Danielsson. **OPPOSITE TOP** The temple in Hfrasney. Concept illustration by Ioan Dumitscu. **OPPOSITE BOTTOM** A blacksmith forging weapons at Fjölnir's farm. Concept illustration by Philipp Scherer.

BELOW Amleth and his fellow Berserker warriors raid the Slav village. **OPPOSITE TOP** In battle, Amleth (Alexander Skarsgård) is possessed by the dual Óðinnic influences of a bear and a wolf. **OPPOSITE BOTTOM** Berserkers approach the village to plunder and destroy. Storyboards by William Simpson.

Can you talk a little about Icelandic settlers' understanding of prayer, or their general sense of spirituality?

When you're interested in the mind-set of a group of people, the foundation for that mind-set has to be their religion, their big idea system. That's true for all cultures. It doesn't matter if they're secular or religious; there is a cosmology that that society agrees on. One of the interesting things about Iceland at this time is that there were many religions coexisting at the same time. During the settlement period, you had Nordic pagans, Christians from Ireland, more continental Christians, and even Christians from the Eastern Orthodox Church. In many ways, Iceland was a multicultural society. To understand what made these people tick, you have to go into their belief system: how they communicated with bigger forces, since that

dictated what they saw as a proper life and a proper way of living. In *The Northman*, Amleth is bound by an oath from childhood to avenge his father. Then after his lost years, he's called back to his mission and must fulfill his oath. To make that real for him and the audience, we had to explore Amleth's belief system. That's something that interested both Rob and me.

In your script, you and Robert draw parallels between the three main seers, or shaman-like characters: Willem Dafoe's Heimir the Fool, Ingvar Sigurðsson's He-Witch, and Björk's Seeress.

Our original idea was to introduce a secret network of shamans, sorcerers, and seeresses. It doesn't matter if you are a Slavic witch, a sorcerer holed up in an Icelandic cave, or the court shaman in a tiny kingdom. These people all operated on the same plane of existence,

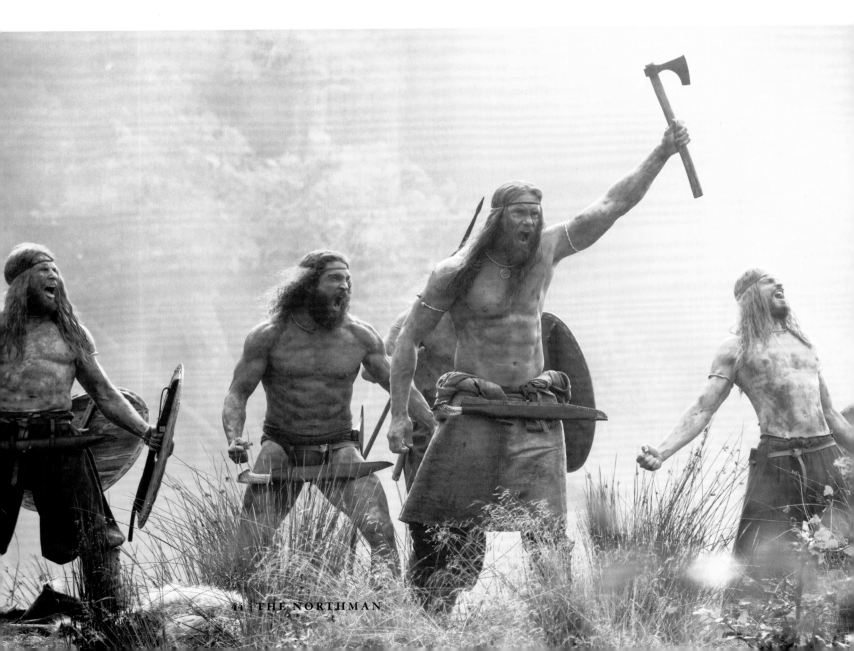

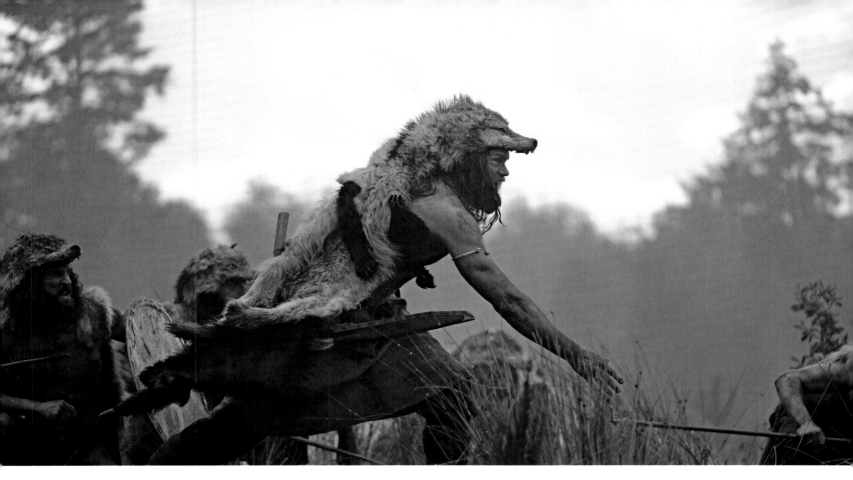

which is above, or parallel, to reality. The supernatural network was one way of making that part of this reality seem more substantial—the idea that people with magical powers are all working with the same tools. In *The Northman*, Björk's character already has knowledge of Amleth and can read him as soon as she meets him. We don't understand how she does it, but she has communicated with him somehow by tapping into the right channel on the astral plane.

Robert says that he wanted to cut the Knattleikr game scene from the script, but you rescued it every time he'd try to get rid of it. Can you talk about the integral role of Knattleikr in the Icelandic sagas?

Knattleikr is featured in many of the key Icelandic sagas. Nobody knows exactly what Knattleikr gameplay was like, but its dramatic circumstances are always the same in the sagas. A typical Knattleikr game is presided over by a chief called a *goði*, a man who has earthly and spiritual power (Fjölnir is a *goði*). There's usually a feast held at the same time every year to celebrate the end of harvest. And in the sagas, something very dramatic often happens at these Knattleikr games: Someone is killed or treated unfairly during the game, which has repercussions later on.

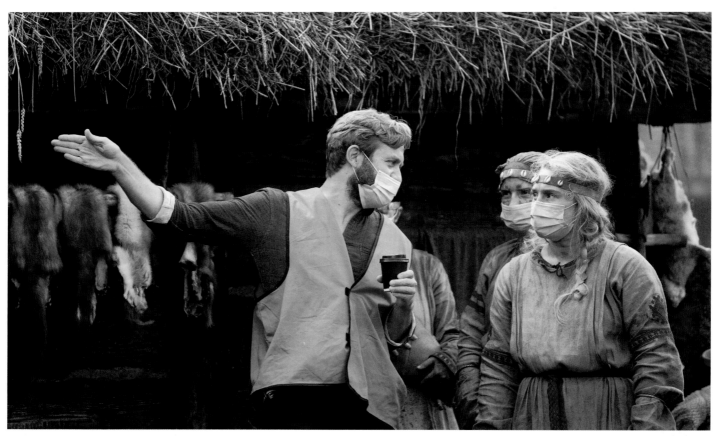

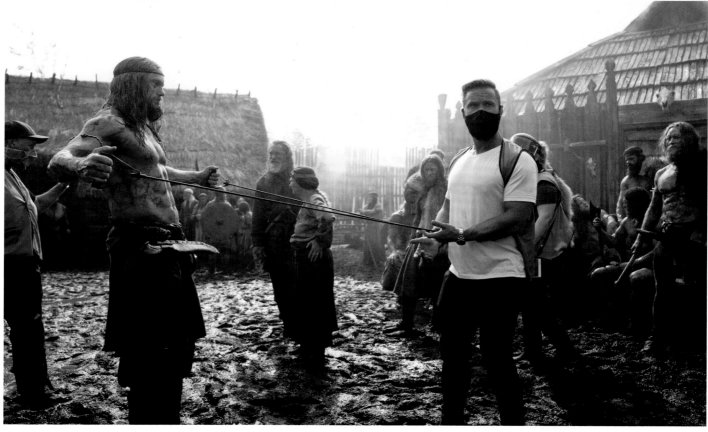

Keeping the Knattleikr game in the script was my way of staying true to the saga narratives. Robert doesn't like sports; I don't like sports either, but sports are a part of people's culture. I also kept it in the script as a narrative tool because by that point in the story, it's been a while since we've seen Amleth in a proper fight, so I felt like we needed to be reminded of what he looks like in action.

The Berserkers' pre-raid ritual and dance scene is exciting and one that Robert enjoyed filming. Can you talk a little about the scene's historic context?

Everything in the script is first based on research and then our interpretation. And while everybody knows what it means to go "berserk," many people have forgotten that the Berserkers were also elite fighters. They were not just some guys that went mad and then collapsed on the battlefield. They had their own cult, which was about shape-shifting and transformation, especially with a focus on bears and wolves. For me, it was important to try to present the Berserkers as truthfully as possible. In some of the Icelandic sagas, the Berserkers became a nuisance after the Viking Age because they had nothing to do. They'd wander around and challenge farmers to fights, so it makes sense that Amleth would be a Berserker by the time he goes to Iceland. The Berserkers were the ultimate form of Ódinnic worship, since they transformed into animals. As a Berserker, Amleth also feeds Ódinn on the battlefield, because you feed Ódinn by feeding human corpses to his ravens. In this way, Amleth fulfills his childhood oath as an adult Berserker, though he doesn't fulfill that oath like he should—he should be doing it by avenging his father.

The poem in that scene is new. We wrote it in cooperation with Haukur Þorgeirsson, a specialist in old Celtic poetry. He brought metaphors and ideas to the scene that come straight from existing materials, like how the Berserkers calm down after battle. That period of calming down is fairly standard and well documented in all the stories about Berserkers, so I wanted to include it in our story, too. The same is true about Amleth's fight with The Mound Dweller. You'll often find a scene like that in the sagas. Viking warriors always had to earn their swords, so you'll often read about warriors picking through burial mounds for some goods or weapons that were buried along with older warriors. But the Vikings couldn't just take those things—they had to earn it. They had to fight for it.

ABOVE The cast and crew set up the scene immediately following the raid. **OPPOSITE TOP** Cinematographer Jarin Blaschke gives instruction during the Slav village raid. **OPPOSITE BOTTOM** Alexander Skarsgård works on his shoulders with trainer Magnus Lygdback between takes. **FOLLOWING PAGE** Amleth (Alexander Skarsgård) and his fellow Beserkers come down from their battle trance.

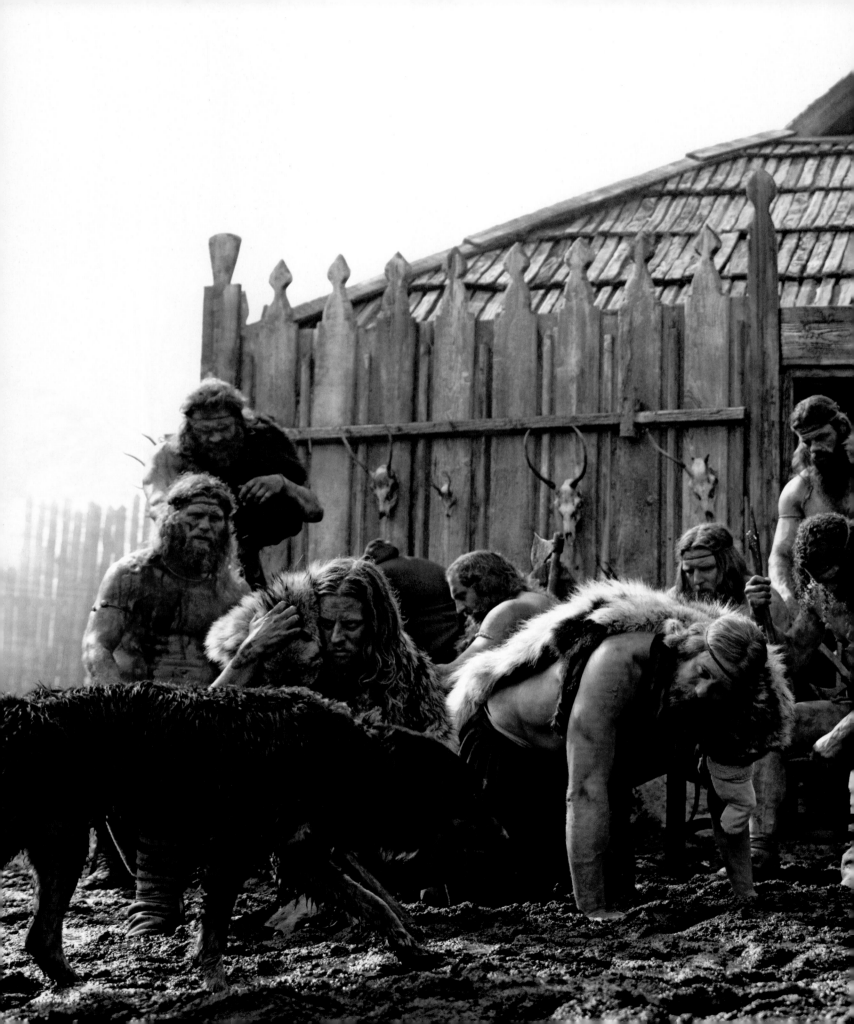

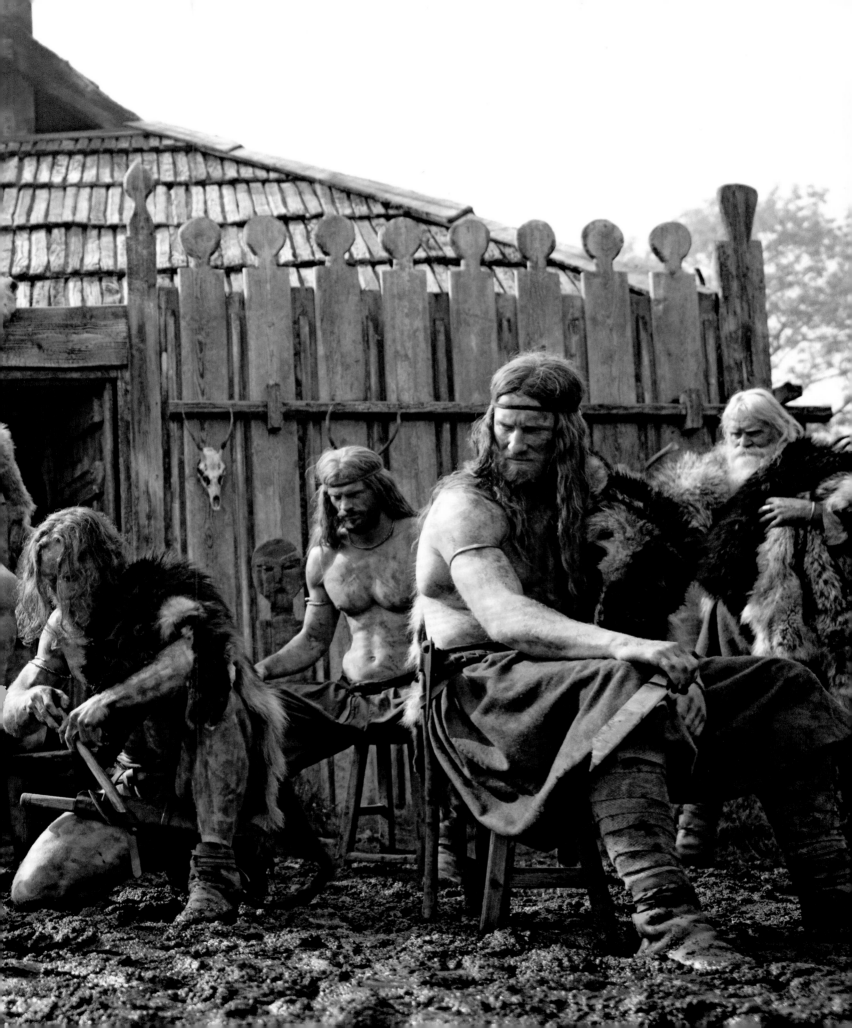

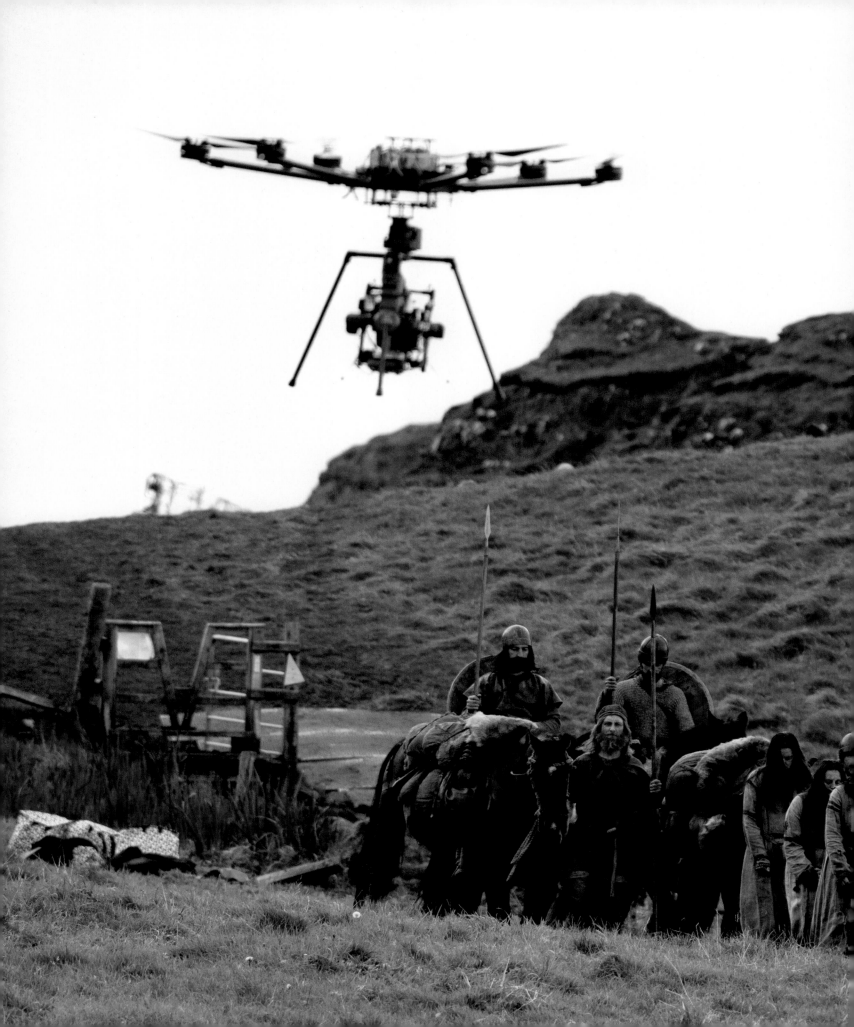

PART II

CAPTURING THE SAGA

Although production began in late 2019, with the construction of several key sets in Northern Ireland, the movie's initial March 2020 start date was preempted by the global COVID-19 pandemic. Changing several key locations to Northern Ireland created various logistical challenges for production, especially for Jarin Blaschke, who shot all three of Eggers' most recent features with a single camera. Blaschke prefers rehearsing with cast members on location as opposed to referring extensively to storyboards. "I want to react to something specific," he says. "The more information I have, the more I can design something singular."

ROBERT EGGERS & JARIN BLASCHKE

Eggers has been working with cinematographer Jarin Blaschke since 2007, when the two collaborated on a short movie based on Edgar Allan Poe's "The Tell-Tale Heart." Eggers was originally drawn to Blaschke because of his foreign-sounding last name, even though Blaschke was born in Westminster, California. Together, Eggers and Blaschke have applied their signature one-camera approach to all three of their feature collaborations. Most contemporary film productions—especially of this size—are filmed using multiple cameras per scene, both for coverage and safety, but Blaschke and Eggers' singular results on *The Witch* and *The Lighthouse* suggested that their unconventional approach would also work for *The Northman*. Still, not being able to visit and plan around the film's locations required a considerable amount of extra storyboarding and preplanning.

You have talked about how, in general, the priority in your work is to reduce everything—camera movements, lighting, etc.—to its essential elements. How did you apply it to The Northman?

Robert: In most scenes that are one shot—and the majority of scenes are [taken in] one shot—a lot of the work that Jarin and I are doing together is rewriting the scene to remove unessential story beats and then reordering the remaining beats so that we can show everything we need to show in a single camera movement. In fact, we [filmed] a handful of small scenes that we [originally] planned on filming in two or three shots, but we got so used to doing one-rs, or long takes, that on the day of the shot we decided, "Let's just shoot it as a one-r."

Jarin: It would be a different movie if we did everything in three shots instead of one. There's a lot of stuff happening in this movie, and it's all action. Rob's first email [to me] had a list of movie references. I remember he also mentioned [wanting] a lot of long takes with "a lot of shit going on" [with] lots of dense camera frames—really, it's a lot of work over half a year (or more) just to line all that up in a logical way so that you can have deceptively simple shots.

Robert: We learned a lot making this movie. When we wrapped, Ethan Hawke put his arms around me and Jarin and said, "Congratulations, guys, you can now do anything that you want. You've done everything you can do in a movie except for car crashes, but you didn't want to do that anyway, Rob." As he left, Jarin and I turned to each other and thought, *Yeah, now we're able to make the movie we just made.*

Jarin: You have to be ready to go too far to know where the right level is. If you're not prepared to go too far, you'll never know if you went far enough.

Robert: Not that this was some experiment in going too far. We made the movie we set out to make, but it was definitely extreme.

During interior scenes, there's a lot of single-source lighting. Everything revolves around a large fireplace or hearth in a lot of your sets. How did you shoot in a cramped, dimly lit environment with fluid camera movements while also illuminating all the details you wanted to be seen?

Robert: One scene where single-source lighting really worked in our favor is in Queen Gudrún's bedroom, when Amleth makes himself known to his mother and she tells him her backstory, which is not what he's expecting. The fireplace is in front of her, so she's front-lit when she first finds out who he is; she's vulnerable. Then, as she starts to tell her story, she crosses the fire and she becomes underlit, like a Boris Karloff monster. She looks totally demonic. Then, when she's

PREVIOUS PAGE A drone captures Fjölnir's men leading a group of slaves to his farm at Freysdalur.
OPPOSITE Cinematographer Jarin Blaschke (left) and director Robert Eggers (right).

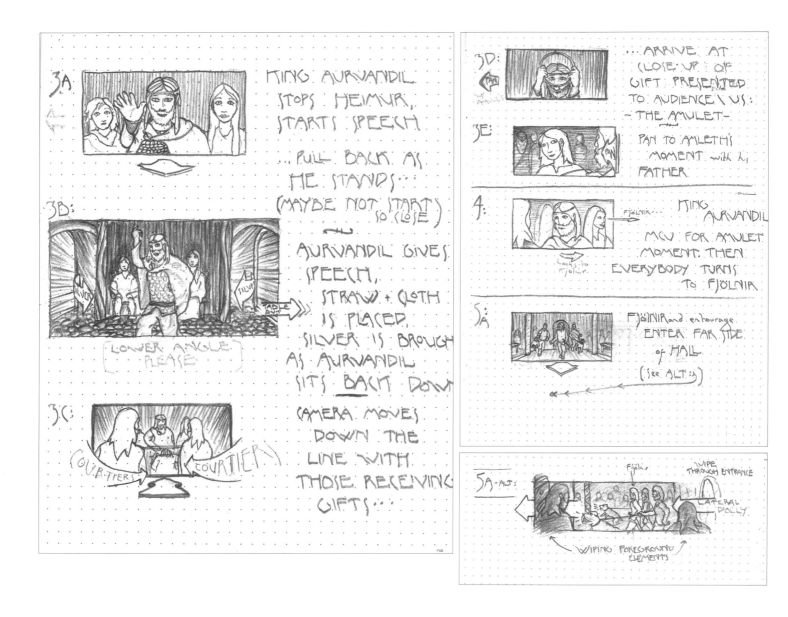

The storyboard images contain the following handwritten notes:

3A: KING AURVANDIL STOPS HEIMIR, STARTS SPEECH

...PULL BACK AS HE STANDS... (MAYBE NOT START SO CLOSE)

3B: AURVANDIL GIVES SPEECH, STRAW + CLOTH IS PLACED, SILVER IS BROUGHT AS AURVANDIL SITS BACK DOWN

LOWER ANGLE PLEASE

SILVER — TABLE OUT — SILVER

3C: CAMERA MOVES DOWN THE LINE WITH THOSE RECEIVING GIFTS...

COURTIERS — COURTIERS

3D: ...ARRIVE AT CLOSE UP OF GIFT PRESENTED TO AUDIENCE \ US: ~ THE AMULET ~

3E: PAN TO AMLETH'S MOMENT WITH h; FATHER

4: KING AURVANDIL MCU FOR AMULET MOMENT. THEN EVERYBODY TURNS TO FJÖLNIR

FJÖLNIR — looks to Fjölnir

5A: FJÖLNIR and entourage ENTER FAR SIDE of HALL. (see ALT:)

5A-ALT: Fjölnir — WIPE THROUGH ENTRANCE — LATERAL DOLLY — WIPING FOREGROUND ELEMENTS

ABOVE Jarin Blaschke's personal storyboards for Young Amleth's necklace bestowal during the banquet scene. OPPOSITE TOP King Aurvandil (Ethan Hawke) prepares to meet his fate. OPPOSITE BOTTOM King Aurvandil passes his legacy to his son Young Amleth (Oscar Novak) with a necklace.

trying to be seductive, she's backlit and looks as beautiful as possible. That was really cool, though other scenes were more challenging.

Jarin: My tendency is to go for naturalism because that's how my brain works. I don't know how to do the studio standard of three-point lighting. I just don't think of things that way. *The Northman* is also an unusual case. Normally, you have to ask questions like, What would the room have in it? [The answer is] usually a window, which is great, but Vikings didn't have windows in their homes. You'd also normally be able to use something simple to light a room, like a lamp. You'd place that at the right spot or have a single window, but in this case

there's only a fire, [which is] always on the floor [and] always exactly in the middle of every frickin' room. Period.

Robert: For scenes like the one in the hut where the female slaves sleep, which we discussed to no end, the fire in there was raging in order to get exposure on the people who are asleep in the scene, [and it looked] unrealistic. We used these massive lighting rigs that Jarin designed for an early scene in King Aurvandil's Great Hall in Hrafnsey. They were later digitally replaced with plates of real fires. If the fire were that big with everyone wearing wool and fur, everyone would have died, but we needed to get exposure in there, so we used these lighting rigs.

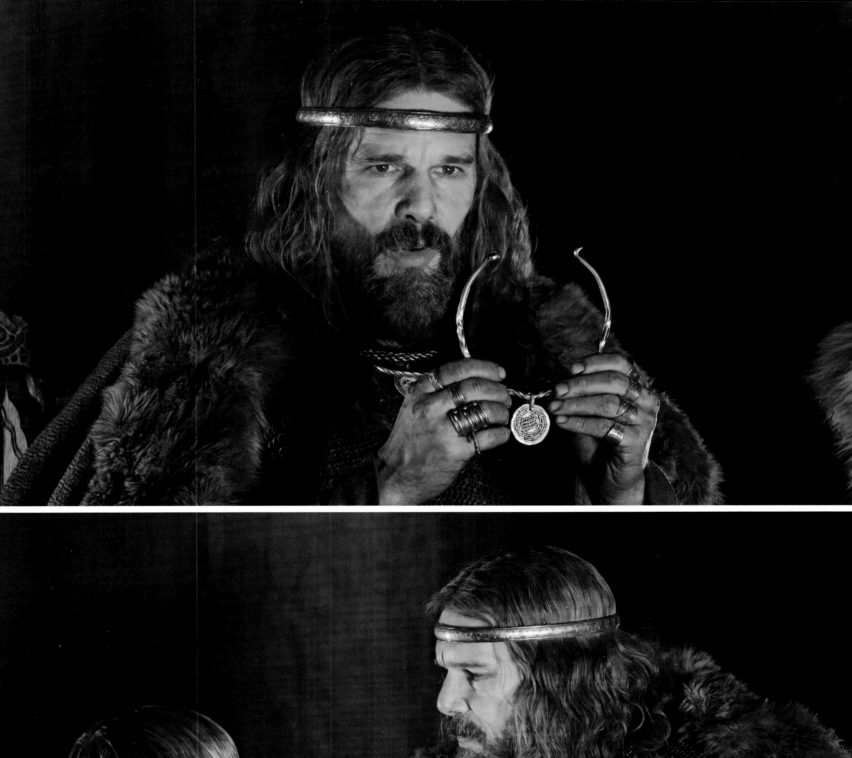
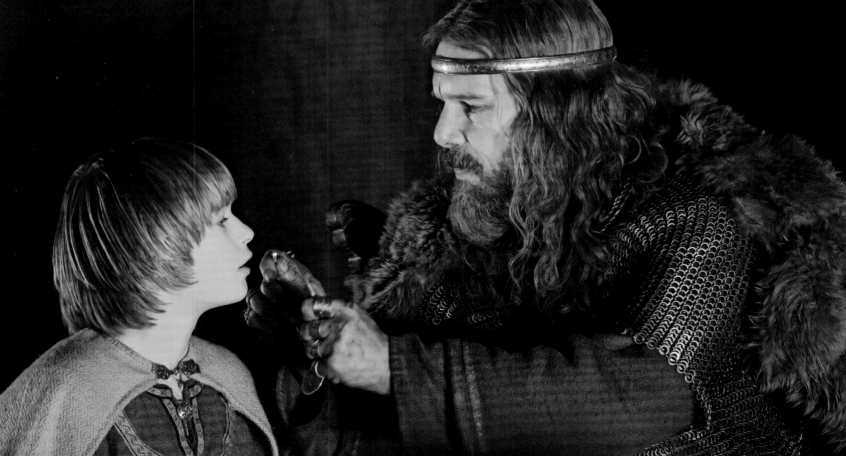

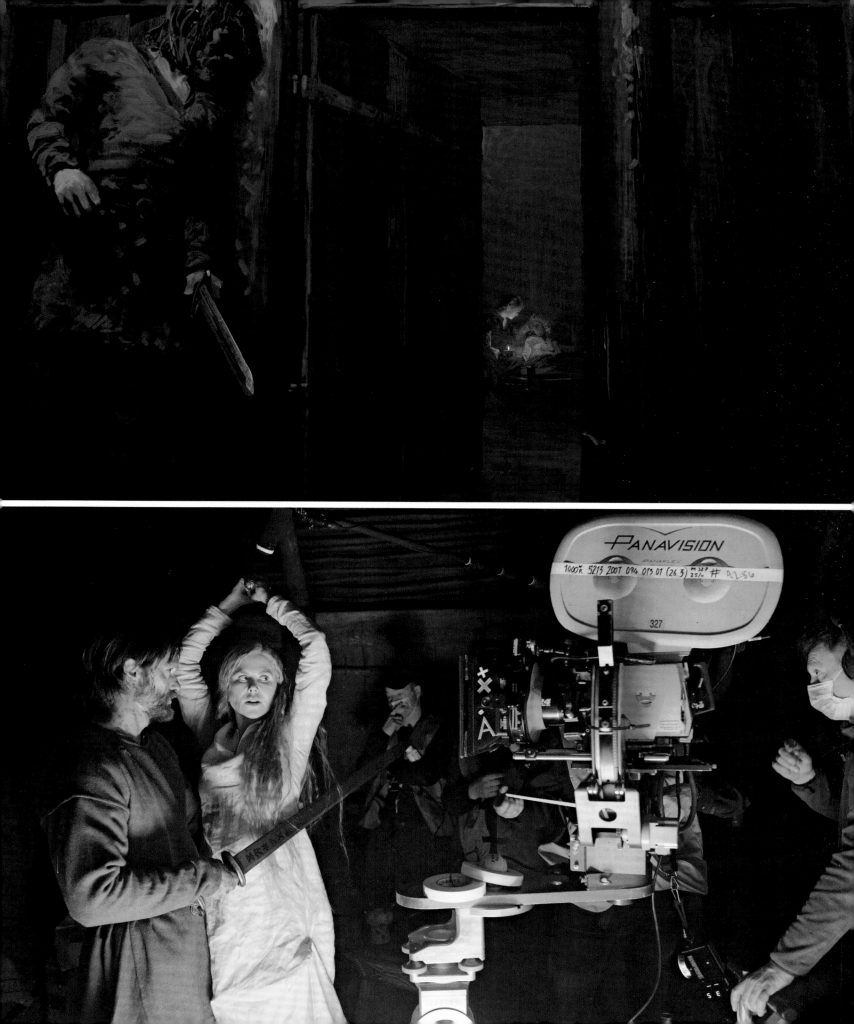

Jarin: For the Great Hall scene, I think we had a lighting rig with ninety bulbs on one side, and ninety bulbs on the other. There were also sixty builds on another side, and sixty on the opposite side. That's about three hundred bulbs to light this space. And we used 500-watt bulbs.

Robert: That was basically the only light source, too [*laughing*].

Robert mentioned that you were more inclined to use cranes and dollies, in general, and that a Steadicam camera was only reluctantly used to stabilize your camera's movements for the Knattleikr game scene. Why do you generally prefer cranes and dollies?

Jarin: A director, or whoever is leading you through this experience, has to be a leader. You are in their hands, so they need to be ahead of you, not figuring it out with you. I don't buy that visceral handheld camera approach to shooting action. I like to know that the filmmaker knows more than I do, rather than just being reactive. They should be telling you where to look, not just what I would look at if I stumbled on

a crazy situation and couldn't make heads or tails of it. That's just my thing. There should be some intention behind what you're looking at. Using a Steadicam makes me feel like I'm floating in space, so for a formally composed [film] like *The Northman*, using dollies and cranes felt right.

Robert: That is, it felt right to *not* use a Steadicam.

Jarin: Yes. Everything has its limits though, even cranes, which blow around in the wind. We learned a lot about cranes on this movie.

Robert: I definitely would say that whenever you can use a rigid crane, use a rigid crane. That would be my recommendation.

Did you prefer to use a rigid crane because of the wind and the bad weather during exterior scenes?

Robert: It's fine to use a telescopic crane. They just tend to break down from the weather.

Jarin: A technocrane tends to blow over more because it's not porous, like a conventional crane. The wind

BELOW Robert Eggers (left) and Jarin Blaschke (middle) prepare Skarsgård (right) to shoot the surprise confrontation with Nicole Kidman. **OPPOSITE TOP** Armed with his sword Draugr, Amleth prepares to rescue his mother Queen Gudrún and her son Gunnar. Concept illustration by Philipp Scherer. **OPPOSITE BOTTOM** Alexander Skarsgård and Nicole Kidman rehearse an unsettling revelation between Amleth and his mother Queen Gudrún.

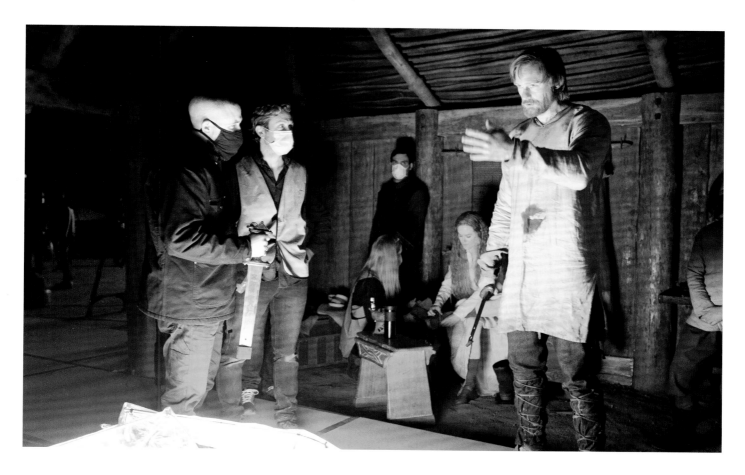

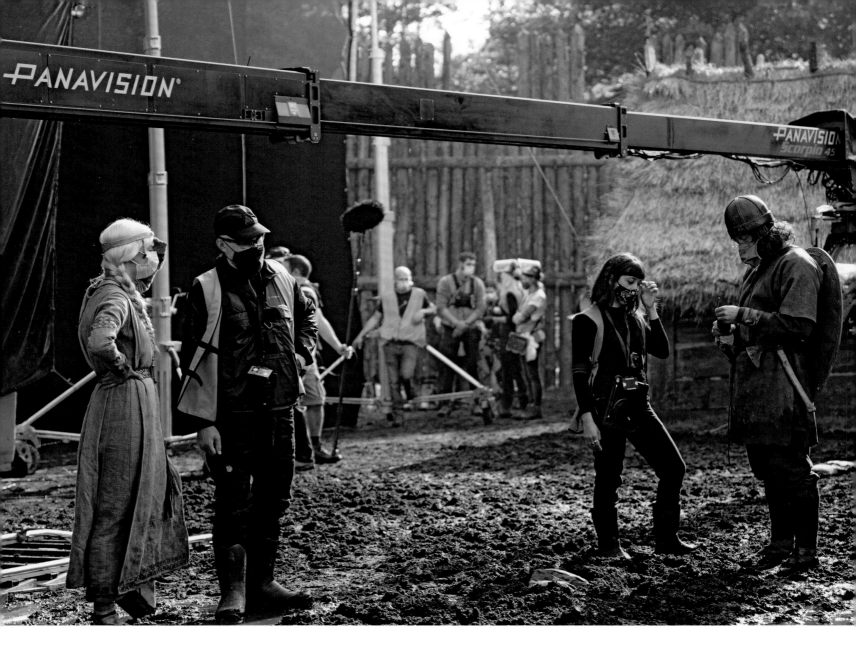

ABOVE Anya Taylor-Joy (far left) and Eggers (middle left) prepare for the village raid scene. **OPPOSITE TOP** Shooting Amleth returning ashore to Iceland to prepare for his revenge. **OPPOSITE BOTTOM** Alexander Skarsgård (left) finishes a scene with Robert Eggers (right).

hits a rigid crane differently than a technocrane. It's easier with a rigid crane because the wind doesn't catch it as much, whereas a technocrane becomes a big, fat sail. On *The Lighthouse*, the first time we ever used the technocrane, which has a longer length than most cranes, we thought, *Oh, technocrane, where have you been all our lives?* We were able to climb around rocks and make the movie. But for *The Northman*, the wind created problems when we used technocranes.

Robert: Our [film] crew on *The Northman* had previously worked on [films such as] *Star Wars*, James Bond, Ridley Scott, etc., so we had a crew who was able to execute our crazy ideas. Jarin would come up with something, and they'd say, "We did something kind of like this on the third Harry Potter movie; maybe we could do this." That was invaluable for us.

Jarin: Yeah, what a resource [the crew was], because it was all just theory for us. They were fully on board to try to solve all of our problems.

Robert, you have said that you weren't interested in doing a movie set in modern times. Jarin, do you feel the same way, given your mutual preference and interest in using only one camera at a time?

Robert: Jarin would be more interested in doing a contemporary movie. I have no interest.

Jarin: I don't know what it is, but I've always been obsessed with other places, other times. I guess, for me, filmmaking is learning about what's not directly at hand. It should give you a sense of discovery. It's hard to articulate, but if I made nothing but period films,

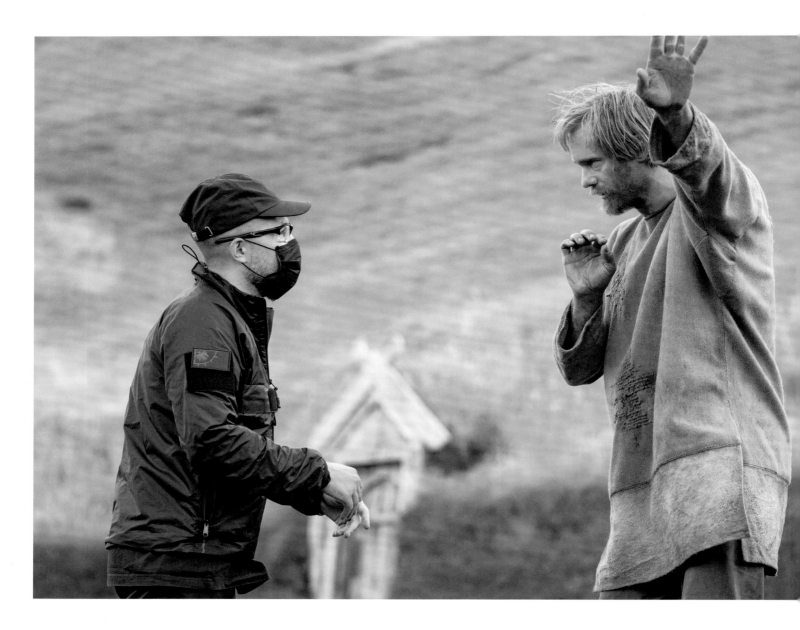

I'd be happy, for sure. Maybe I'm an escapist at heart. When you film a movie in a contemporary setting, it's almost like there are so many light sources; everything's so noisy and so complex. Just give me a room with a window, the seasons of the year, the times of day, and different weather. That is more than enough variety for me. I would love to just go deep and perfect that. It can be overwhelming when you throw in all the clutter and all the mess that we have now. I try to do fewer things as well as I can.

Robert: I just don't have any interest in making a contemporary movie. To me, it's fun to re-create a world. Choosing wallpaper samples for a contemporary thing just sounds awful. The idea of having to shoot a cell phone . . .

Jarin: It's depressing.

Robert: Yeah. The idea of photographing a car is pretty bad, but having to shoot a cell phone . . .

Jarin: Or seeing people typing out emails?

Robert: I'm interested in the stories that I'm interested in telling more than I'm interested in being a filmmaker. I would rather write a book or paint a painting about something that I am into than make a contemporary film—not that it would be any good, nor would anyone want to buy it, or see it, or give a shit about it.

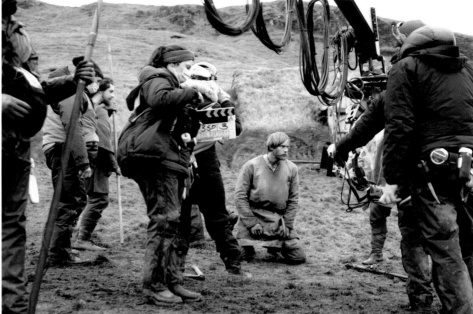

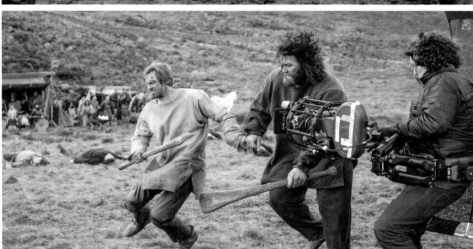

"IT WOULD BE A DIFFERENT MOVIE IF WE DID EVERYTHING IN THREE SHOTS INSTEAD OF ONE. THERE'S A LOT OF STUFF HAPPENING IN THIS MOVIE, AND IT'S ALL ACTION."

—JARIN BLASCHKE

PRODUCER
LARS KNUDSEN

"All Scandinavian roads lead back to the Vikings," according to producer Lars Knudsen (who produced the movie with Mark Huffam, Alexander Skarsgård, and Robert Eggers). The project began to take shape in 2015 when Danish-American Knudsen started talking about making a Viking movie with Skarsgård, "who is Swedish, as you know." They immediately hit it off given their mutual fascination with Viking history and culture. "We wanted to reclaim the Viking genre and make something that felt real and authentic—and on a scale unlike any other Viking film." Then in early 2017, Skarsgård met with Robert Eggers, with whom Knudsen had previously collaborated on *The Witch*. Skarsgård was so impressed with the film that he immediately emailed Knudsen to suggest that they "find someone who was as attentive to period detail and authenticity as Rob." After suggesting he co-write the script with Sjón, Eggers presented Skarsgård and Knudsen with an outline for a *Hamlet*-esque story.

ABOVE Producer Lars Knudsen. Photography by Takashi Seida. **OPPOSITE TOP** Alexander Skarsgård and his fitness trainer Magnus Lygdback stand by during filming of the Berserker raid on the Slav village. **OPPOSITE BOTTOM** All eyes are on Anya Taylor-Joy during rehearsal for the raid scene.

What did you think about Robert and Sjón's script when you first read it?

I had never wanted to make something so badly, but how the hell would we get the budget to make this massive film? During the treatment phase, we had naïvely thought we could make it for $20 million or so. By May of 2019, Rob and Sjón had just finished their draft of *The Northman* just as *The Lighthouse* was about to premiere at Cannes. New Regency was a financier on that film, too, and Rob loved working with them, so we sent them the script exclusively. Three months later, we were scouting in Iceland and Northern Ireland. We went into full-on prep in November and started shooting twenty weeks later.

The amount of research and historic details that went into this project is remarkable. How did you work toward establishing the movie's unique tone and style through its setting and period details?

Like Rob's previous movies, *The Northman* is character-driven and highly crafted cinema. Everything was meticulously researched. We worked with the world's most up-to-date Viking historians to articulate the physical world of the Viking Age—the Old Norse mind-set as well as their mythology—more authentically than has ever been seen onscreen. The movie's physical world—its architecture, clothing, and props—is based on scholarly findings. During the writing phase, Rob wanted the characters to speak simply and infrequently. He wanted their speech to be full of metaphor and accidental poetry because everything in their world is of spiritual and mythical importance, [but] should also seem believable. The plot's supernatural and magical occurrences would also be subtle, even though the characters in the film experience them as real. And, as in Shakespeare's plays, there would be a sense of humor and irony, even in *The Northman*'s most tragic moments. Jarin Blaschke and Rob also insisted on working in the same manner as their previous collaborations with a single camera and only using sticks, dollies, and cranes. [They did not want any] handheld camerawork and no traditional multicamera coverage, so the cinematic language of the film was extremely well planned and specific. Everything was shot-listed and storyboarded beforehand.

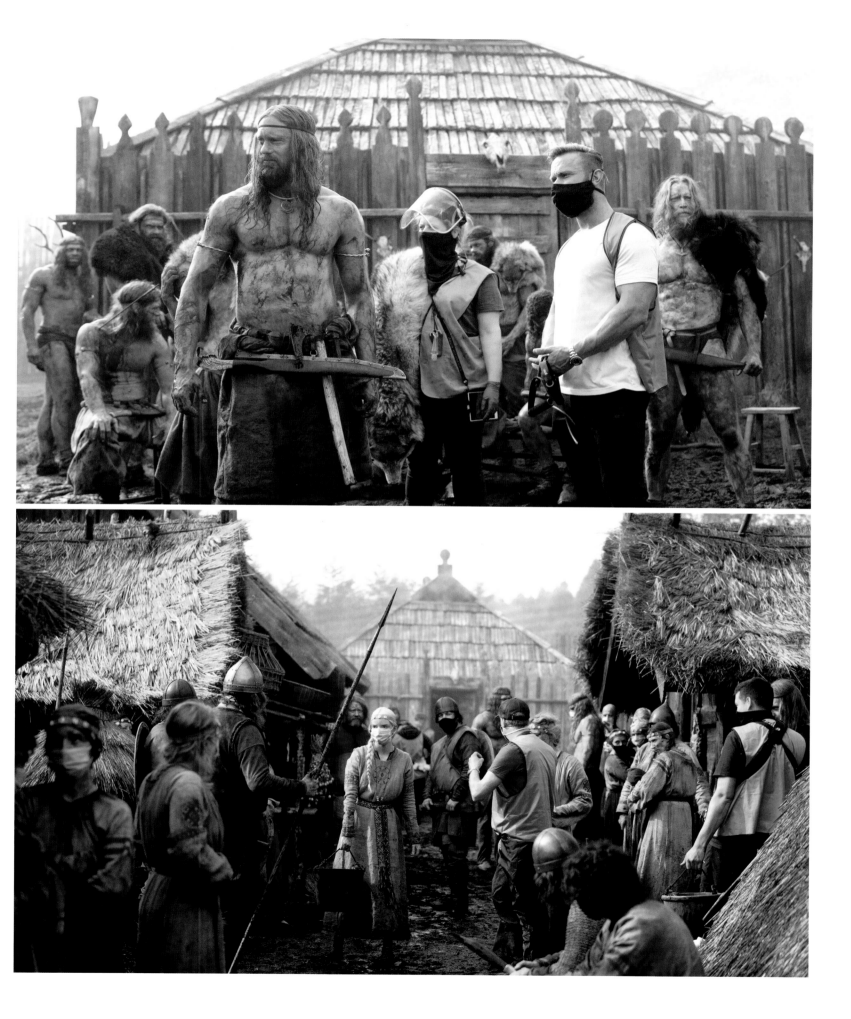

Because filming had to pause due to the COVID pandemic, what sort of changes did it require of you in terms of planning and completing the production?

The COVID break gave Jarin and Robert a silver lining, because they were able to use that extra time to storyboard the entire film and be even more prepared for the shoot. That said, this was obviously also a time filled with uncertainty. I will be forever grateful to New Regency for having the courage to put the film back into pre-production when they did. It was a big risk that paid off. We were one of the first major film productions to prep and shoot during the pandemic. No one knew what was coming around the corner or if we'd have to shut down. Working during a pandemic was extremely challenging. At first, I think everyone on the crew was grateful to be working, but after a while, especially on such a long shoot like ours, it really started to wear on everyone. The paranoia and fear of getting COVID and how it might affect the movie's cast and crew; wearing a mask for twelve hours a day; and not knowing what the people you're working with look like. All of that gets to you and burns you out . . . but we did it.

Is there a scene or an image from the film that made you think, Is this going to work?

During prep, we flew the renowned Viking scholar Neil Price to Belfast to consult on the film's sets, architecture, clothing, props, etc. I remember that after he saw everything, he became so overwhelmed that he had to sit down and gather himself. At that moment, I knew this film would feel real and authentic.

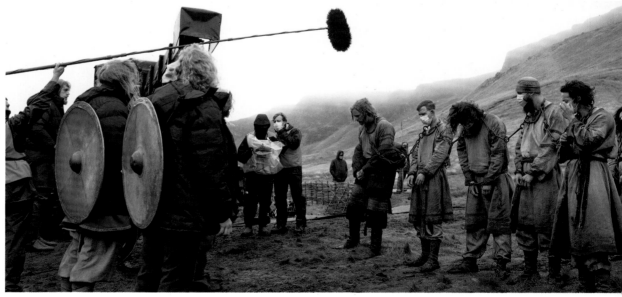

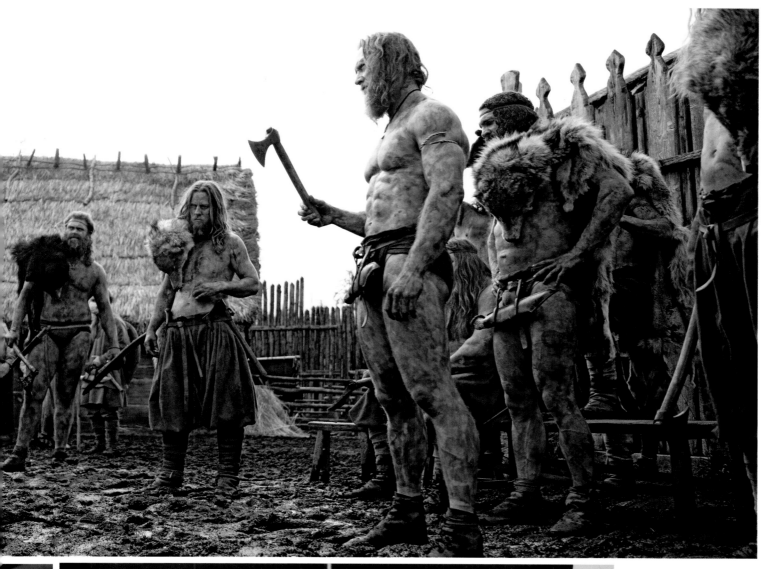

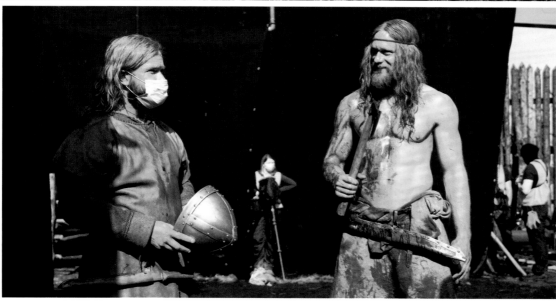

ABOVE The Berserker raiding party prepares to strike, with some help from Robert Eggers (far left). **OPPOSITE LEFT** Enslaved Slavs prepare for inspection. **LEFT** Alexander Skarsgård takes a breather before rejoining the bloody village battle.

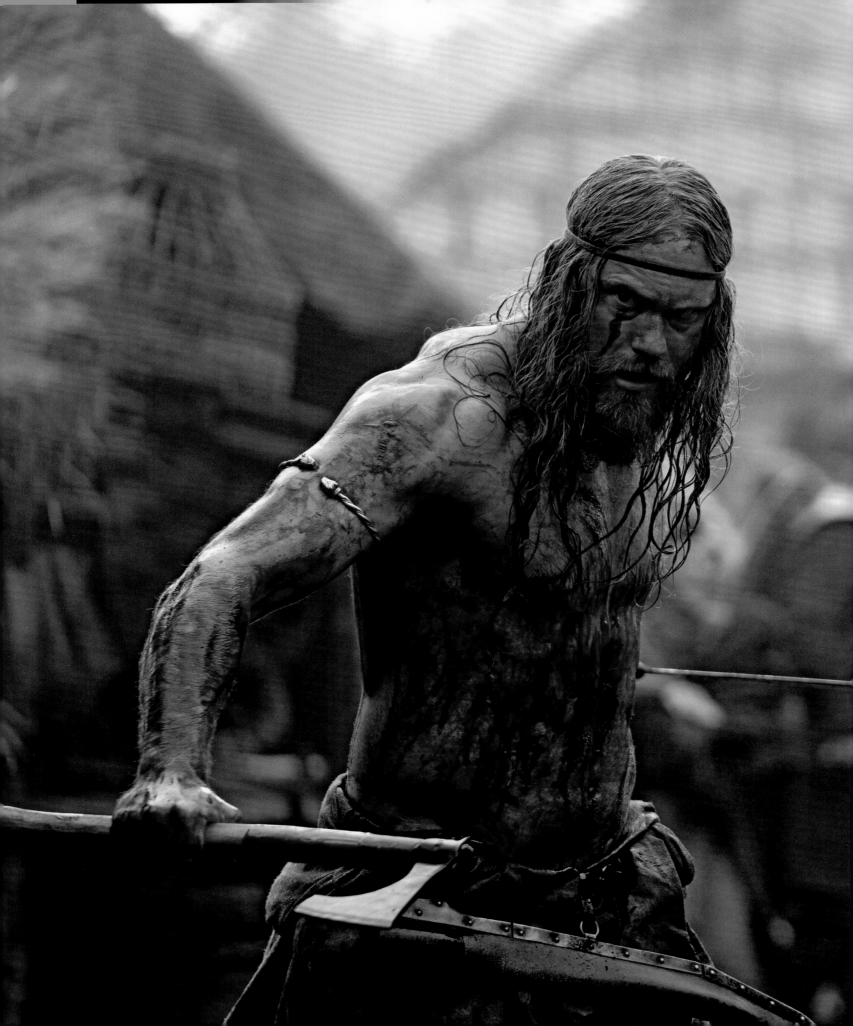

PART III
THE SAGA IN ACTION

The film's formidable ensemble cast brings an emotional inflection to their roles that challenges our sympathies for the characters. Referring to the historians on the crew, the cast learned to see the world through their characters' eyes and place supernatural influences on the plane of reality. Challenges abounded, as the actors worked through freezing mud, billowing smoke, and less-than-favorable weather conditions—not to mention ice-cold fake blood.

67

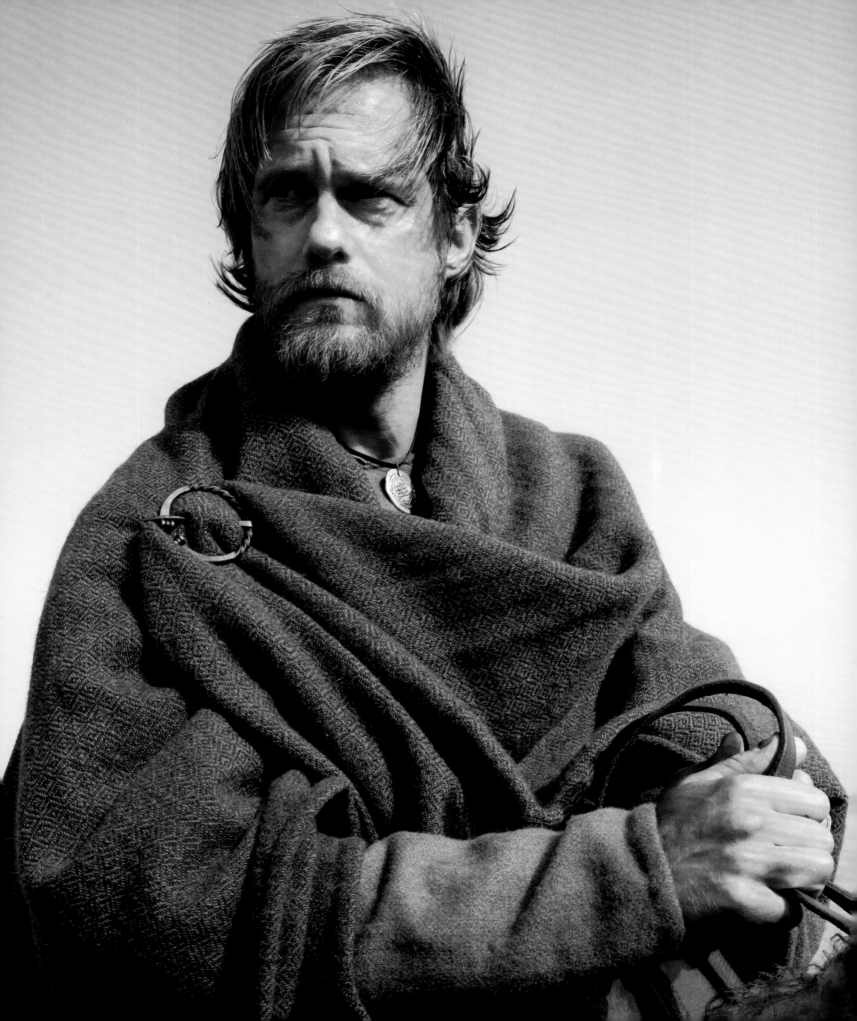

ALEXANDER SKARSGÅRD ⟨AMLETH⟩

Deciding first on a Viking story was a major hurdle for actor and producer Alexander Skarsgård, although he knew that he wanted to do something with the Norse sagas. But *The Northman* wasn't just any passion project for Skarsgård, who describes the Vikings as an "integral part of life in Scandinavia." So much so that as a child, he suggested to his parents to name his younger brothers with Norse names when they were born, both of which stuck (if only as middle names). For his brother Gustaf, Alexander suggested *orm*, or "snake," and for his other brother Sam, the Norse ice giant *Ymer* felt appropriate. Although there were moments that both physically and mentally required every last bit of self-perseverance, the hope of achieving anything close to Eggers and Jarin's storyboard was just the motivation he needed to keep going and to create a "really beautiful scene."

Were there any qualities of the Vikings or their behavior that you immediately knew you wanted to either avoid or play up?

I knew that I wanted to avoid clichés about the heroic Vikings, which would not have made for an interesting character to me—not as an actor or from my personal point of view. And we all wanted to make these characters seem complex. There are a few moments in the movie where you're not sure who you're rooting for anymore, because the antagonist either has qualities or does things that you might sympathize with, or the protagonist does stuff that you find horrific and appalling. Vikings weren't that heroic in real life; there was actually a lot of infighting among them. But they've still been appropriated in such a way that everybody now imagines the Vikings were out to conquer and expand Sweden, Denmark, and Norway. That sort of national pride didn't exist at the time: You could be loyal to your chieftain, or you could have stabbed him in the back. The Vikings were opportunists, and settling in Iceland gave them a great opportunity to enrich themselves, their families, and their loved ones. But they had no sense of national pride, so that motivation is not in our movie. The Vikings were all about family, not about country.

How would you say that your understanding of Amleth and his story changed as you acted over the course of filming?

We shot a lot of smaller scenes during the first week or two of the shoot with a lot of mundane scenes on Fjölnir's farm that ultimately lead into the movie's bigger set pieces. It gave me a good opportunity to get to know Rob and Jarin and to better understand how they work. By the time we shot the movie, we'd already been developing *The Northman* with Rob for about four or five years. But still, those first few days were the first time that we were together on a movie set, and I saw how Rob and Jarin shot every scene with one camera. Every scene is like a dance between the actors and the camera. I'm not used to that. On most movies, you have a couple of cameras, or at least a couple of different shots per scene, so you have greater flexibility later on [to use the best shots]. Rob and Jarin's approach is incredibly technical and precise. For *The Northman*, they had a storyboard for each scene six months before we shot it, so it'd be completely lit and set up by the time we'd go to a location. There was no room to improvise; you kind of had to make it work. That can be intimidating, but on day one you have to choose to dive in and be excited about that way of working and to try to bring some life to these extremely specific conditions, even if it is more challenging. The first few weeks of the shoot were great, though, because we got to know each other better and learned how to dance with each other. We then shot the Berserker dance during the shoot's third week; that's the scene where the Berserkers transform into their spirit animals. Shooting the scene was cathartic and a nice jumping-off point after two weeks of shooting quiet, mundane scenes on the farm. I'm glad that we only shot that scene after we'd gotten to know each other and how to work better together.

PREVIOUS PAGE Amleth (Alexander Skarsgård) goes on the warpath during the Berserkers' raid. **OPPOSITE** Alexander Skarsgård rides on horseback around the shore of Tyrella Beach, Northern Ireland.

BELOW Robert Eggers' initial sketch of Amleth. **OPPOSITE** Robert Eggers (left) gives direction to Anya Taylor-Joy and Alexander Skarsgård.

You specifically trained to add muscles to your shoulders. How did your physical training help you to get into Amleth's character?

I trained with Magnus Lygdback. We worked on *Tarzan* together, and he's also a good friend of mine. The fact that we were very familiar with each other helped us in terms of our work ethic. For [Amleth], we didn't want my muscles to look like they came from hours and hours at Gold's Gym, but as if they belonged to someone who's done hard labor. A lot of my training was practical. Because Amleth works out in the field and lifts heavy boulders all day, we focused on my shoulders and arms. We did a lot of deadlifting and even used a sword that we would swing around to develop my shoulders and upper back strength.

You worked with actors who were taller than you in the Knattleikr game scene, as well as a couple of other action scenes, such as when Amleth fights The Mound Dweller, played by Ian Whyte, who is seven foot one. What was it like to work with these massive guys?

It was quite demoralizing because Magnus and I had been training for nine months just to get [me] as big as possible. Then I showed up for the Knattleikr game, where they put me up against Hafþór Júlíus Björnsson, the strongest man on the planet. He is a giant of a man, three times my size. [He was] the guy I had to fight, so I looked like a little ant in that scene compared with him. Fortunately for me, Hafþór's a gentle giant, so I survived, but the whole week was very intense. We shot in a very remote location in the Mourne Mountains, where it was cold, rainy, and windy. Rob and Jarin use a still camera, and each sequence of the Knattleikr game is one single shot. It was a nightmare to try to [capture everything] when you have fifteen stuntmen running across a field, fighting each other (mostly tackling and hitting each other). You have to perfect every single hit, punch, and fall. On a "normal" movie, you have other cameras providing coverage, so you can cut to that footage or you can play around with it. It's okay if three seconds aren't great, because if it's a two-minute-long

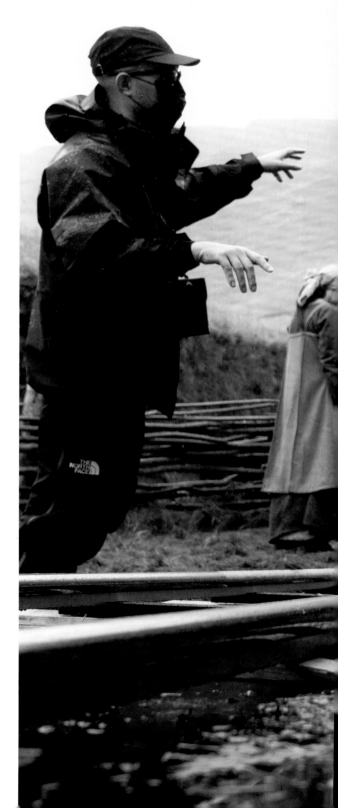

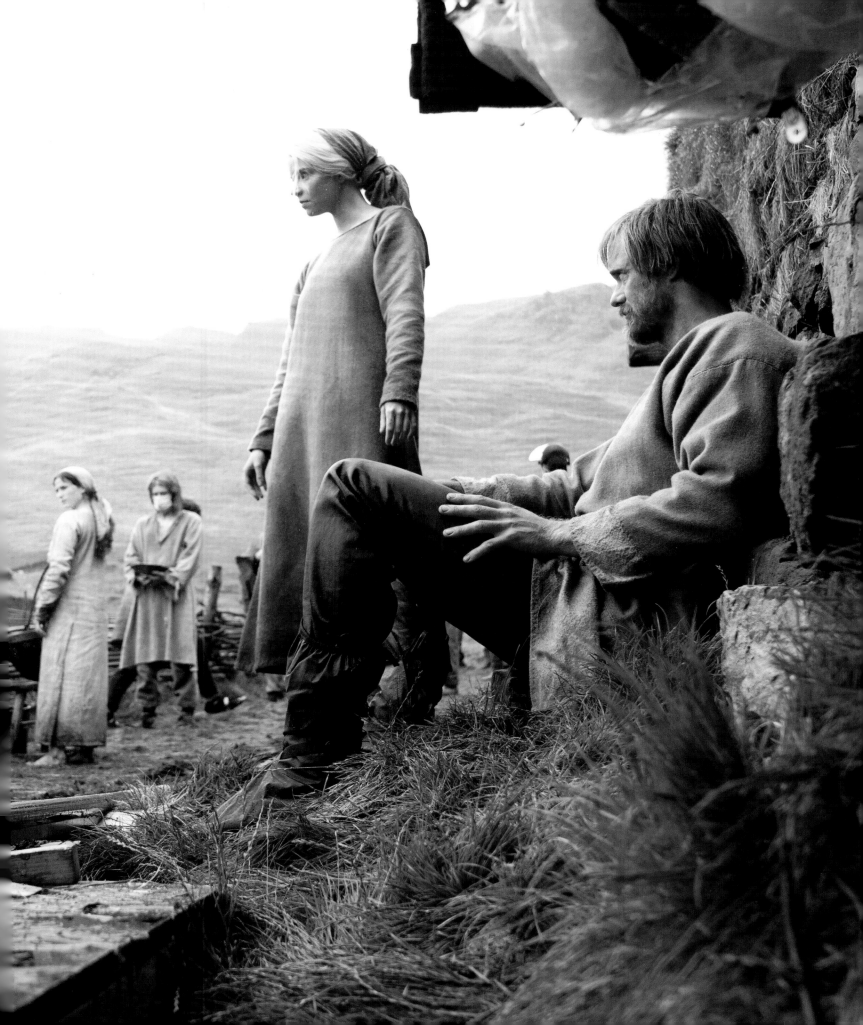

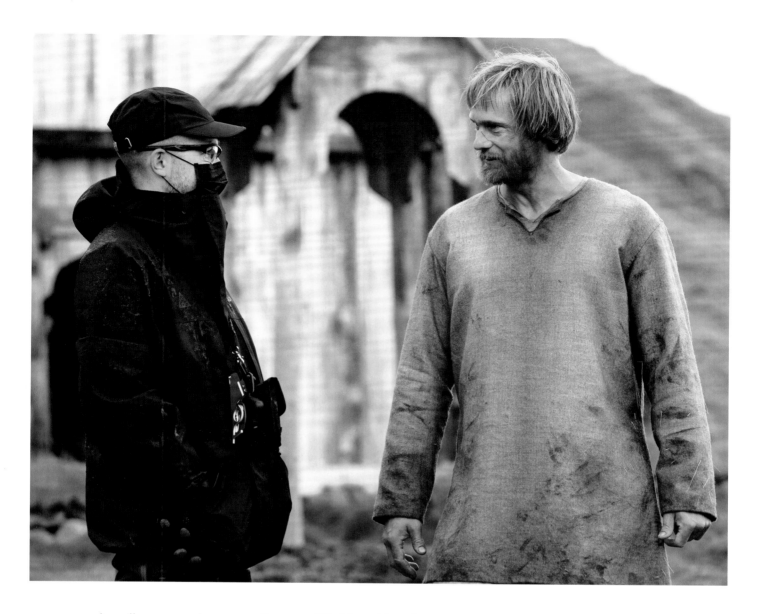

sequence, you've still got so much coverage. On our set I'd get pummeled by the strongest dude on the planet, and even though I felt great, I'd be in the mud thinking, *Alright, I think that must be it, right? We got it, right?* But then something would come up like, "There's a horse in the background who fell the wrong way," or "One out of these forty-two hits didn't look perfect," so we'd have to do the whole scene over again. The flip side is by the twenty-sixth time you've done a sequence like that—and you finally nail it—it feels like you've won gold at the Olympics. Because on a "normal" movie, you shoot it and think, *Oh, that looks good.* Then you move on to the next scene. But because we didn't have any [additional camera] coverage, the rush of adrenaline you feel when a take works—and Rob and Jarin are happy—made for some of the most memorable experiences of my career. It was pure joy.

Working with and reacting to your costars is obviously a big part of an actor's process. Can you talk about a scene or a quality of your performance that resulted from working with Anya Taylor-Joy and Nicole Kidman?

For me, it was important to find the right balance between the movie's big set pieces and what I consider to be the heart of the movie, the family drama. [Up until] the scene where Amleth confronts Queen Gudrún, the whole point of his journey is avenging his father and saving his mother. And when Amleth gets to Fjölnir's farm, he believes that his mother was either brainwashed by his uncle or that she's just faking their relationship because she's being held captive. Amleth has waited twenty-five years for this moment to tell his mother that he is her son, that he is alive,

ABOVE Robert Eggers (left) and Skarsgård prepare to shoot their next scene.
OPPOSITE TOP Costars Alexander Skarsgård and Anya Taylor-Joy share a laugh while shooting in Gleniff Horseshoe, Ireland.
OPPOSITE BOTTOM Skarsgård enjoys some downtime during the filming of the Knattleikr match.

BELOW Fjölnir prepares to strike his nephew Amleth. **BOTTOM LEFT** Skarsgård takes a water break between takes of the physically draining sword fight. **BOTTOM CENTER AND OPPOSITE BOTTOM** The Mount Hekla sword fight was filmed over the course of one week. **OPPOSITE TOP** The cast and crew prepare the Mount Hekla sword fight set in Hightown Quarry, Northern Ireland.

and that he is there to save her. But when Amleth's big moment comes, the scene doesn't go quite as he'd planned. It's a beautifully written scene, and we filmed it after a couple of weeks of shooting on big set pieces. I love shooting big action sequences, too, but it was also kind of lovely to be in a room with Rob, Jarin, and Nicole—who is one of the finest actors out there—for a long, meaty scene. It was definitely one of the highlights, if not the highlight, of the entire shoot.

It was also very important to set up Amleth's relationship with Olga, especially because Anya and I don't have that many scenes together at the beginning of the

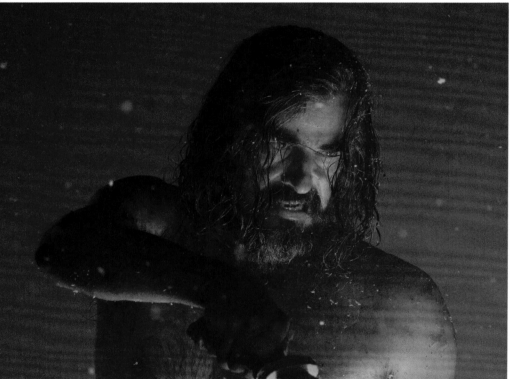

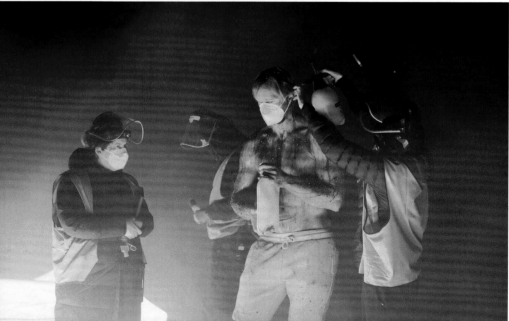

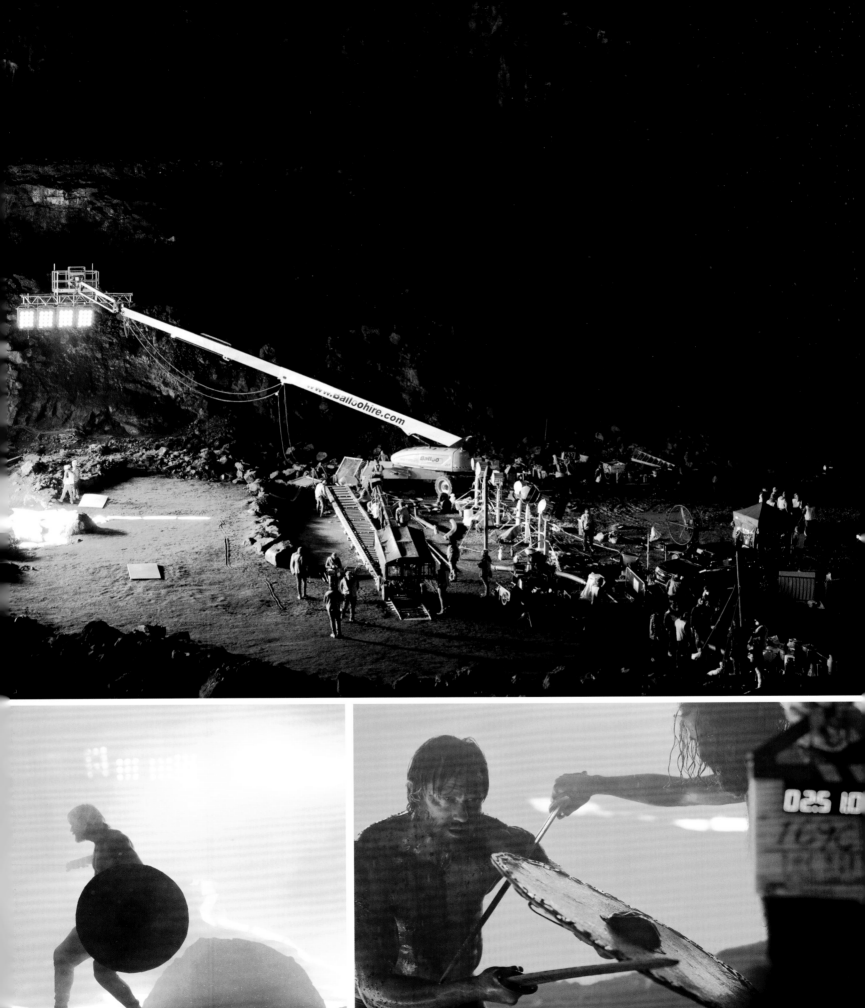

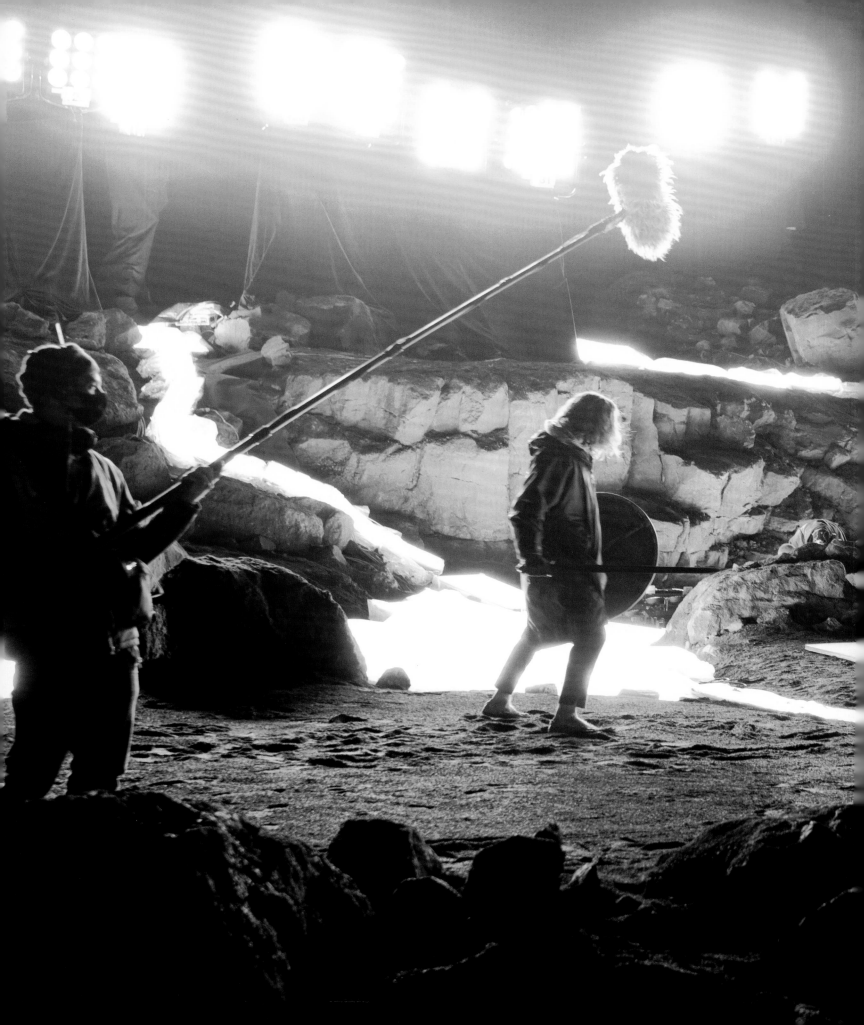

movie. Olga's so integral to the story and to the fate of my character, so we tried to ensure that viewers understand her importance and the role that she plays in Amleth's fate.

OPPOSITE Alexander Skarsgård and Claes Bang try to stay warm while rehearsing.

The Mount Hekla final sword fight scene also seems to have been very demanding. Not only did you also have to learn a physically demanding fight choreography, but you also had to shoot the scene in a quarry in a state of undress. What was filming the scene like?

We took a week to shoot the Mount Hekla sword fight, and it was probably the toughest week on a movie set I've ever experienced. It's a long, choreographed sequence, and we shot it in late fall in Northern Ireland, so it was freezing cold. I was also soaking wet because my character had been stabbed so many times that I was covered in fake blood. Before each take, I had to step outside, naked in the freezing cold and in the dead of night. It was 4 a.m. or 5 a.m., and I was standing there, butt naked, while they hosed me down with ice-cold blood water. Then I'd go into this long, choreographed fight with Claes, and in an environment where we couldn't breathe, because they added smoke and fire everywhere. We were coughing and our eyes teared up, so we couldn't see anything either. Then we had to go through a really tough choreographed sword fight while we were both dead tired and our bodies were so aching and frozen that we couldn't feel our fingers or toes anymore. It was grueling. The only thing that made me get through those nights was remembering Rob and Jarin's storyboards. They were so memorable and beautiful that when I was standing there shivering and so tired that I wanted to cry, I thought, *We're aiming for something quite unique here, and if we can somehow make it look like those storyboards, it could be a really beautiful scene.*

"WE HAD TO GO THROUGH A REALLY TOUGH CHOREOGRAPHED SWORD FIGHT WHILE WE WERE BOTH DEAD TIRED AND OUR BODIES WERE SO ACHING AND FROZEN THAT WE COULDN'T FEEL OUR FINGERS OR TOES ANYMORE."

—ALEXANDER SKARSGÅRD

ANYA TAYLOR-JOY
(OLGA OF THE BIRCH FOREST)

For Eggers, casting Anya Taylor-Joy as Olga "informed a lot of my choices." The director and actress had previously collaborated on *The Witch*, so Taylor-Joy was already familiar with Eggers and Blaschke's one-camera approach to filmmaking and, like Skarsgård, compares the process to dancing. She adds, "I like when there are boundaries like that; you always end up doing something more unexpected." Taylor-Joy also loves working with Eggers because, like him, she's a perfectionist. "Of course, perfection doesn't exist, but it does in a moment. I believe you can have what I call 'the magic take,' where things just work. I'm always chasing that feeling, and I think Rob is, too."

How did you prepare for the role of Olga?

I try to spend time with a character in my head, to figure out how they walk into a room and how they see the world, just trying to pluck their eyes out and put them into mine. I was also lucky enough to work with dialect coach Brendan Gunn. He helped the whole cast to speak the language—particularly Old Slavic, which is kind of a bastardization of different accents that Robert collected—and ensured that every clan sounded different. That was really helpful. I also tried to keep the musicality out of my voice—meaning, I tried to make my line readings more flat and hard, and less singsongy. The hard tone adds something, I think, because it matches the landscape that you see Olga in and instantly helps you to understand how hard her life is.

As Olga, you play an enslaved protagonist who, unlike the more privileged characters, doesn't have the benefit of being able to pray or express her faith freely. How did you process or get into this side of your role?

Olga is a seer, so she's somebody that doesn't have a very big wall up separating her from the supernatural, which really informs her actions and how she sees the world. I felt very lucky that I'd already worked with Rob on *The Witch*, as far as accepting the supernatural as real. I, myself, am a believer in forces that are bigger than us, so it also wasn't very difficult for me to tap into that. It's something that I really enjoyed

about playing Olga: Her deep connection to the land and her deep faith in fate really carried me through this performance.

The weather conditions during the film's shoot seem to have been rather extreme. Did it help you to get into the movie's world?

During the shoot, I assumed the role of unofficial cold cheerleader. I always love pushing myself in my work, and extreme weather is something that naturally pushes you. We spent a lot of time in the sea, which I loved because I love cold-water swimming. It was so windy on the set of Fjölnir's farm that you would literally get buffeted around. I also think that having just come out of quarantine I was so overwhelmed by the beauty of what we were allowed to do: We got to collaborate and create and play—everything that we love to do as artists. I was ecstatic every single day on set and kind of ran up to people, saying, "Aren't we so lucky? We get to do this for art." I think all of us were really up for the challenge, too. Our lovely executive producer Sam Hanson even joined the slave cast members, taking off his shoes and being absolutely freezing [with us]. I think the day that I struggled the most was when we shot the scene where Amleth and Olga eat mushrooms outside. The mud on the ground was very deep and frozen. I like to think that I'm not much of a complainer, so when I ask Rob for help, I think he takes me seriously. My feet were completely frozen—I couldn't walk on them anymore—and it

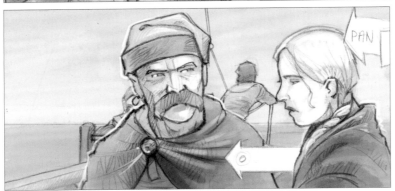

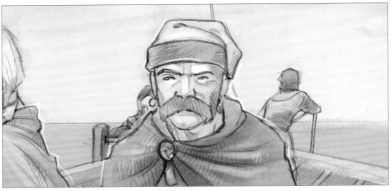

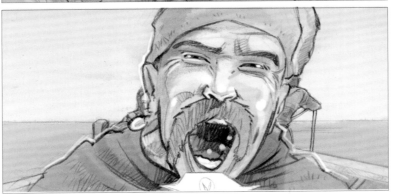

was the kind of cold that burns your feet. As soon as the scene was over, I'd shove my feet on top of a hot-water bottle. But it was a great experience. I love any scene where I am very muddy, dirty, or covered in blood, because you, the performer, have to overcome what you are feeling in order to give truth to what the character is experiencing, and I loved all of it.

Is there a scene or a detail from the movie that really stands out or exemplifies what you took away from working on it?

Performance-wise, I think the boat scene was my favorite. I loved any scene where we were outdoors in a peaceful location. You really gain a sense of camaraderie when you're all battling against the elements together. That's what makes it so electric. But the boat scene was my favorite because I got to do a wonderful scene with Alex and to experience all of these emotions. It was also special for me because we had Ralph Ineson on the boat with us [playing Captain Volodymyr]. He'd previously played my father in *The Witch*; I love working with him so much. I cannot overstate how healing and special it was to be around that group of people, especially after quarantine, and to be telling this story. I also knew that Rob really cared about the boat scene, so I put extra pressure on myself to get it right for him. After we did the first take, he came up to me, and said, "Whoa. That was good. Let's keep going." Anytime you get praise like that from Rob, it really bolsters you and makes you want to go deeper and deeper.

ABOVE Olga's confrontation with Captain Volodymyr over her attempt to jump off the boat with Amleth. Storyboards by Adam Pescott. **OPPOSITE** Olga (Anya Taylor-Joy) plans her escape with Amleth on horseback. **FOLLOWING PAGE** Anya Taylor-Joy endures the cold water between takes.

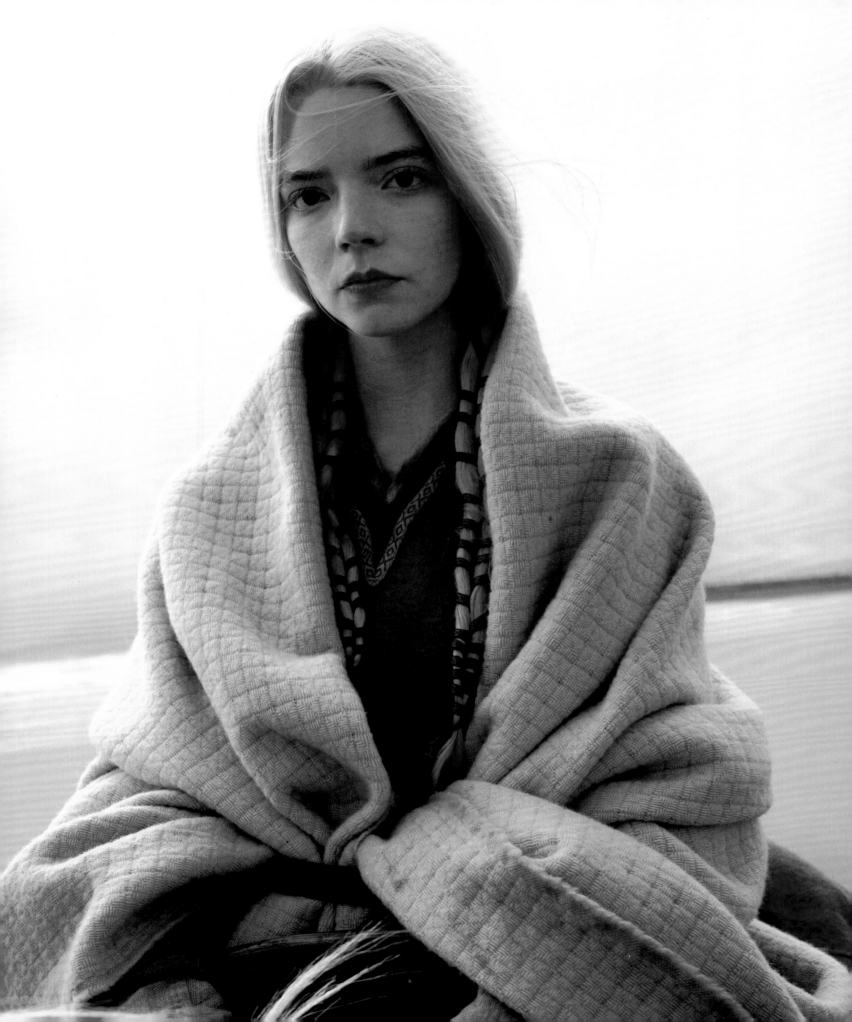

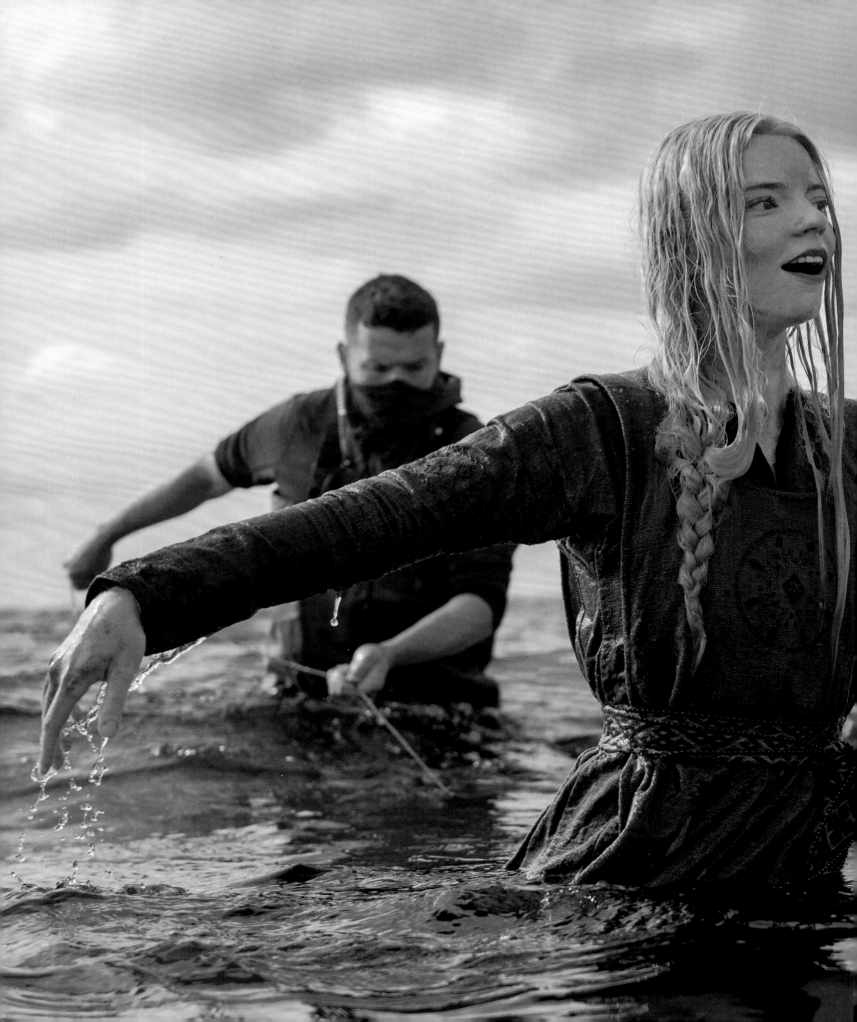

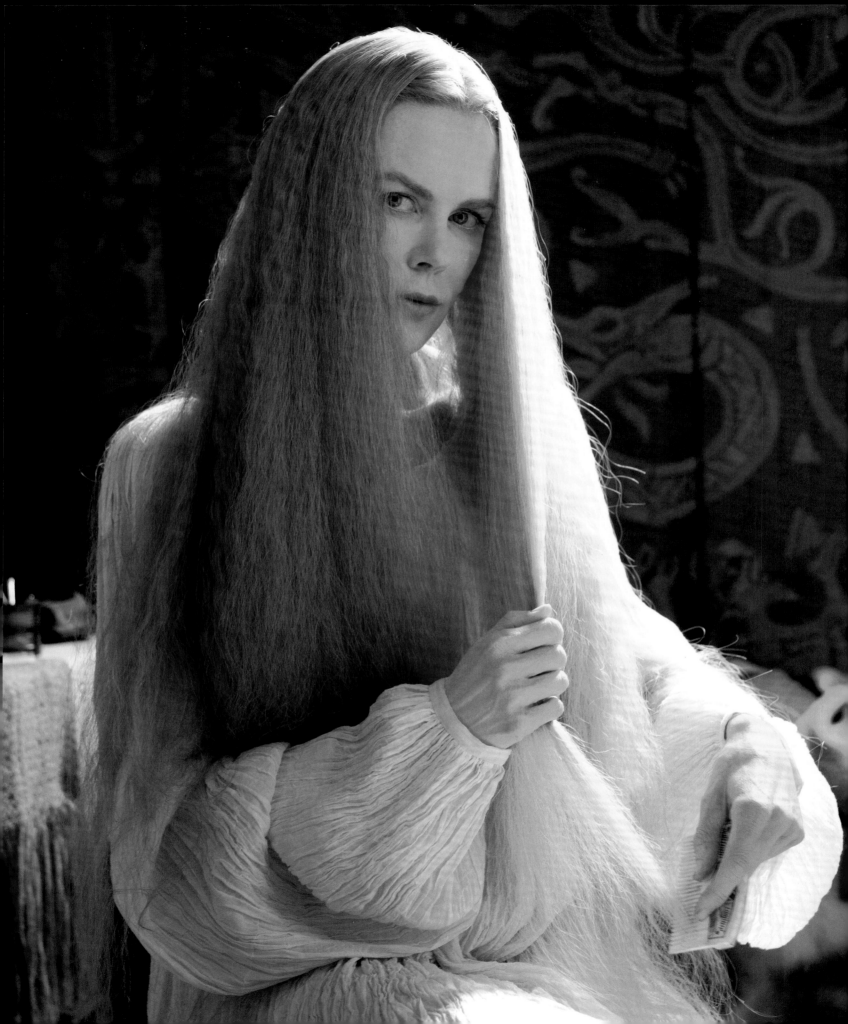

NICOLE KIDMAN ⟨QUEEN GUDRÚN⟩

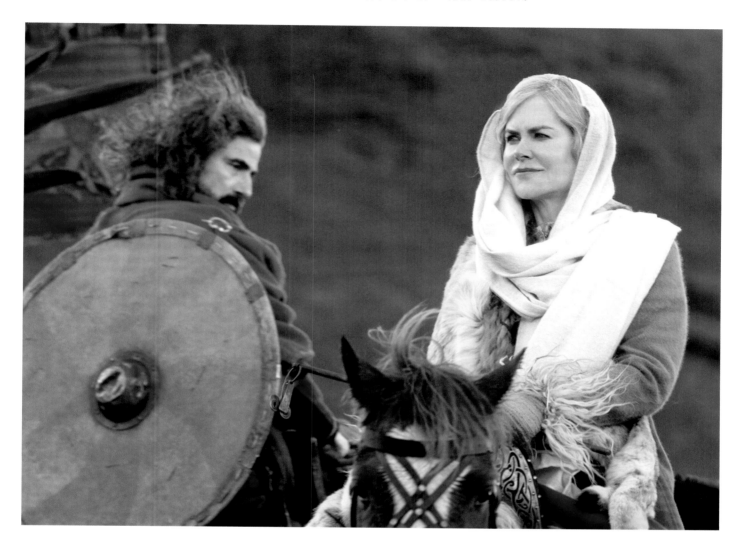

The versatile Australian star Nicole Kidman plays Queen Gudrún with an appropriately mercurial edge. Kidman's versatility will come as no surprise to anyone who's followed her career. She has garnered multiple awards and dozens of nominations for work in a variety of leading roles, including *The Hours*, for which she won the Academy Award for Best Actress, and was the recipient of the 70th Anniversary Prize at the 2017 Cannes Film Festival for her general accomplishments. TV viewers will also recognize Kidman's range for her recent work in the TV shows *Top of the Lake*, *Big Little Lies*, and *Bangkok Hilton*, for which she won the Australian Academy of Cinema and Television Arts (AACTA) Award for Best Lead Actress in a Television Drama. However, fans are bound to be surprised by her performance as Gudrún, whose full-throated intensity can sometimes be jarring given her treacherously subdued tone.

ABOVE Fjölnir the Brotherless (Claes Bang) consorts with his Queen Gudrún. **OPPOSITE** Queen Gudrún (Nicole Kidman) secretly schemes in her bedchamber.

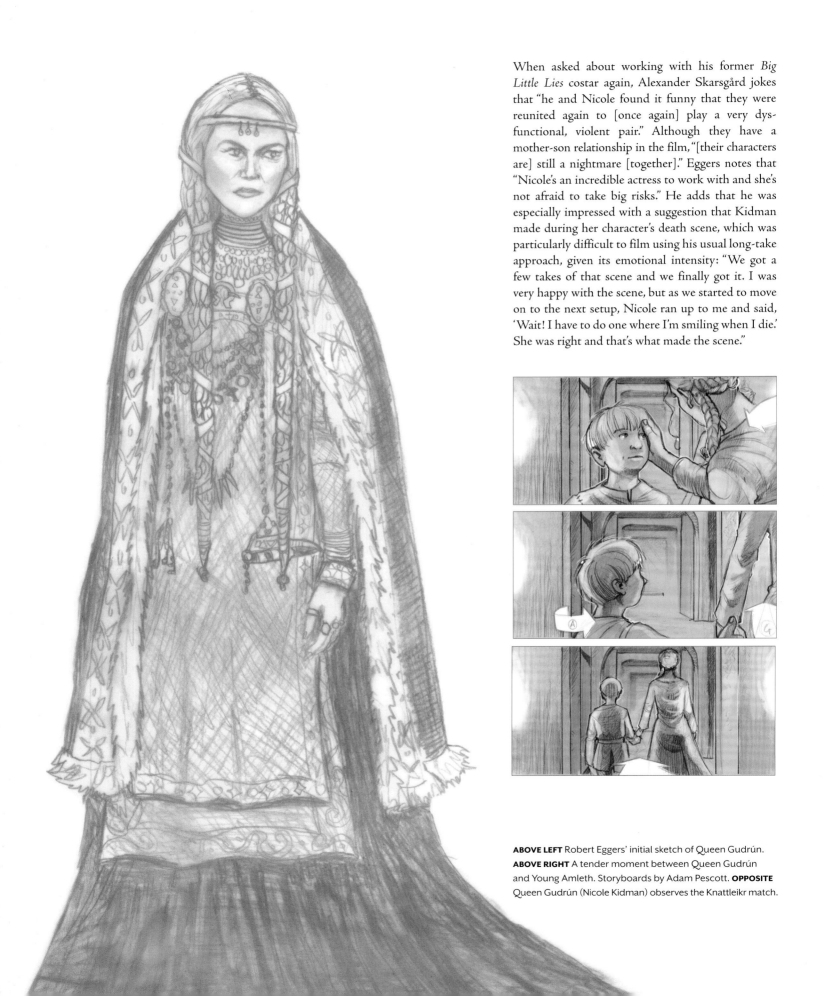

When asked about working with his former *Big Little Lies* costar again, Alexander Skarsgård jokes that "he and Nicole found it funny that they were reunited again to [once again] play a very dysfunctional, violent pair." Although they have a mother-son relationship in the film, "[their characters are] still a nightmare [together]." Eggers notes that "Nicole's an incredible actress to work with and she's not afraid to take big risks." He adds that he was especially impressed with a suggestion that Kidman made during her character's death scene, which was particularly difficult to film using his usual long-take approach, given its emotional intensity: "We got a few takes of that scene and we finally got it. I was very happy with the scene, but as we started to move on to the next setup, Nicole ran up to me and said, 'Wait! I have to do one where I'm smiling when I die.' She was right and that's what made the scene."

ABOVE LEFT Robert Eggers' initial sketch of Queen Gudrún.
ABOVE RIGHT A tender moment between Queen Gudrún and Young Amleth. Storyboards by Adam Pescott. **OPPOSITE** Queen Gudrún (Nicole Kidman) observes the Knattleikr match.

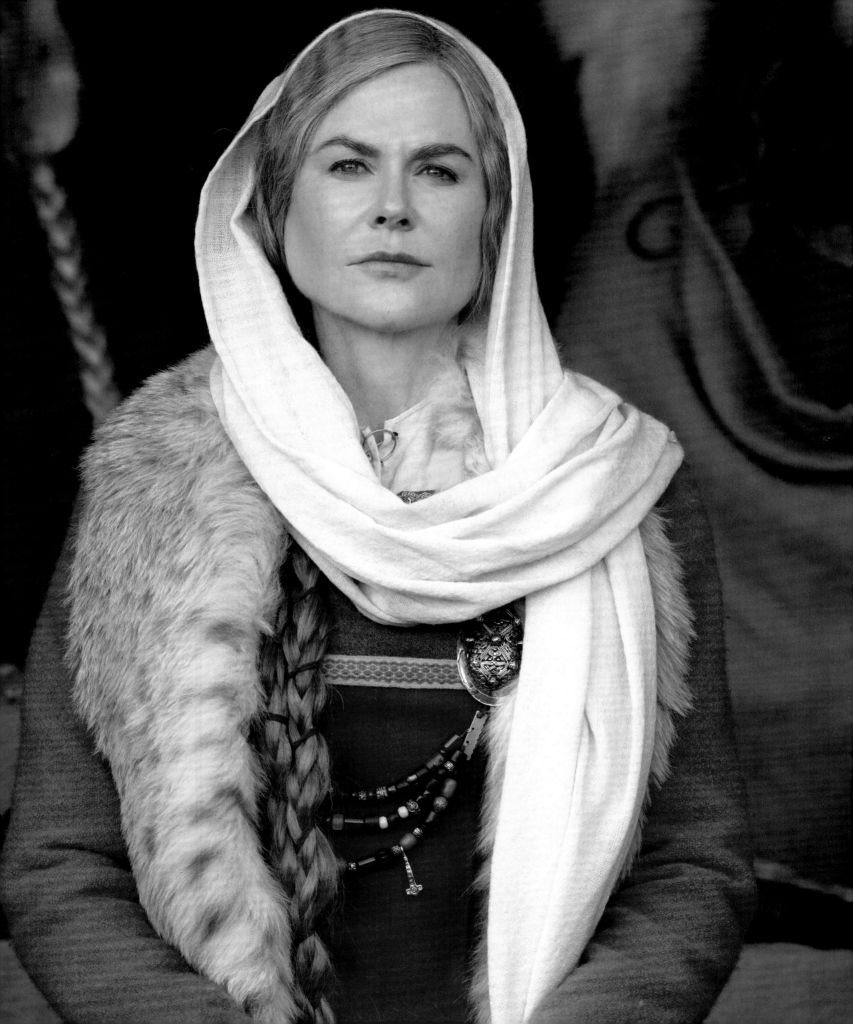

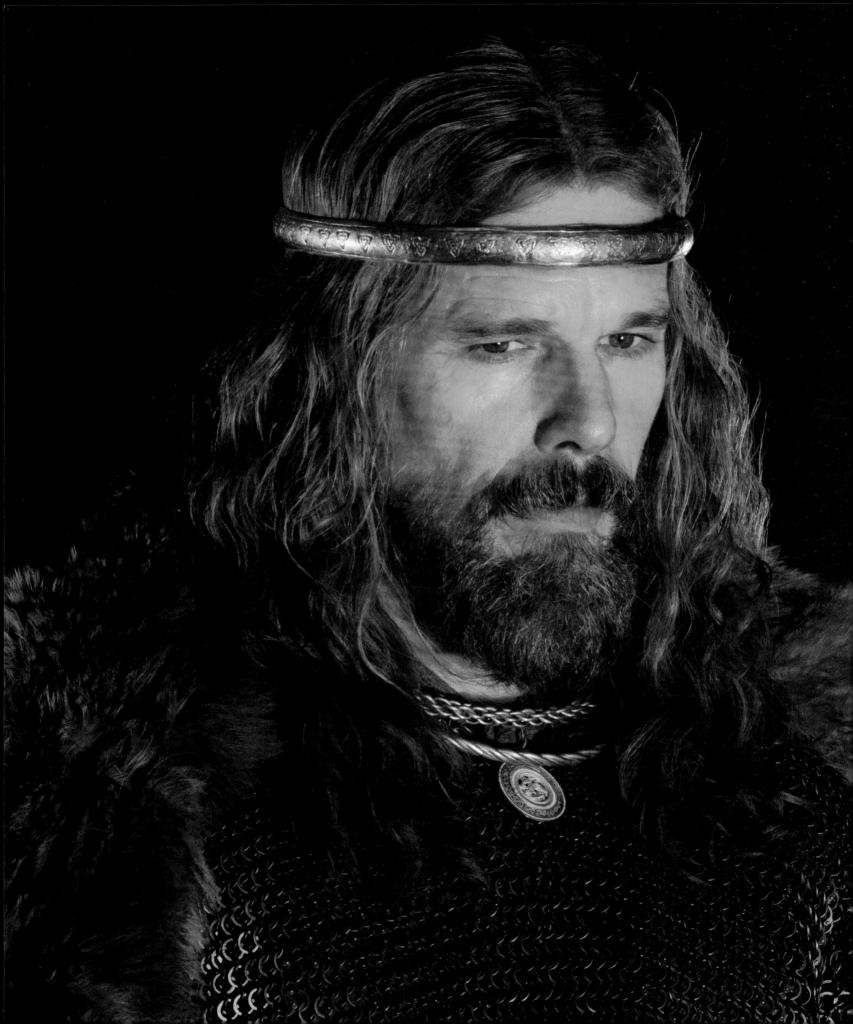

ETHAN HAWKE
⟨KING AURVANDIL WAR-RAVEN⟩

As Amleth's father, Ethan Hawke expresses a lot of King Aurvandil's character in a short amount of screen time. Hawke has honed his craft over the course of a considerable and varied film career, including his award-winning performances in *Before Midnight* and *First Reformed*. In addition, Hawke has starred in a number of demanding theater roles, including both Chekhov's *Ivanov* and *The Seagull*, as well as Tom Stoppad's three-part *The Coast of Utopia*, for which he won a Tony Award in 2007 for Best Performance by an Actor in a Featured Role in a Play.

BELOW King Aurvandil returns home from battle. **OPPOSITE** King Aurvandil (Ethan Hawke) holds court at Hrafnsey.

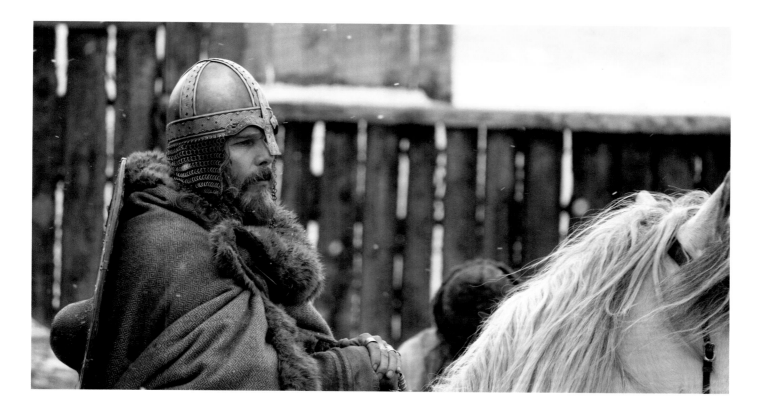

"I THINK [KING AURVANDIL] THINKS SO WELL OF HIMSELF THAT HE CAN'T IMAGINE OTHER PEOPLE DON'T LOVE HIM."

—ETHAN HAWKE

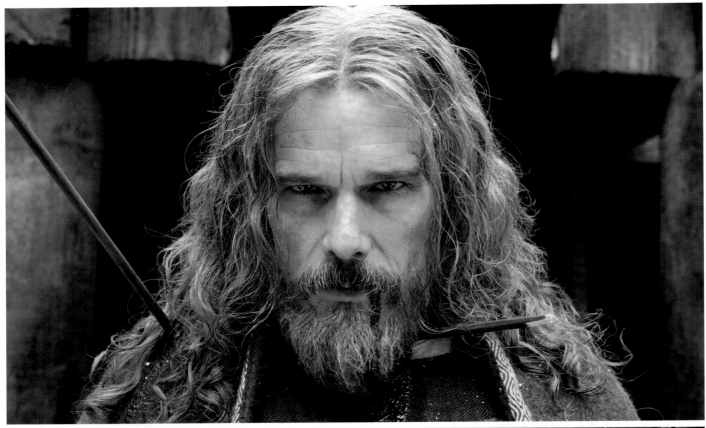

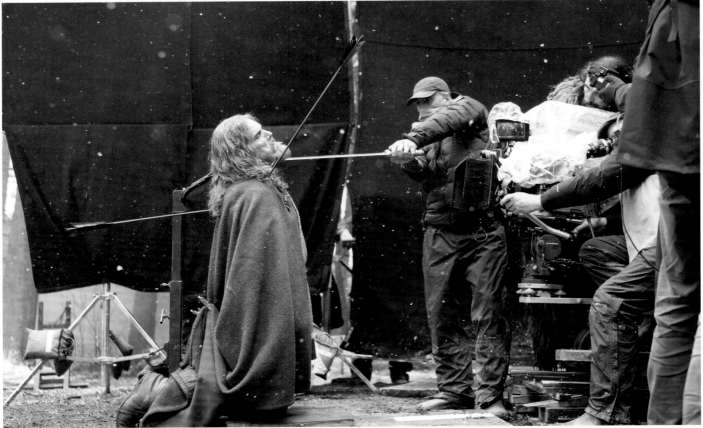

When he read *The Northman*'s script, Hawke was immediately impressed with it. He compares Sjón and Eggers' writing to a great poem whose specificity of language and detail was less like a typical movie script, which strives for broad appeal, and more like the distinctive work of playwrights, the best of whom he commends for developing their own language. Hawke's paternal, but elusive, presence looms over the movie and challenges viewers to see King Aurvandil as a more complicated character as the movie progresses. "I think [King Aurvandil] thinks so well of himself that he can't imagine other people don't love him," Hawke says. "You could see that level of ego as narcissism, or you could see it as a projection of his own goodwill. I don't know what it is, but I find that very interesting."

ABOVE LEFT Robert Eggers' initial sketch of King Aurvandil War-Raven. **ABOVE RIGHT** Young Amleth witnessing his father King Aurvandil's death. Storyboards by Adam Pescott. **OPPOSITE TOP** King Aurvandil (Ethan Hawke) is shot with arrows by his traitorous brother Fjölnir. **OPPOSITE BOTTOM** Ethan Hawke prepares to shoot King Aurvandil's final death scene.

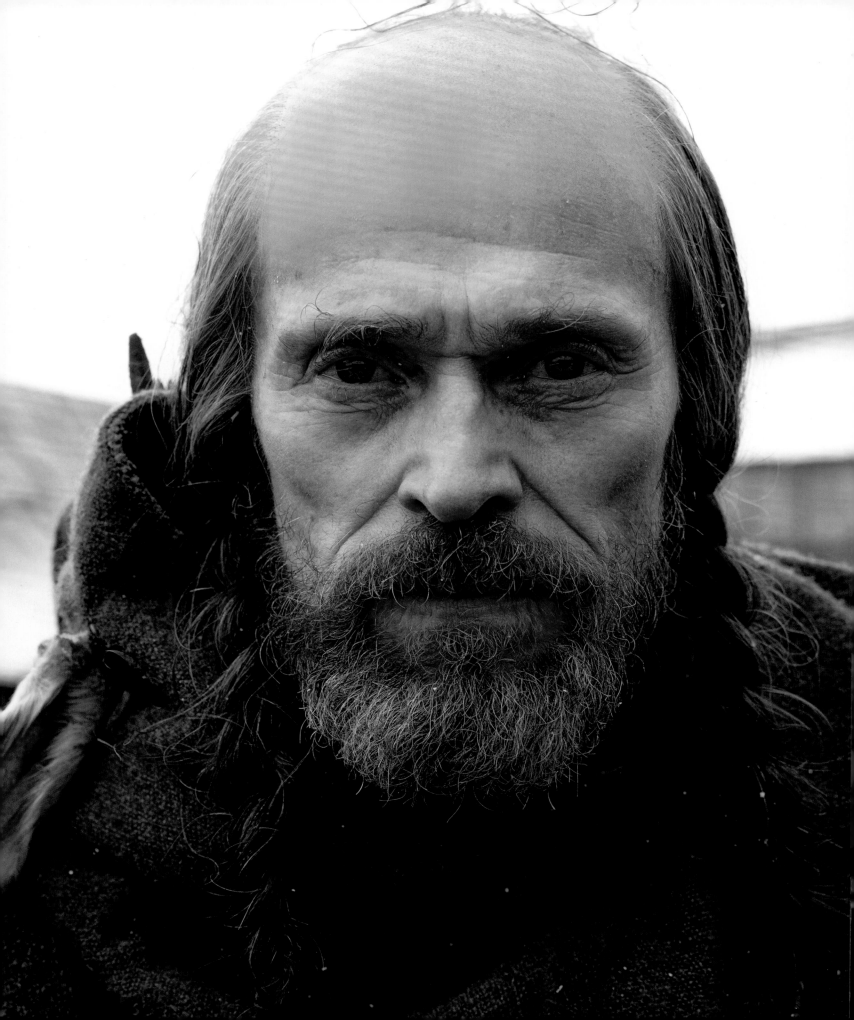

WILLEM DAFOE (HEIMIR THE FOOL)

From roles such as Sergeant Elias Grodin In *Platoon* to the Son of God in *The Last Temptation of Christ* to Vincent van Gogh in *At Eternity's Gate*, four-time Academy Award nominee Willem Dafoe is no stranger to roles that require nuance. The dual nature of Dafoe's role as Heimir the Fool, who is part jester and part shaman, makes him the only character who can speak freely at court, utilizing humor to impart thinly veiled observations and criticisms that others dare not utter. He is therefore able to influence both Amleth and King Aurvandil. Before starring in *The Lighthouse*, Dafoe eagerly sought out Eggers after seeing *The Witch*.

BELOW Robert Eggers gives direction to Willem Dafoe. **OPPOSITE** Heimir (Willem Dafoe), Hrafnsey's oracular jester, is part of a trio of supernatural characters in the film.

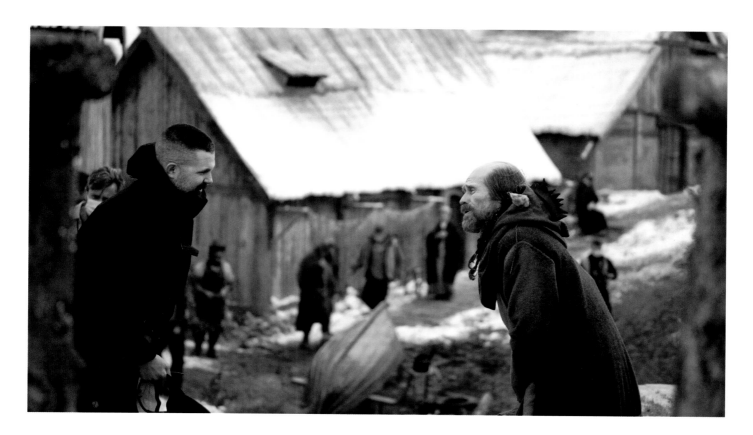

"I GET SUCKED INTO [ROBERT'S] RESEARCH, ESPECIALLY ON THIS PROJECT, SINCE *THE NORTHMAN* IS ABOUT A TIME IN HISTORY AND A CULTURE THAT I DIDN'T KNOW A LOT ABOUT."

—WILLEM DAFOE

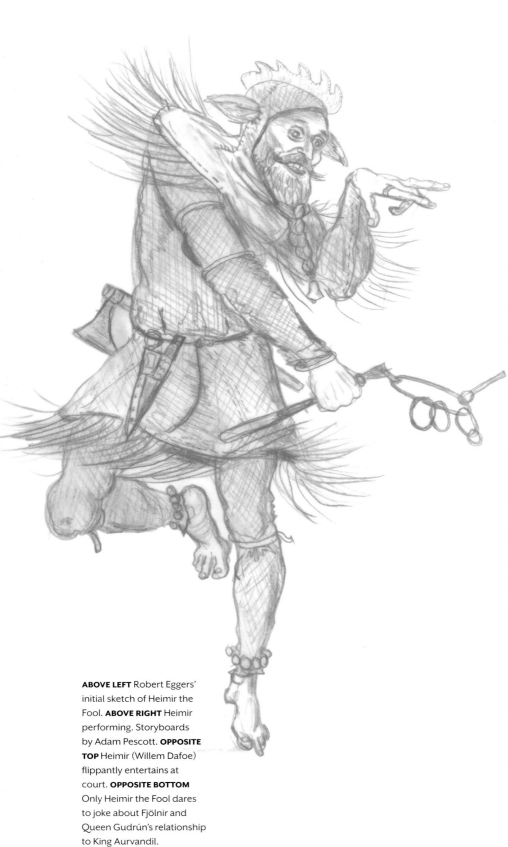

Dafoe's performances in Eggers' two most recent movies speak to not only his sheer physicality but also to his emotional range as an actor. Speaking of Eggers, Dafoe compliments the director by noting that "I think he tapped into certain things he'd seen as far as my energy, my sense of humor, and my love of doing physical things." Dafoe also loves Eggers' research-intensive approach to screenwriting and character development: "I get sucked into [Robert's] research, especially on this project, since *The Northman* is about a time in history and a culture that I didn't know a lot about. [Robert] said to me, 'Listen, what do you want me to send you as far as research?' 'Bring it on,' I said, 'and I'll see what's useful to me.'"

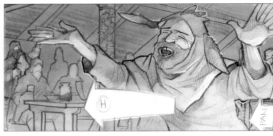

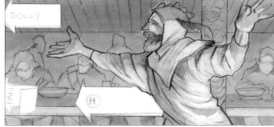

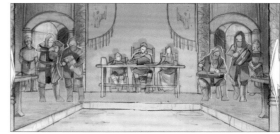

ABOVE LEFT Robert Eggers' initial sketch of Heimir the Fool. **ABOVE RIGHT** Heimir performing. Storyboards by Adam Pescott. **OPPOSITE TOP** Heimir (Willem Dafoe) flippantly entertains at court. **OPPOSITE BOTTOM** Only Heimir the Fool dares to joke about Fjölnir and Queen Gudrún's relationship to King Aurvandil.

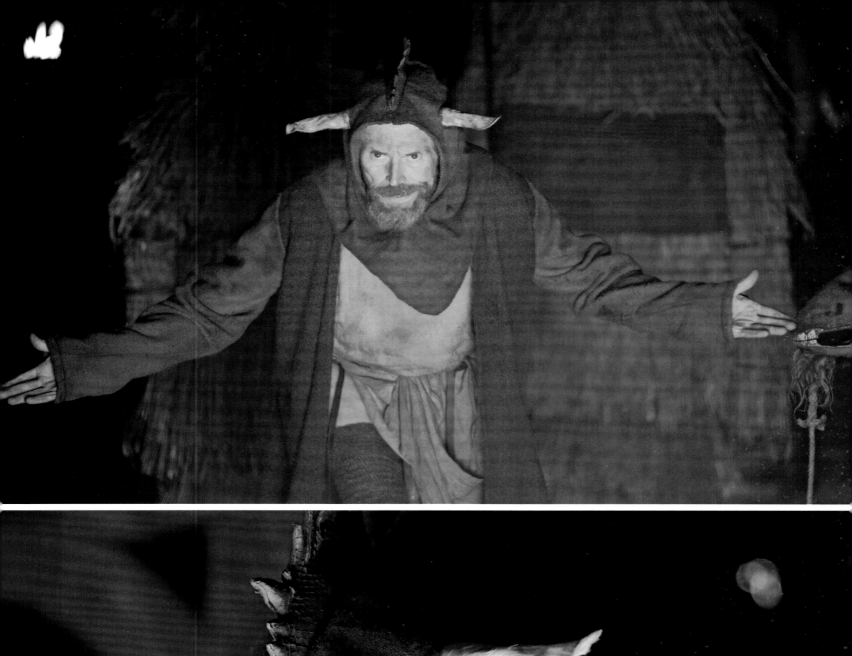
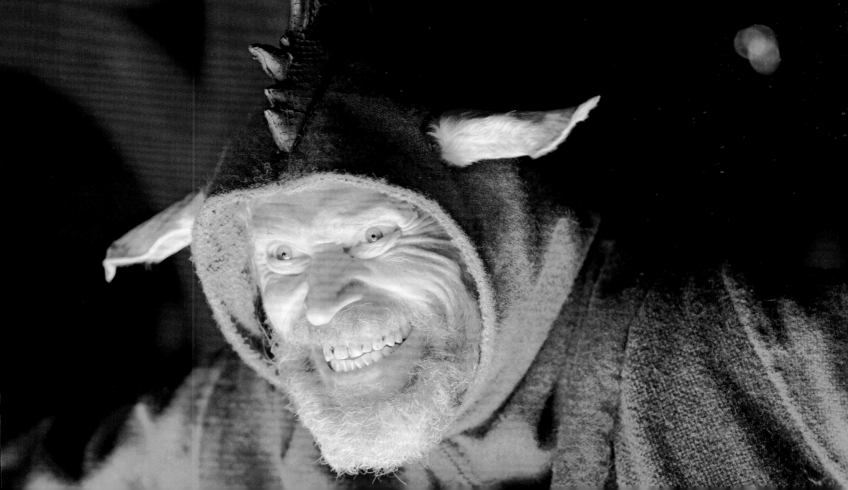

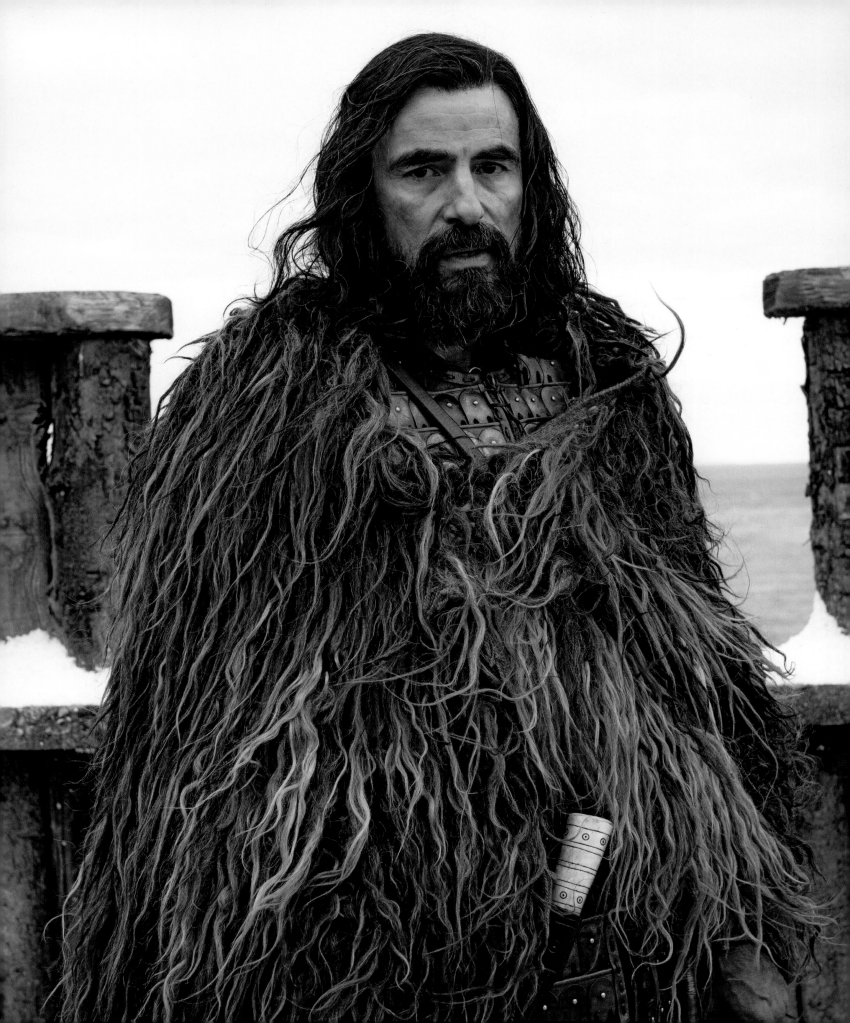

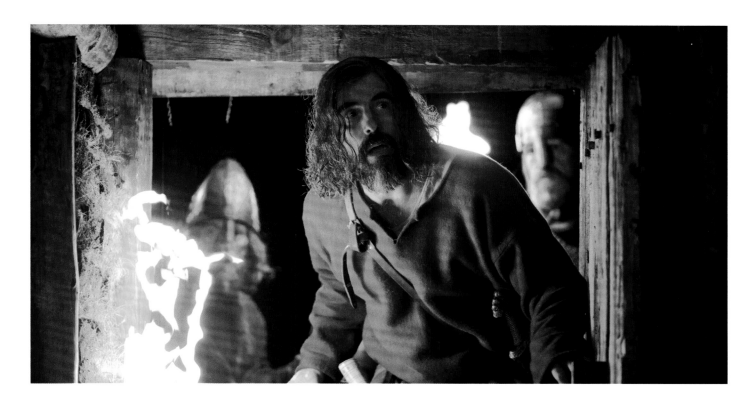

CLAES BANG
(FJÖLNIR THE BROTHERLESS)

Danish actor Claes Bang's reserved performance as the villainous Fjölnir will come as no surprise to fans of his outstanding recent roles as Sasha Mann in *The Affair*, as well as the seductive title character in *Dracula* (TV miniseries, 2020). As Fjölnir, Bang draws viewers' attention with a smoldering intensity that suggests a depth of emotion. Although Bang might be best known for his film and TV work, he was classically trained at the Danish National School of Theatre after a formative high school performance in *Hair*.

ABOVE Fjölnir and his henchmen discover that Amleth escaped. **BELOW** Robert Eggers' initial sketch of Fjölnir the Brotherless. **OPPOSITE** Fjölnir the Brotherless (Claes Bang) after he slays King Aurvandil and steals his kingdom.

"FJÖLNIR IS AURVANDIL'S POORER HALF-BROTHER, AND WHILE HE HAS RETAINERS, HE AND HIS MEN HAVE VISIBLY LESS THAN AURVANDIL AND HIS MEN."

—COSTUME DESIGNER LINDA MUIR

Bang would go on to receive acclaim for his break-through lead role in Ruben Ostlund's Palme D'Or–winning *The Square*, for which he also won the European Film Award (EFA) for Best Actor in 2017, the first time this honor was bestowed on a Dane. Bang also writes music and performs guitar and piano for his self-described "one-man band" This Is Not America, which takes its moniker from the David Bowie song of the same name. Being Danish, Bang was particularly drawn to the script. In a recent interview, he notes the role of Fjölnir was one of the most physically demanding that he has performed, because it required six months of training to get into Viking shape. Performing and acting as a Viking warrior didn't pose a great challenge for Bang once he saw himself in costume designer Linda Muir's meticulously rendered clothing. He adds that the Fjölnir costume allowed him to embody the soul of the character.

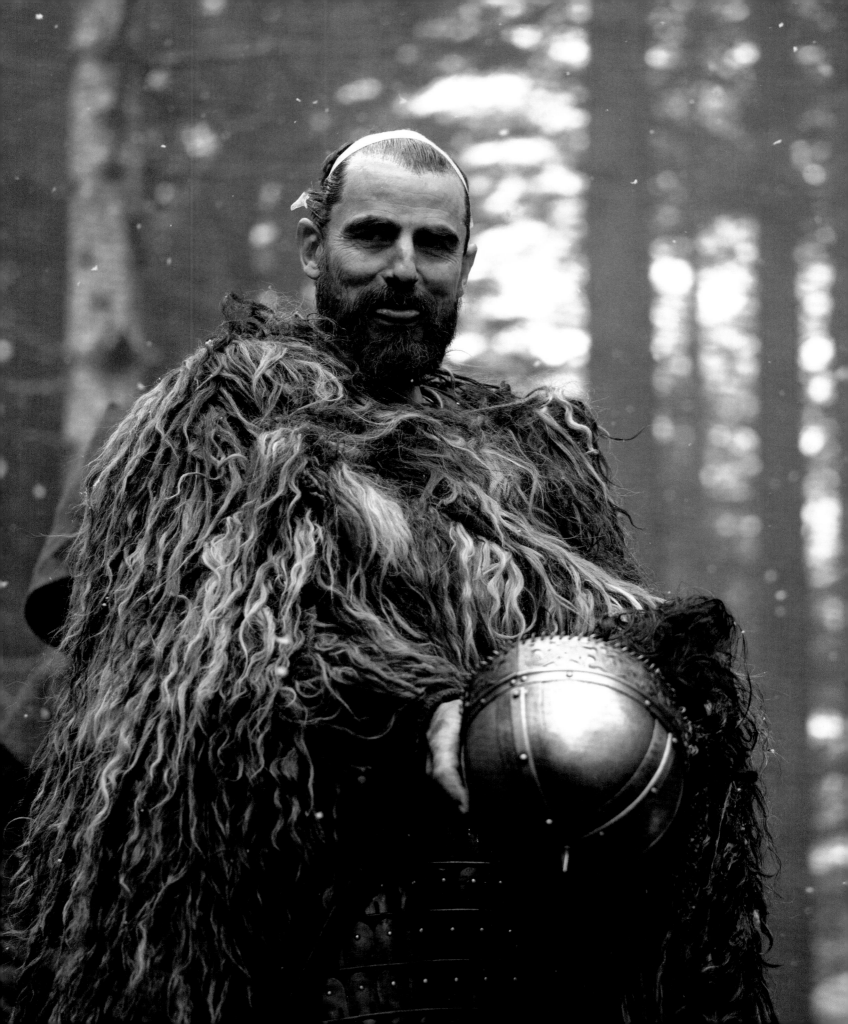

PART IV
HISTORY SHAPES THE SAGA

Eggers and Sjón drew inspiration from and consulted with a trio of Viking historians: Neil Price, Jóhanna Katrín Friðriksdóttir, and Terry Gunnell. With special reference to Price's archaeological research, the two co-writers grounded their saga in details that are not only specific to their characters but also reflect the drama's period and setting. Eggers and his collaborators deliberately blur the line between the drama's history and folklore, which helps add psychological complexity to Amleth's narrative.

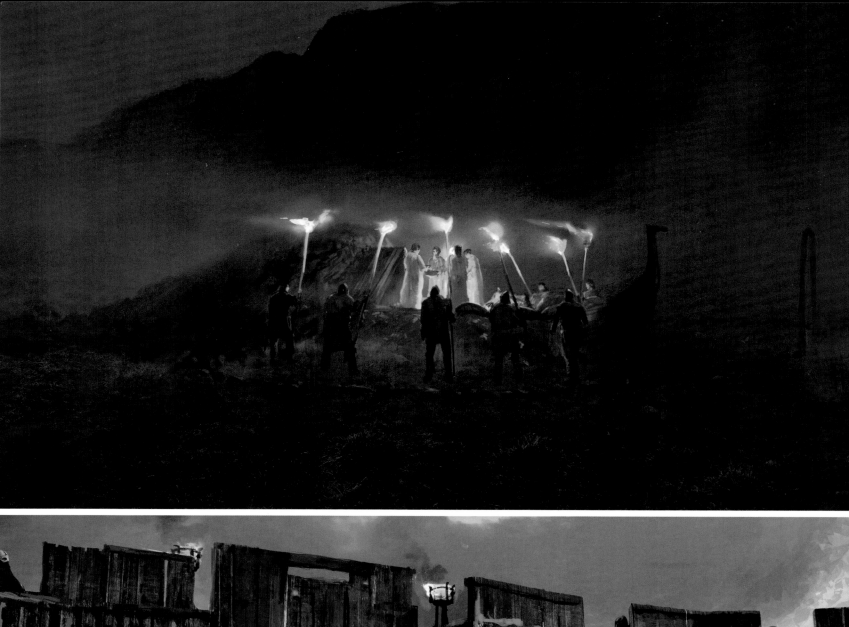
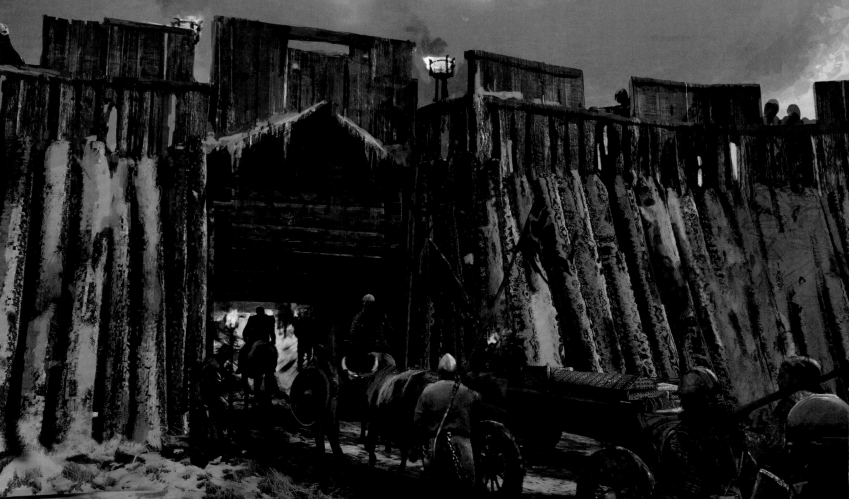

VIKING EXPERT
NEIL PRICE

British archaeologist, professor, and author Neil Price's research and scholarship on the Viking Age was a major touchstone for the entire film crew, especially his 2012 Cornell University lecture series and books. Price's nuanced reasoning and wide range of knowledge of life during the Viking Age—even including the gaps in our current knowledge—help make his presentations both accessible and thrilling. Eggers and Sjón were especially inspired by Price's books *The Viking Way: Religion and War in the Late Iron Age Scandinavia* and *The Children of Ash and Elm: A History of the Vikings*, which led them to seek out and hire Price as an official consultant for the movie.

What kind of stories are the Viking sagas and how do they differ, depending on their original location, from other accounts of life during the Viking Age?

Although the sagas have become synonymous with the Vikings, they're actually not from the Viking Age. They're from the Middle Ages, and while they have the Viking period as their setting, most of them were written a couple of hundred years after the end of the Viking Age. A lot happened between the period described in the sagas and when they were written. Broadly speaking, while there are several different saga genres, there are two in particular that people tend to use when they look for information about the Viking Age.

One of those two genres is known as the sagas of Icelanders, which are also sometimes referred to as the "family sagas." These stories are set in Iceland and concern particular families and districts, their lives, and their (usually violent) interactions with their neighbors. Every now and then the people in these sagas go abroad to Norway and elsewhere, and we see what happens to them there, but the action always returns to Iceland. As sources of information about the Viking Age, the family sagas are generally considered to be more reliable than other saga genres, though there's an entire field of scholarship debating how much we can really trust them. The sagas are not straight-up history, but they're also not total fiction either. It's up to the individual researcher to decide where their own opinions fall on that sliding scale, and every saga needs to be considered individually.

The other main saga genre is that of the legendary sagas, which are more like medieval romances, similar to the famous Arthurian stories, or knightly tales, involving heroes, princesses, monsters, and the like. The legendary sagas are set in Scandinavia, too, though they tend to be much broader in geographical scope. They're certainly not history—even less than the family sagas—but they're also not complete invention either. Some of the legendary sagas are set around the same time as the family sagas, but some of them also relate tales of earlier centuries.

Why were the Vikings in Iceland in the late ninth and early tenth centuries?

At the start of the Viking Age in Scandinavia, there were lots of little states, and we don't really know what else to call them—whether they're little kingdoms or polities—which by the ninth century had begun to gradually combine into larger kingdoms. Scandinavia had a lot of domestic conflict, and the winners of those conflicts were people like Harald Fairhair, who claimed to have started the unification of Norway into one kingdom. These conflicts also had losers, people who didn't fit in with the new social order. Iceland is really unique because it was a social experiment. A traditional view of Iceland's settlement (around 870 CE) holds that people who were unhappy with life in Norway moved to an uninhabited place in the North Atlantic with the goal of making a new society. That is probably something of a retrospective political construction, but there's no doubt that Iceland really was

a republic of farmers, like Fjölnir, and that was actually a hell of a thing to create at this time—and it also didn't really work. In the first part of *The Northman*, Fjölnir takes power in Hrafnsey by murdering his brother Aurvandil and marrying his brother's widow, Queen Gudrún. Then Amleth grows up and seeks his revenge. By this time, Fjölnir has come down in the world and is living as a farmer in Iceland. He's got a prosperous farm, but he hasn't got a little kingdom like King Aurvandil did in Hrafnsey. Robert was very keen to decorate Fjölnir's Icelandic farm with King Aurvandil's wall tapestries; however, in Iceland, they're a bit too long for Fjölnir's walls, which shows how he's come down in the world. He's a leading farmer in his district, but his house is nobody's idea of paradise.

In your book The Children of Ash and Elm, ***you talk about how the Christians' point of view affects our understanding of Viking life. Have you noticed significant Christian editorializing or commentary baked into the extant accounts of the Vikings and their culture?***

That's a huge question, and there's a lot of debate about it. The short answer is yes. Almost all of our Scandinavian sources, the sagas and the poems, come to us

through a later, Christian filter. But although the idea of heavy Christian influence has almost become a cliché, we also have to ask ourselves why these medieval Icelandic Christians were so interested in their pagan ancestors, even kind of proud of them. We also know that a lot of pre-Christian customs continued through the Christian period. You can see this in medieval laws that forbade people from practicing pagan activities, and if you need to pass a law against something, it suggests people are actually doing it.

There are some very specific religious crossovers, like how the first human couple in Norse mythology are called "Ash" and "Elm." Isn't it worrying that their names begin with *A* and *E*? I don't know whether they're Adam and Eve, but that's quite a coincidence—[as is] the underworld, one of the realms of the dead, which is pronounced roughly "heal" and spelled *Hel*, [and isn't it also a] bit of a coincidence that it's more or less the same word as the Christian "hell." The thirteenth-century Icelandic historian Snorri Sturluson talks about *Hel* as a bad place. It's cold, dark, and miserable; you don't want to go there. But if you look at

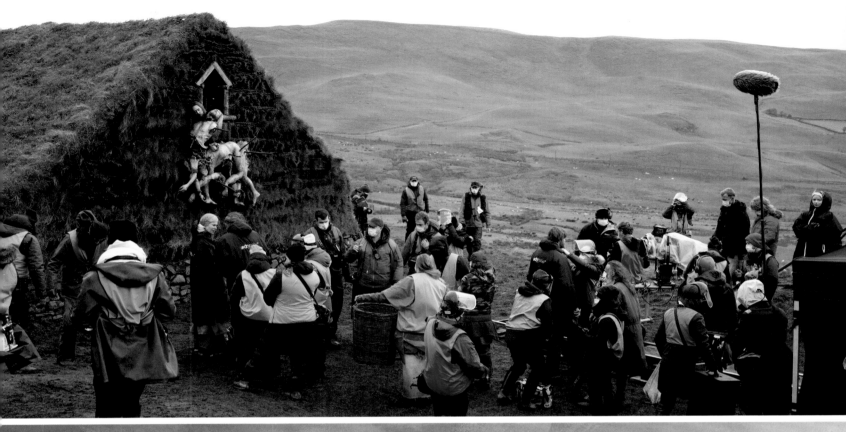

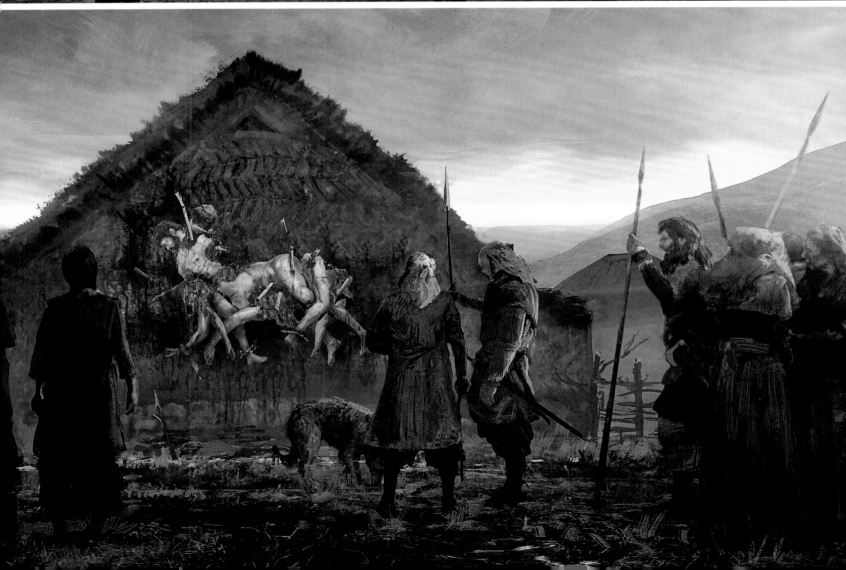

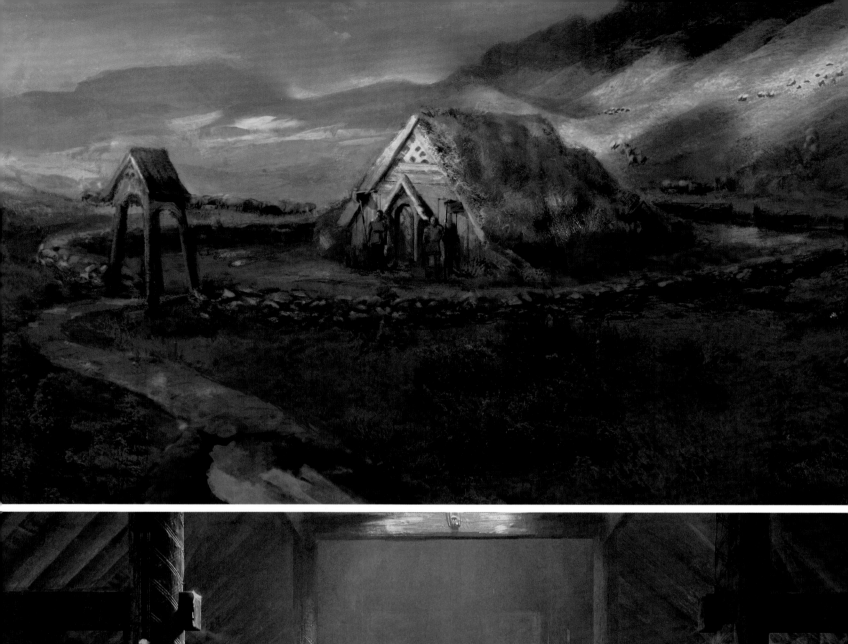

Viking Age poetry and even some of the sagas, nobody seems to think *Hel* is bad. There are really prominent characters who clearly think that they'll go to *Hel*, and nobody thought that was odd or negative.

I think that the Norse gods probably disappeared very quickly during the Christian era. I don't think many people secretly worshipped Óðinn in the [thirteenth century], but that invisible population that I mentioned—not just specific entities like elves, but the idea of living in a world populated by other powers—persisted. The Christians who wrote the sagas were working (or reworking) older material, but they still had a remnant of the Vikings' point of view as well. So, the sagas are a fusion of those two perspectives. [The writings from] people like Saxo Grammaticus, who gave us the original Amleth story and wrote political history in the context of his time, and the Danish and Norwegian kingdoms, [who] had their own power struggles and their own agendas in writing official histories of their past, make things even more mixed up and harder to untangle.

You've also written about how some Norse farmers had built little shedlike structures next to their homes where they could commune with their gods, similar to the underground temple scene in which King Aurvandil and Young Amleth meet Heimir the Fool. Would you say that a Viking's sense of spirituality, or connection to higher powers, was dependent on one's class?

Yeah, that makes sense. There is a hierarchy of access to religion (or whatever you want to call it), just as there is a hierarchy to everything else. Religious worship was an expression of power. Unlike the general population, the elites—especially kings, but also the rank of people below them—claimed to be the gods' descendants. They were family members with the gods, so they had a slightly different relationship with the gods than everybody else at this time. Both King Aurvandil, in Hrafnsey, and Fjölnir, in Iceland, have their little temples—we don't know what to call them. There are several sequences in *The Northman*—and Robert did this in his previous movies as well—where you can either interpret what you're seeing as "real" supernatural events or as subjective experiences: Maybe somebody's dreaming, or they've been drugged, or are having a vision, or whatever. Those experiences were not as ambiguous to the people in the movie; that was just their experience. How you, the viewer, choose to interpret that experience is up to you. I really like that ambiguity.

Did anything in Robert and Sjón's script surprise you or make you think, This is exactly how I imagine life at this time was like?

I teach occasional classes on historical movies and how filmmakers have used archaeology to understand the past. Many of these films put forward a rather simplistic view of the ancient world, painted in broad strokes with obvious heroes and villains. There's nothing so clear-cut like that in *The Northman*. Amleth, the central character, is brave and committed, but also utterly ruthless—not least, he is partly responsible for destroying the Slav village and killing or enslaving its inhabitants, including Olga, with whom he later forms a relationship. The movie subverts expectations, I think. And then there's that revelation about Queen Gudrún toward the end of the movie, which changes our view of her and suggests a different motive for the murder of King Aurvandil (even though Amleth loves him, the audience has never been in any doubt that he, too, was a killer and a slaver). I like that cold, unsentimental view of the Viking Age.

Something else that surprised me, because it's not in the script, was how many of the enslaved people on Fjölnir's farm speak with Irish and Scottish accents. At first, I thought, *Well, this is a bit weird*. Then again, research shows—and Sjón and Robert would certainly know this—that a lot of the early Icelandic settlers came from the Irish Sea area. And although we don't know what their accents were like, you'd probably hear where they came from in their voices. That's a lovely detail. The Vikings are often stereotyped as blond and blue-eyed, which was really not the case. They also came from a lot of different places, as they do in *The Northman*. Amleth extends his familial line with a Slavic woman, and it's also implied that Queen Gudrún comes from somewhere else, too, because she was captured on a raid. I really like that they slipped in this multiethnic view of the past. That was really well done.

BELOW Grass turf grew on the roofs of the Freysdalur sets over the course of a monthslong break in shooting. **OPPOSITE TOP** Fjölnir's turf temple at Freysdalur. Concept illustration by Ioan Dumitscu. **OPPOSITE BOTTOM** Washing day at Freysdalur's longhouse. Concept illustration by Philipp Scherer.

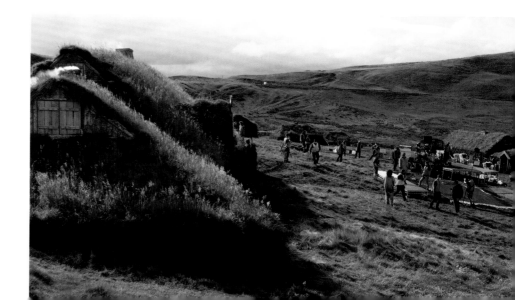

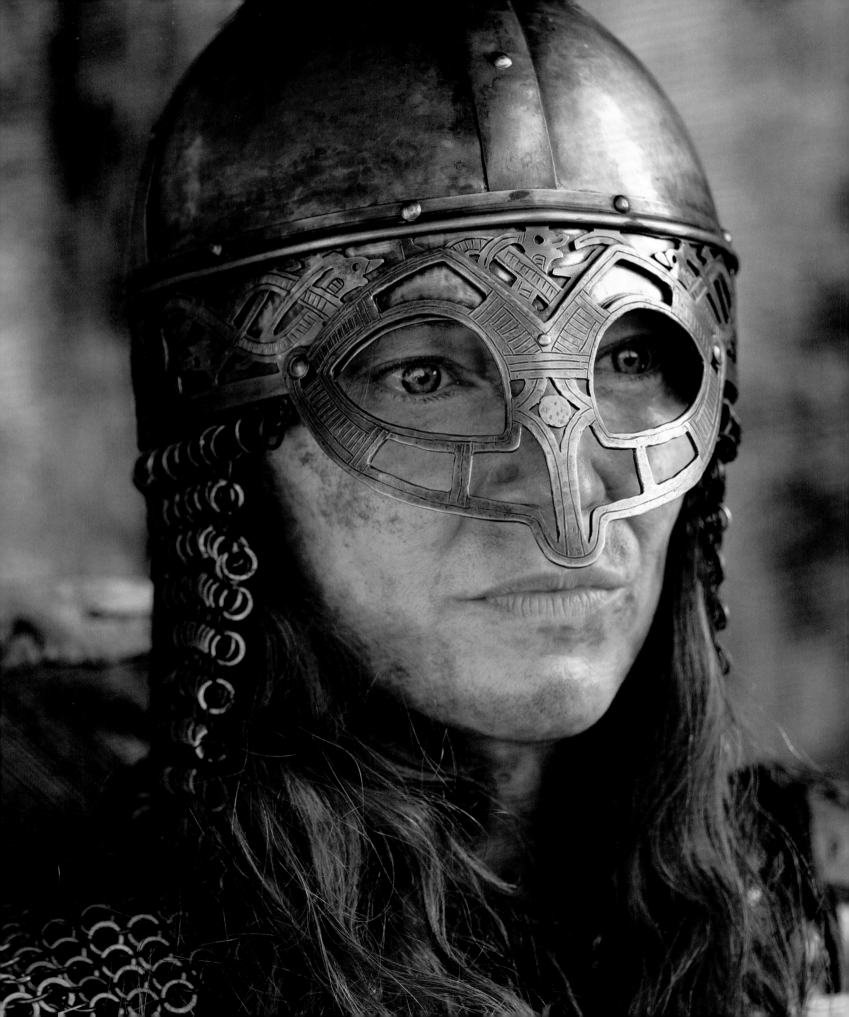

HISTORIAN AND AUTHOR
JÓHANNA KATRÍN FRIÐRIKSDÓTTIR

Jóhanna Katrín Friðriksdóttir never really planned to be an Icelandic sagas expert. She received her bachelor's degree in English at the University of Iceland, for which she studied medieval English, but her formal university studies only reminded her of how much she loved reading about Norse mythology and the sagas when she was in high school. "I wound up doing a PhD [at the University of Oxford]," Friðriksdóttir says. "There was never a plan; I just kept going." Friðriksdóttir would go on to write a book that integrated her studies, *Valkyrie: The Women of the Viking World*, which became a reference point for Eggers, who hired Friðriksdóttir as a consultant for the film.

How would you say differences in gender were depicted or represented in the sagas? Viking society was obviously patriarchal, but is it fair to say that the Vikings were also less male-dominated than many of us think?

One thing I generally try to highlight when I talk about this is that there's a lot of vocabulary in Old Norse about women as advice-givers and partners in a marriage, so that suggests that they had a strong position and were respected. Women got a lot of legal rights when they married; they had the right to determine a certain amount of things within their households, to spend a certain amount of money without asking for permission, and so on. There's also a word for some women, *eyraruna*, that's often translated as "confidante," which is a less well-defined role [that means] being your husband's advice-giver. Women were obviously important in Viking society, so it was always smart to ask your wife for advice whenever you were in an unfamiliar or tricky situation. That's all there in the original sagas, but it kind of gets written out of the narrative during the nineteenth and early twentieth centuries, which is when these big Viking histories were written. All of those histories' original source material had to be reclaimed by feminist scholars from the 1970s onward, but those elements, which we could call proto-feminist, are now recognized parts of the sagas. I'm often keen to get away from the sense that the more

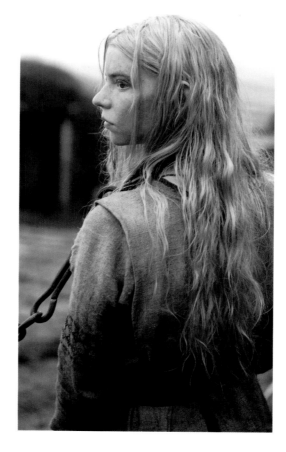

LEFT Olga (Anya Taylor-Joy) on her way to Fjölnir's farm after her village has been destroyed by Amleth and his fellow Berserkers. **OPPOSITE** The armored Shield Maiden (Katie Pattinson) prepares for battle.

ABOVE The survivors of the Slav village massacre cringe in fear after they're chained together and prepared for evaluation. **OPPOSITE** Olga (Anya Taylor-Joy) in chains.

a woman behaved like a man, the more admired she would have been. I don't think that's true for the Viking Age, and I also don't believe in shield-maidens (warrior women) or anything like that, which is often a disappointment to contemporary readers as well. Some people are very invested in seeing Viking women as warrior women, and disputing that image is not always welcome, because our modern understanding of what is positive about women tends to be what makes them more like men. I don't think that that was true for the Vikings.

At the end of The Northman, *we see a burning barn on Fjölnir's farm, which symbolically complements the volcanic eruption at Mount Hekla. These images seem to herald the end of the Viking*

Age. Can you talk a little about the unsustainable nature of the Vikings' Icelandic settlements, as well as the reality of life for some of their farms' slaves, like Olga?

There's a lot of debate in scholarship as to whether or not we should refer to the settlers as Vikings. Many of them were probably Norse, and they brought enslaved people, especially women, with them. Life was generally quite harsh for most people given that much of the work to keep yourself and your family fed and clothed was very demanding physically, and in terms of the time spent doing it. But for enslaved people, life was even worse, and those women also probably didn't have a very nice life once they arrived in Iceland. We

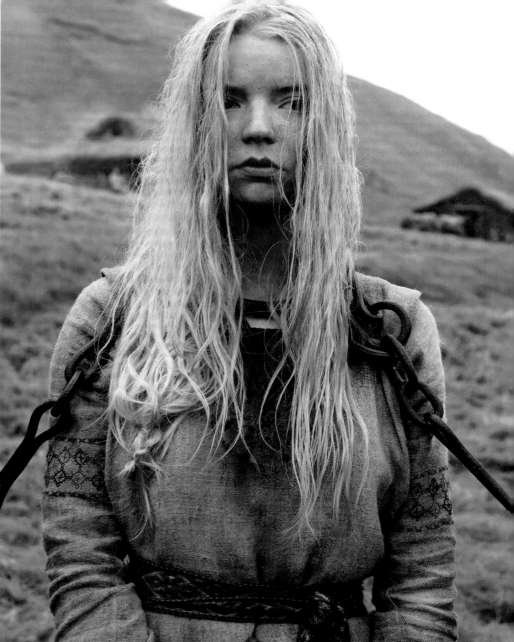

"THERE'S A LOT OF VOCABULARY IN OLD NORSE ABOUT WOMEN AS
ADVICE-GIVERS AND PARTNERS IN A MARRIAGE, SO THAT SUGGESTS
THAT THEY HAD A STRONG POSITION AND WERE RESPECTED."

—JÓHANNA KATRÍN FRIÐRIKSDÓTTIR

obviously can't be sure, though, but some archaeological evidence suggests that slaves were treated in much the same way as cattle. The narrators and authors of these written sources often find it hard to talk about having families that weren't purely Norwegian.

Were there qualities to the film's depiction of Viking life—either in the script or from conversations with Robert—that really surprised you?

The scene where Amleth confronts Queen Gudrún has probably stuck with me the most. I can't think of a saga that has exactly the same things at stake, or features the same narrative details, but I still feel like there could have been a saga author who wrote that scene—even though we don't have one like it in our extant sources. I'm thinking particularly of Amleth's surprise, and maybe even disillusionment, when his mother reveals that she's not just a passive victim after he's sustained his own, perhaps more naïve, idea about her character for all those years. That's consistent with the spirit of the sagas, so it rings true emotionally.

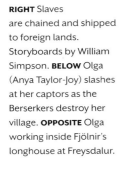

RIGHT Slaves are chained and shipped to foreign lands. Storyboards by William Simpson. **BELOW** Olga (Anya Taylor-Joy) slashes at her captors as the Berserkers destroy her village. **OPPOSITE** Olga working inside Fjölnir's longhouse at Freysdalur.

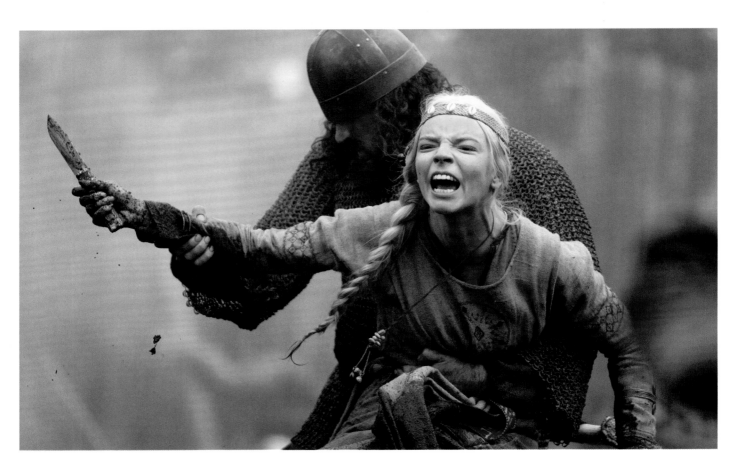

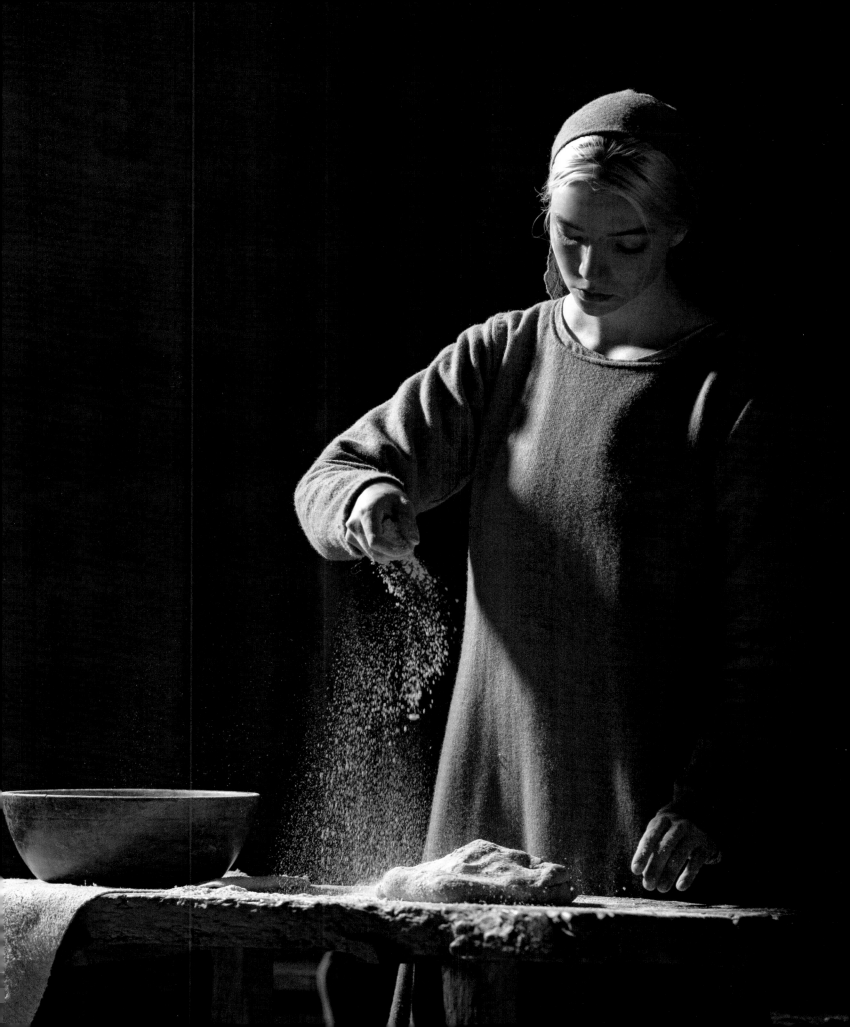

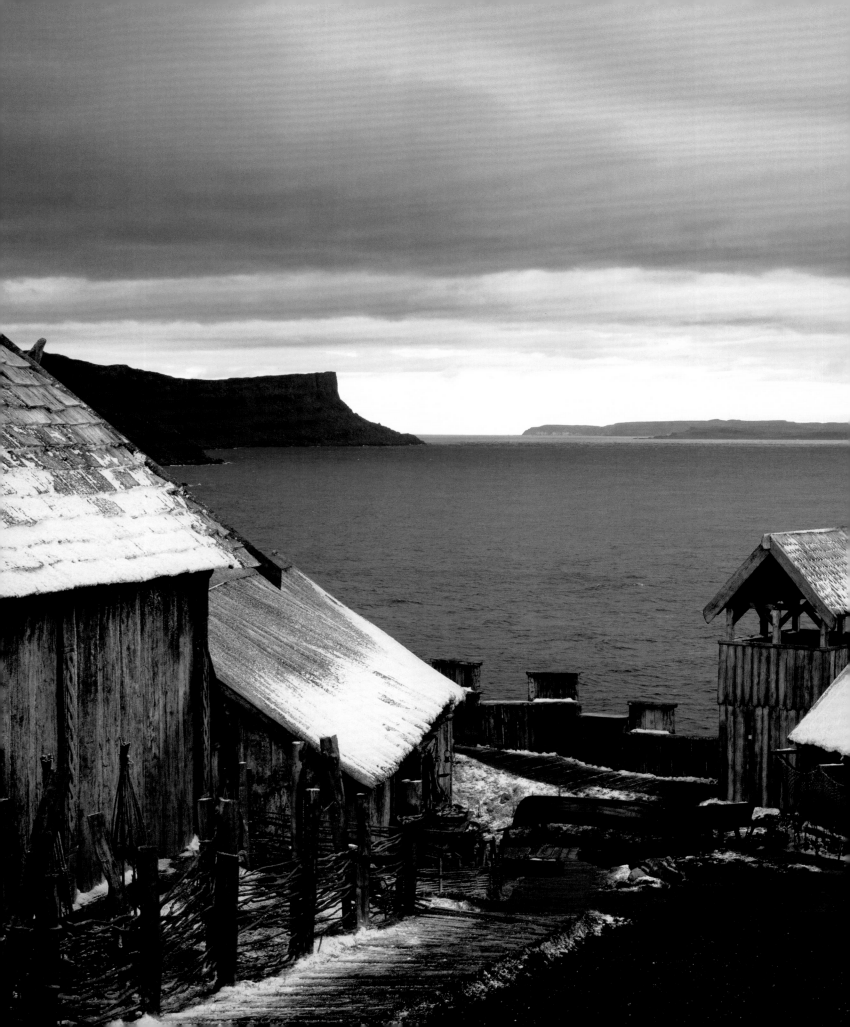

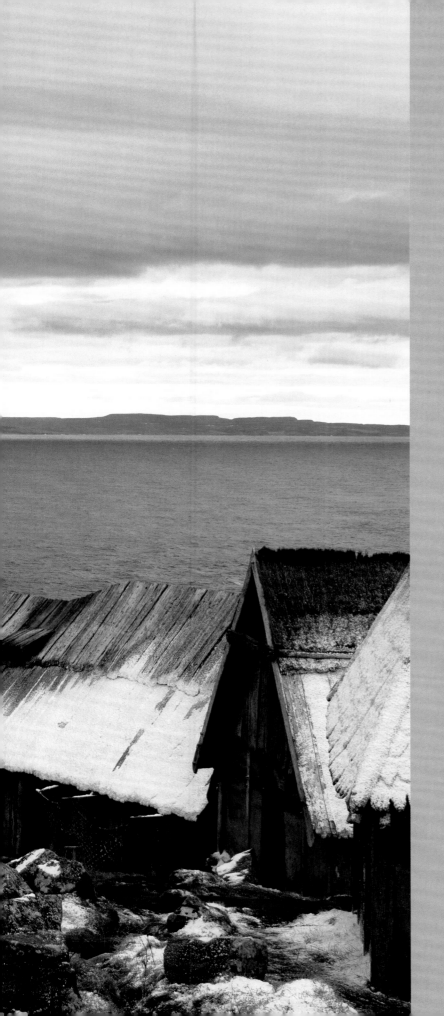

PART V
CREATING THE SAGA'S WORLD

Filming for the movie began in Knock Dhu, Northern Ireland, where intense weather conditions—especially fog, wind, and hard-driving rain—required adjustment to the production schedule. Other unique creative challenges arose, given not only Eggers' intensive focus on historic details but also re-creating an authentic-looking period that is not as well documented in history. Thankfully, production designer Craig Lathrop, location manager Naomi Liston, and costume designer Linda Muir all brought a level of care and attention to detail that helped Eggers' movie feel like a vivid portrait of real Viking life.

PRODUCTION DESIGNER

CRAIG LATHROP

Craig Lathrop faced a number of practical challenges when determining how to build the film's sets. And after having worked with Eggers on both *The Witch* and *The Lighthouse*, Lathrop knew that the film would require him and his team to create the rich world of these characters. "It's such a fascinating world," Lathrop said in a recent interview, "we were able to build these characters' homes and temples, Viking and Slavic villages, and an Icelandic farm." Lathrop worked diligently with the movie's art department in Belfast to meet Eggers' high expectations and enlisted the help of numerous craftspeople and artists to create the detail-rich sets and props the film required. Lathrop was particularly inspired by all the historic research. "When I started, my knowledge of Viking archaeology and history was probably not much greater than the average person, so I was discovering a whole world, everything from the plant materials that they used to make dye with and what colors they used, to who these people were, how they lived, and what their day-to-day living was like. Getting into that mind-set was really fun."

What were some of your primary research sources and how did they change the way you saw to bring the script to life?

Everything was heavily researched, but there were some challenges finding everything that we needed. For example, in the early temple scene at Hrafnsey, you can see a series of large idols of the Norse gods. Today, there aren't any large idols of the Norse gods still in existence. There's writing that indicates that there *were* idols to the gods, but the only thing that we were able to find were some small pewter figurines—and even those are just figures that we *believe* to be Norse gods. The Vikings didn't put labels on anything, so [the challenge was] how do we know that a figurine with a phallus is an idol of Freyr and not just somebody's horny uncle? I don't know that you can [know] for sure.

For the structures, we leaned pretty heavily on the work of traditional archaeologists who came before us, and the experimental archaeologists and architects who've tried to determine what Viking buildings must have looked like. A substantial amount of what we

know has come from studying postholes found in the ground. Their buildings were mostly made of wood, so we only have the scars in the ground that indicate where buildings were and a few descriptions. We don't have any art or drawings, with the exception of some small sculptures that are reminiscent of Viking long-houses. Because the structures were made of wood, most of the details are lost to time. For instance, [to re-create] the columns in King Aurvandil's Great Hall, there are no such columns left [to base them on], though we do have plenty of burial remains. The Vikings were very skilled carvers, and we have tons of examples of what they carved. But the fact that none of these pillars exist anymore meant that I had to use the examples we had and then invent the rest. I believe that in the great hall of a king the columns would have been carved. But what did they look like? The Great Hall's columns on our set were based on carvings from the historic Oseberg archaeological find from 1903. Those carvings are about as big as my hand, and I used them as a reference for our life-size columns.

Sometimes the research matched what we were hoping to find. Rob and I wanted to use stone for the

PREVOUS PAGE AND OPPOSITE TOP The set for King Aurvandil's North Atlantic kingdom in Torr Head, Northern Ireland. OPPOSITE BOTTOM Craig Lathrop and his team worked with a group of Indian carvers to build nine-and-a-half-foot tall idols to represent the Norse gods that might have been worshipped by King Aurvandil and Fjölnir.

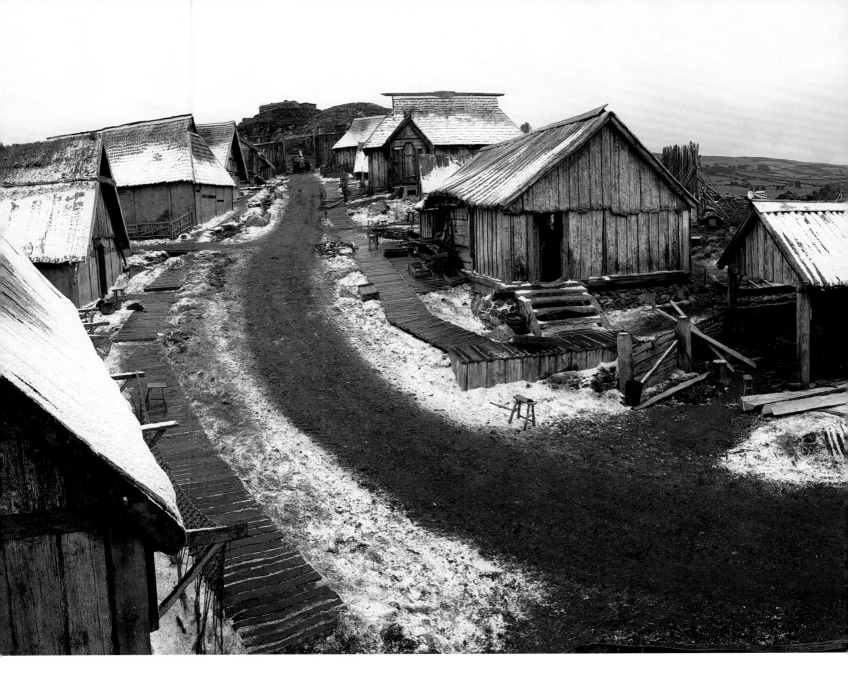

floors of the Great Hall [not only to give a sense of] majesty [but also] for the sound [stone] makes when people and horses walk on it. But all of our research showed that the Vikings had wooden floors. I kept digging for alternatives until I came across a relatively new [archaeological] find on Orkney island, [which is] off the coast of northern Scotland. They'd recently unearthed a longhouse with a stone floor and stone benches running along either side of the building. They found it underneath another ruin on the island. There isn't much wood on Orkney, so I believe [the Vikings] used the materials they did have and made a stone floor. It was beautiful, and we re-created it for King Aurvandil's Great Hall, right down to the size

of the slabs. The Great Hall set was built out of local Irish stone, similar to what was found in Orkney.

Does building structures that Jarin can easily move in and out of—particularly with lighting rigs, camera dollies, and cranes—change the way that you built the sets?

It created a few extra steps. The first thing was to decide what we wanted it to look like. Then Jarin and Rob decided what they want the camera to do. For instance, we wanted to have a long crane shot that goes all the way through the fifty-some-odd feet of the longhouse at Fjölnir's farm. [However,] the arm of

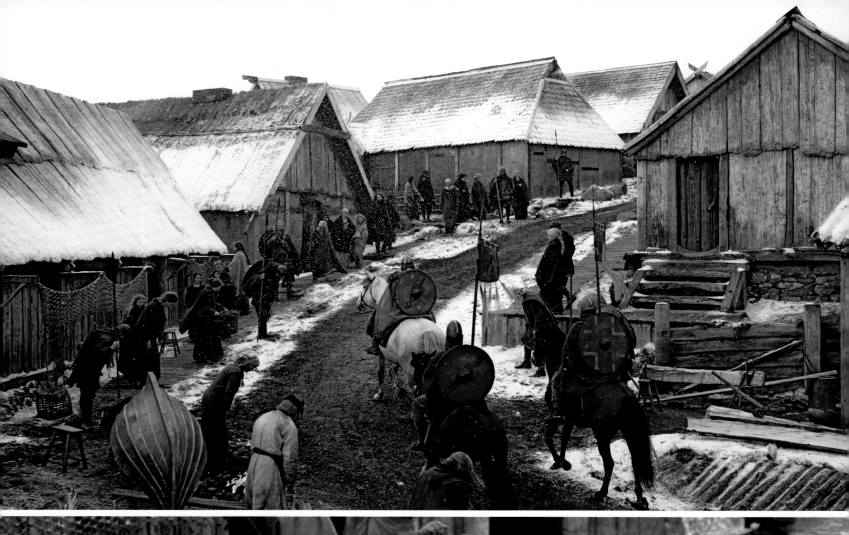
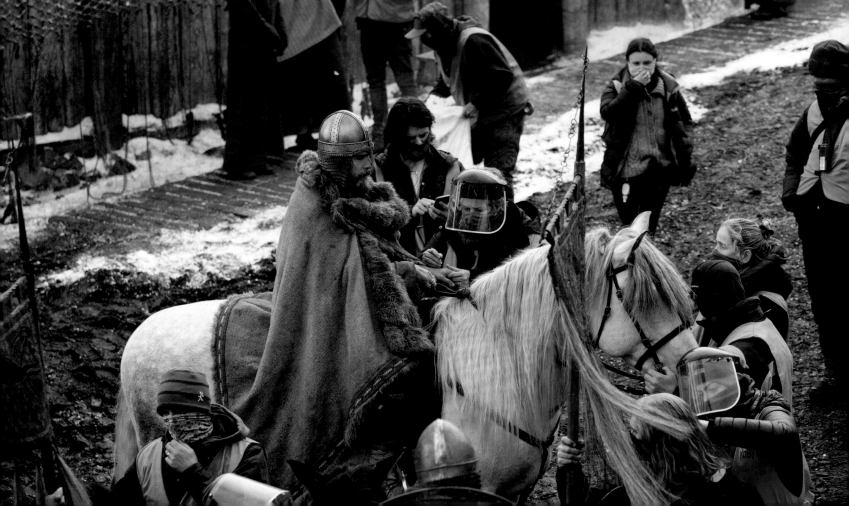

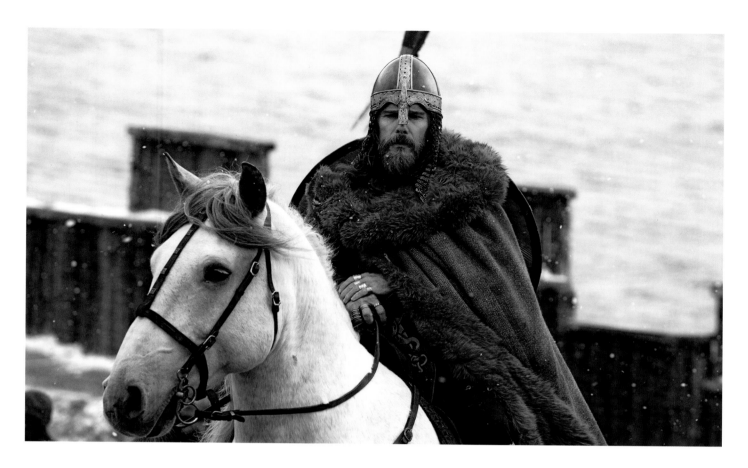

the crane would hit the first doorway before it would let the camera get all the way down the hall, so we designed the set so that those obstructing elements would fly up and out of the way as the camera passed by. There were many times where we wanted to get the camera to do something that the equipment or the set wouldn't allow unless we compensated for it. So that's what we did.

One set that immediately stands out is the Mount Hekla battle scene, which was filmed at Hightown Quarry in Northern Ireland.

We scouted the real Mount Hekla in Iceland. We flew around it in a helicopter, and it's beautiful and I feel lucky to have seen it in person. Our set was built by moving a lot of sand and rocks around with very big trucks. And the little kid in me just kept saying, *How cool is this?* It was like sculpting with a bulldozer.

You also had to make sure that the volcanic sand matched that of Mount Hekla's, and ten different kinds of black sand were hauled in?

I was looking for the right color; it had to be that Hekla black sand color. And we did find it. We also brought

in black rubber sand for some of the stunt work. We [also] had some special sand made, so we had to make sure that the color was right as well. Turns out there's not a lot of volcanic sand in Ireland! It's funny, because when we went back to Iceland after the primary shoot, everywhere I looked in Iceland [I noticed] black sand. "This is what we wanted. Oh, look, [there's some more as] we're walking down a path. That's what we wanted, too." Still, we found it [in the end], and hopefully you liked the results.

What were some of the logistical challenges that you faced while working on the film?

The logistics for some of [the sets] were really tricky. The Norse gods' idols that we talked about earlier are nine-foot-tall idols that we carved out of wood. We had them carved in India and sent to Ireland, so there was a lot of back-and-forth to get them right. We designed 3D computer models at the art department in Belfast [that we] printed out on nine-and-a-half-foot prints from all angles and then sent [them] to India [to make]. As they were being carved, I would get photos of the progress every couple of days and send them notes. So, when it looked like we might shut down because of COVID, I was worried about

ABOVE King Aurvandil returns home from battle. **OPPOSITE TOP** King Aurvandil's (Ethan Hawke) men return to the fictitious Scottish kingdom of Hrafnsey. **OPPOSITE BOTTOM** The crew observes COVID-related safety protocol while helping Ethan Hawke prepare for the processional homecoming scene.

BELOW King Aurvandil's march home. Storyboards by Adam Pescott. **OPPOSITE** The outer gates of King Aurvandil's Hrafnsey kingdom set as seen from the inside.

the carvers in India. Thankfully, they were almost finished, so they put a few extra people on the job and finished before they had to lock down. But even then, we weren't able to put the idols on a ship. The shipping channels from India to Ireland became unreliable due to the pandemic, so even though they were finished, we still weren't sure if they were going to make it over. In the end, we put the last two sculptures on a plane to Belfast, and the idols were warehoused until we could get back to work a couple of months later. The work that we had done in India was beautiful, including a fifty-foot-tall tapestry [of Yggdrasil, the Norse world tree] that depicted the *Völsunga Saga*. We had two sets of that tapestry made (four in all), one for either side of the longhouse in Hrafnsey, and a second set that was distressed and torn to fit in the longhouse at Fjölnir's farm. The rest had its own level of difficulty, but we had a little bit more control because I had everyone I needed—sculptors, plasterers, carpenters, painters, prop makers, and prop painters—all in Belfast, so we were able to do whatever we needed to. It's always a little bit harder when you have to plan from afar. Those were the things that kept me up at night.

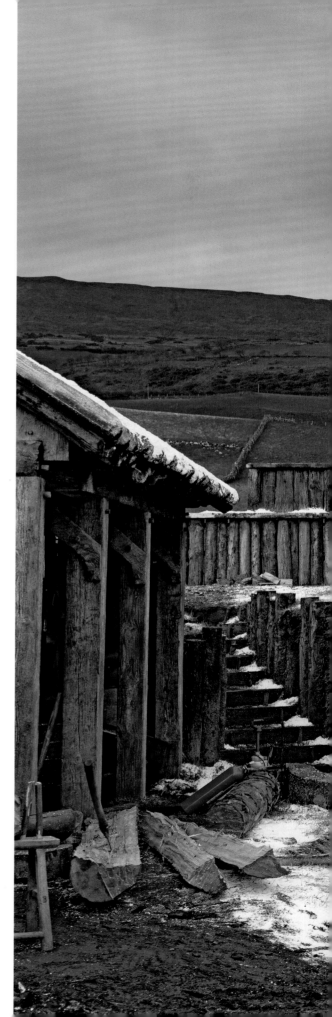

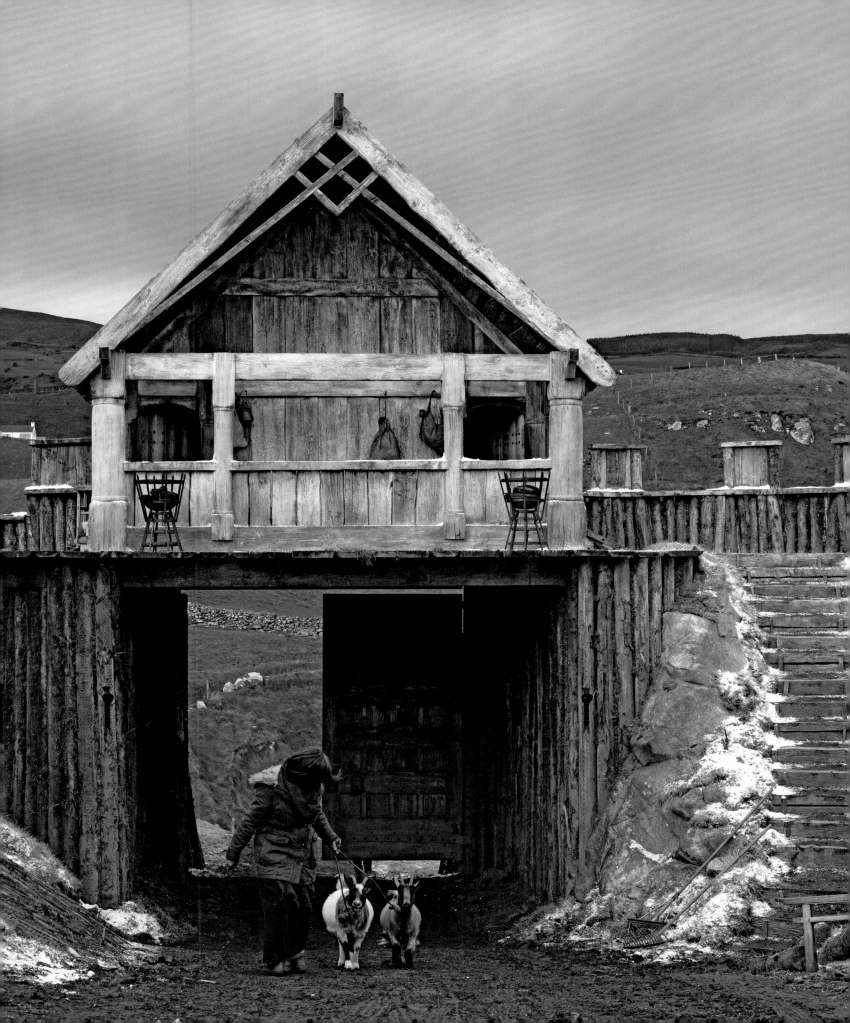

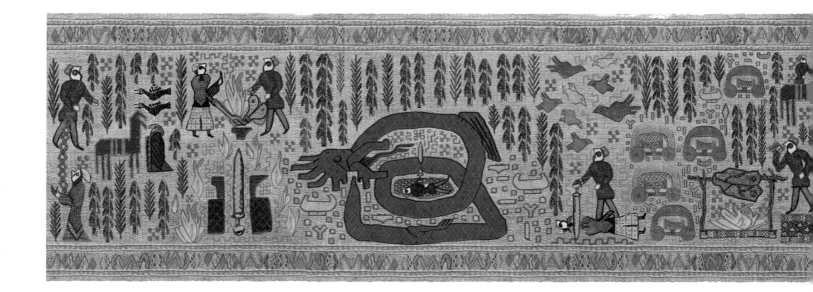

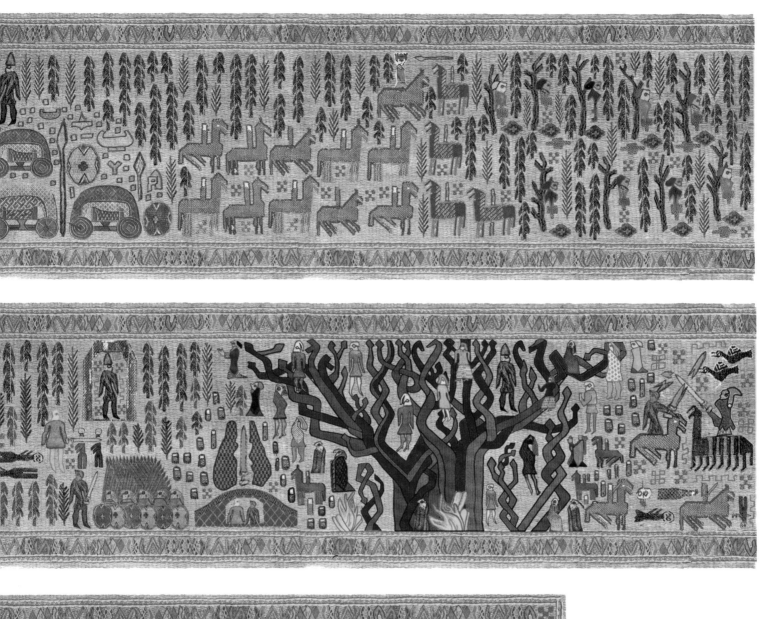

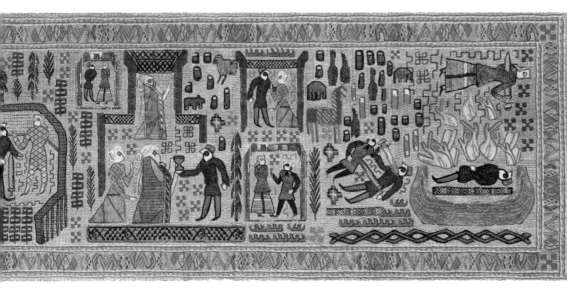

ABOVE An elaborate fifty-foot-tall tapestry depicts scenes from the *Völsunga Saga*. Concept illustration by Michael Eaton.

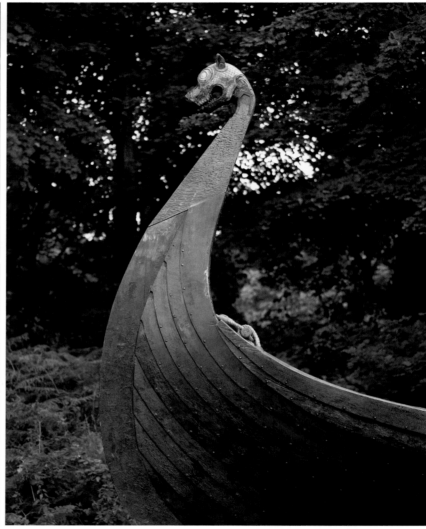

TOP LEFT, TOP RIGHT, AND RIGHT Two authentic Viking ships were designed by production designer Craig Lathrop and his team and constructed by Czech shipwright Radim Zapletal. **ABOVE LEFT** Olga and Amleth aboard Captain Volodymyr's knörr. Storyboards by Adam Pescott. **OPPOSITE TOP** The constructed ships were transported across Europe from Prague and then placed on a cargo ship to Northern Ireland. **OPPOSITE BOTTOM** Alexander Skarsgård prepares to shoot a pivotal scene aboard Captain Volodymyr's knörr.

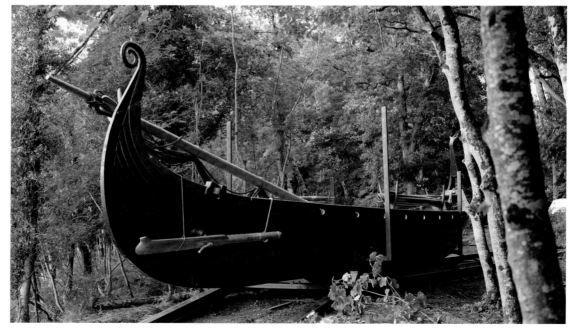

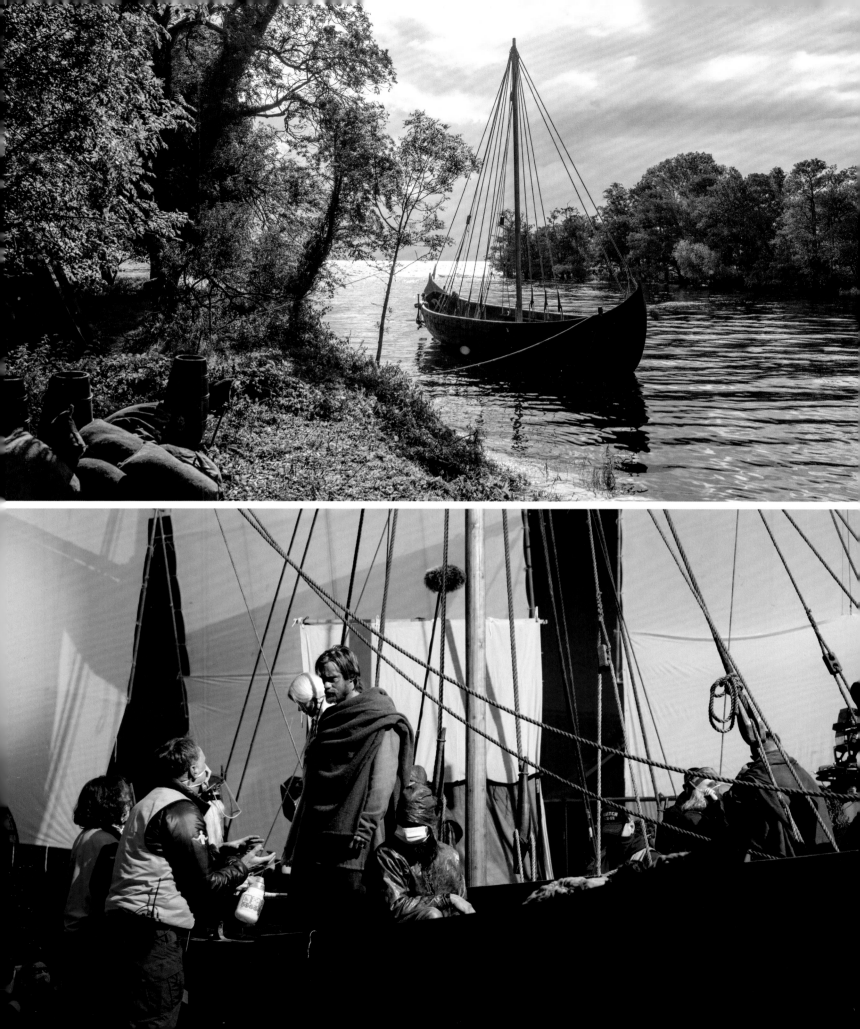

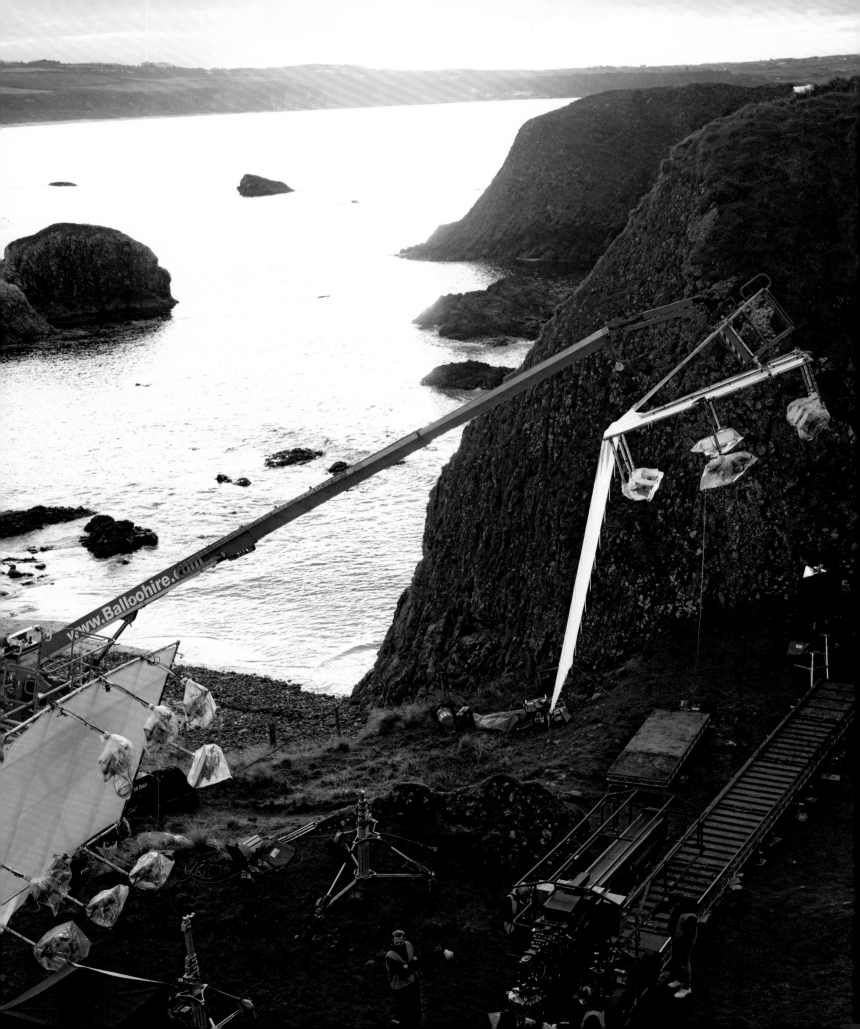

LOCATION MANAGER
NAOMI LISTON

Scottish-born and Ireland-based location manager Naomi Liston has mostly worked in the UK for the last seventeen years. Liston recently won the Production Guild of Great Britain's 2021 Makers & Shakers Award for Outstanding Creative Use of a Location on *The Northman*. Liston had initially worked with producer Mark Huffam on *Your Highness*, and they went on to collaborate on a couple of other projects, including *Game of Thrones*. When Huffam phoned location manager Naomi Liston to find some locations for *The Northman*, given her authoritative familiarity with *Game of Thrones'* UK locations, she recalls, "You always take Mark Huffam's call. He's that kind of a producer." Liston's familiarity with the country made it easy for her to find a variety of visually and topographically distinct areas that could double for Scotland, the Slav village, and Iceland. In addition, all of the shooting locations have their own character and are rich with their own history that can be traced back to real Viking settlers.

How did the production's move from Iceland to Northern Ireland impact your team?

What normally happens at the start of production is we'll want to shoot the whole world [of the movie] and we'll keep looking until we can no longer afford to. The production schedule, as well as the actors' availability, will also often help determine what can and can't be done. For *The Northman*, we were initially approached to shoot a few scenes that were meant to be shot in Iceland. But once the pandemic hit, they soon realized that they were not going to do much of their main shoot in Iceland. Then the conversation with Mark Huffam and New Regency became, "Naomi? You and I need to find Iceland in Northern Ireland," which was tough for me on two levels. First, I had to manage the filmmakers' disappointment, particularly Robert, Jarin, and Craig's. It was a real tall task for me to try to fulfill *The Northman's* creative and visual demands, and at the level that this movie demanded. Thankfully, I had already found them a number of Northern Irish locations that could double for Scotland, the Slav village, and bits of Iceland, too. Still, some major locations had come our way because

of the pandemic shift, like the Mount Hekla [scene] and the Knattleikr game [scene], the latter of which was originally meant to be on an ice lake or a glacier. That was really tough.

A movie's location really informs the character of any given scene. Let's start by talking about Hrafnsey, which is King Aurvandil's kingdom, and which was filmed in Torr Head.

Correct. Torr Head doubles for Hrafnsey, which in the script would be Scotland. Torr Head was one of the first locations that I showed them during our initial scout. We took a winding, single-track road down to Torr Head, a fantastic peninsula that looks out into the North Sea, where you can see Scotland in the distance. Robert and Craig started running around, and as soon as a director and a production designer start imagining how they can make a location work, then you know that they've fallen in love with the spot. Still, Torr Head was by no means the easiest location to film at. We built on a hill, and the only access road was this tiny, little, potholed, single-track road. I had to build a provision access road that came around the

side of the peninsula and up the hill, which merged with and became the main road that took you through the village itself. We also built the slaves' hut at the back of Torr Head, a secondary peninsula that sort of drops down and then rises up again. So, we had to figure out how to bring in construction materials. We ended up building this superstructure of a ramp, and [we] had to make the steps of the ramp to the exact measurements of what a horse could walk down, because we had to get horses down there as well. That was pretty incredible.

You also had to earn the trust of Torr Head's inhabitants to build in their backyards. What kind of negotiating did that take?

My first step was to find out who owned the land. Turns out there are four different landowners, most of whom lived on Torr Road. I literally had to knock on one of their doors and introduce myself to be invited in. The landowner was an elderly lady whose husband used to be the main farmer there. He'd passed away, so her sons ran the farm, though she's still very much the matriarchal figure. I had to sit them down at the table and say, "You don't know me from Adam, but this is who I am, this is what I'm doing, and would

you be interested in us building a Viking village on your ground?" [I would tell them] we'd shot *Game of Thrones* at Fair Head and Murlough Bay (which are the next peninsulas along the coast). These are very tight-knit communities. They all know one another, and half of them are intermarried to each other. One of the residents of Torr Head had [built] some fencing for me at Murlough Bay, so I was able to say [to them], "People *do* know me. Please phone Pat McCarey or Sean McBride, if you need to. They know me very well. We don't rape and pillage the land; we put everything back as we found it. But ultimately, I'm telling you that we're going to be here for this many months, and there is going to be a Viking village on your bit of ground." It was a fantastic experience for them, and they loved every minute of it.

The Knattleikr game scene sounds like it was pretty demanding and was filmed at Eagles Rock in the Mourne Mountains, where there was a three-mile road leading up to the shooting location. What was it like to set up for it?

That was really difficult. Jarin and I went ahead and scouted. I chose an area that was a lot closer to our unit base and was therefore easier to service, but Jarin kept

walking. And he kept walking . . . and walking. [Finally, I said,] "Jarin, stop walking. Just stop walking."

"No, no, honestly; let's keep going," [he urged]. And [then] he found a spot.

"For fuck's sake, Jarin," [I replied.]

"But it's perfect!" [Jarin exclaimed.]

Jarin had found this absolutely flat bowl with a full 360-degree view of the mountains, so we had to let go of our initial idea of the Knattleikr [game scene] being like an ice hockey game, as we were never going to physically be able to create a fake ice rink. We were getting to the stage of production where we would have been doing a disservice to the movie if we didn't push ourselves and make this location work. Jarin and I presented [Robert and Craig] the location and made it work.

You also had to deal with a lot of rain and bad weather at some of your shooting locations, particularly fog at Gleniff Horseshoe, which doubles for the hidden valley where Olga and Amleth go after he's carried off by the Valkyrja.

Oh god, Gleniff Horseshoe was a hard-won location, and of course, they instantly fell in love with it, which was great for every reason. Our Gleniff Horseshoe location was owned by four different brothers and

cousins. They're older gentlemen who had all fallen out over the years for whatever reasons, but getting them to let us shoot at Gleniff Horseshoe sort of brought them back together. Originally, only half of them wanted to do it and the remaining ones didn't, so there was a lot of back-and-forth. Lots of last-minute decisions had to be made, but then they were our best friends when it came time to shoot. I thought, *You bastards, what you put me through getting to this stage! Lovely. Thanks.*

The Knock Dhu set, which is the main location for all the scenes at Fjölnir's farm, was one of the first locations ready to begin shooting before the lockdown.

Yeah! Knock Dhu was going to be our first shooting location. We were a couple of days away from shooting there, too, so everything was already set up. Knock Dhu was also the first location I showed them for Fjölnir's farm. Craig wasn't 100 percent sure about it, for whatever reason, so we went scouting, and scouting, and scouting, and ended up right back at Knock Dhu. The set ended up looking incredible, and I think it also brought something very special to the movie's character.

ABOVE A few of the elaborate lighting rigs used by the crew. **OPPOSITE** Crew members prepare to shoot Amleth and Olga at Gleniff Horseshoe.

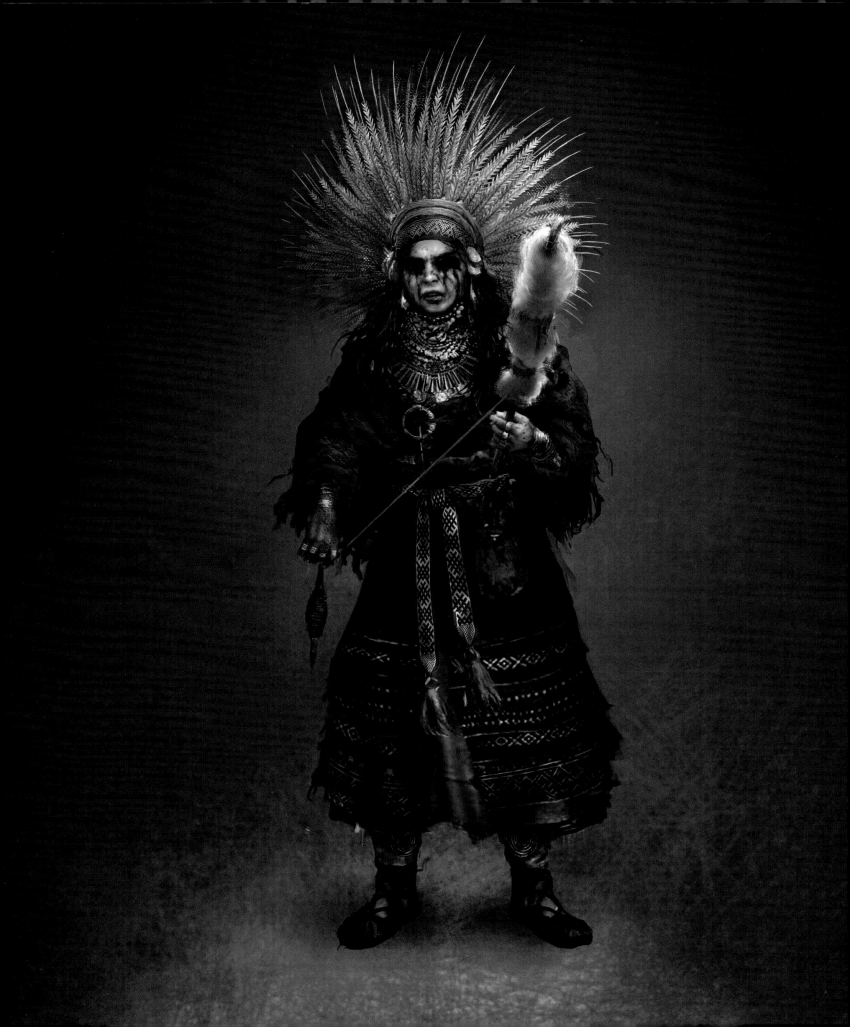

COSTUME DESIGNER
LINDA MUIR

Linda Muir had previously worked with Eggers as a member of his team on both *The Witch* and *The Lighthouse*, but *The Northman* posed many unique costume challenges, especially given the production's size. Muir created eighty original costume sketches, from which 918 hand-sewn items unique to the historical setting were fabricated. She took inspiration from various Viking Age items uncovered at many archaeological finds, including the Oseberg Tapestry, Thorsberg trousers, Haithabu apron-dress, and Viborg shirt, which were vital garment discoveries. But the designs and material of the movie's wardrobe often dictated their own terms, so Muir and her team—including costume supervisor Louise Cassettari and costume cutter Frances Sweeney, and maker/consultant Nille Glæsel—had to address various creative challenges as they considered how to reflect the movie's characters through clothing. "Costumes must look appropriate and engage the audience," says Muir. "But in order to make a story point, at times they must also do heavy lifting. We try to foresee issues, but there are always complete, ugly surprises. Chain mail and hair, I've learned, are bitter enemies." Muir shares her inspiration behind her strategic choices in creating wardrobes for the characters.

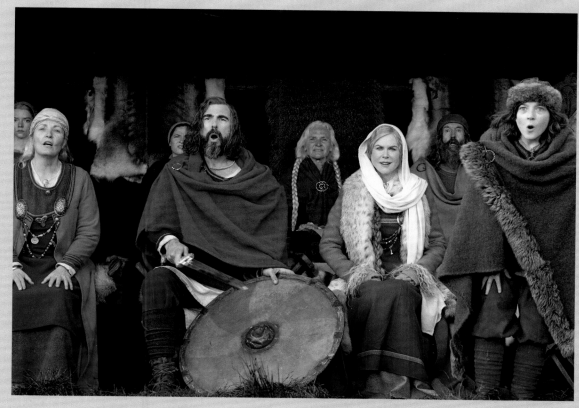

LEFT (from left to right) Fjölnir (Claes Bang), Queen Gudrún (Nicole Kidman), and their son Gunnar (Elliott Rose) cheer on the sidelines of the Knattleikr match. **OPPOSITE** The Seeress. Concept illustration by Ryan Hong.

YOUNG AMLETH

Linda: In the film, the first shot that we see of a person features Amleth on the rampart. Here, we see an intricately woven dragon band across the chest of his madder tunic. The neckline and wrists of his tunic are finished with a delicate band depicting intertwined serpents. His cloak hem is embellished with a wide band that is hand-embroidered with shields and spearheads in silver metallic threads and silk threads of red, blue, and mustard. Additionally, young Amleth has blue woven garters held by gold buckles at the knee, silver brooches, pins, and clasps. Merely wearing all of these items and colors indicates that this boy is from a very wealthy family, and the motifs—such as the shields, spears, and dragons—suggest a desire for strength, his protection in war, and success on his path of learning.

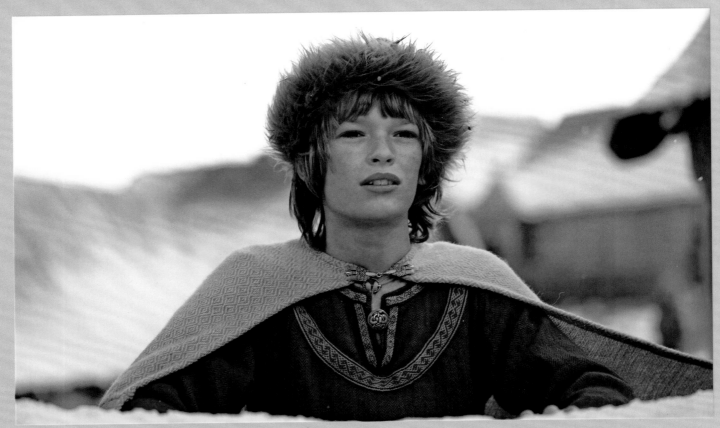

"WEARING ALL OF THESE ITEMS AND THE MOTIFS—SHIELDS, SPEARS, AND DRAGONS—SUGGEST A DESIRE FOR STRENGTH, HIS PROTECTION IN WAR, AND SUCCESS ON HIS PATH OF LEARNING."

—LINDA MUIR

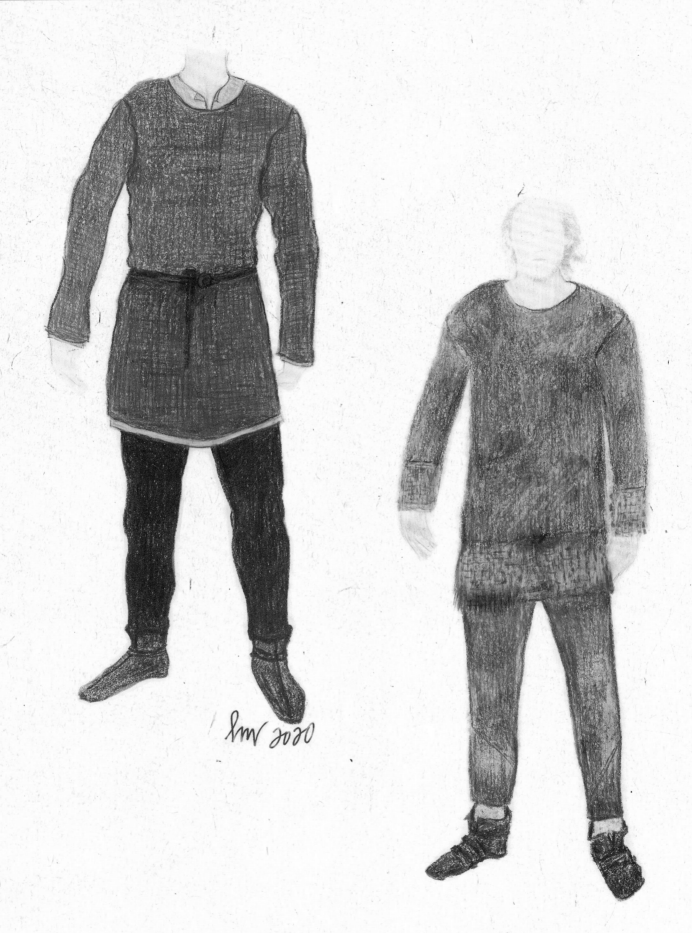

AMLETH

Linda: As a Viking Berserker in Land of the Rus, Amleth figures out that Fjölnir and Queen Gudrún are alive; he has to disguise himself and change his clothing very quickly, so he drags the body of a dead Slav into the bushes and assumes the Slav's identity by stripping off his shirt, cutting his own hair, and branding himself. I said to Robert, "I think I should design the bottom half of Amleth's costume—his Eastern-influenced trousers, leg wraps, and boots—so that it can carry him from his time as a Viking Berserker through the change into his Slav [slave] look, [yet] still have his overall look be believable and continue on through the journey to his arrival at Fjölnir's Icelandic farm." Once at Fjölnir's farm, Amleth's costuming changes yet again, and we see clothing that could be typical of slaves: coarse fibers; no embellishment other than layers and layers of mending marks; minimal coverage, but enough to keep the slaves healthy; and often no shoes. For many of our slaves, we created "bare foot" shoes by cutting away as much material as possible from toed shoes, painting them with "mud," and then using leather straps to further obscure the shoe [and] to help keep them on. In a few critical scenes where the soles of the bare foot shoes read, Anya stoically chose to go barefoot in the extreme cold. But since Amleth has ongoing stunts, slippery thatched rooftops, and harsh terrains to navigate, he remained in his Berserker boots throughout the film. I designed a version with additional wide leather straps to indicate that while he was a slave, he was also trying to keep his own boots viable for as long as possible.

After Amleth saves Gunnar, he's granted special privileges, so his clothing becomes slightly better. We see clothing more indicative of a typical lower-class Viking man [with] simple-cut tunics in natural linen, hemp, nettle, or wool with no tablet-woven trim. Olga steals clothing for Amleth when she escapes the farm, and for these I brought back little hints of [his] Hrafnsey [childhood]. I used King Aurvandil's grand diamond twill-patterned wool for Amleth's cloak, but I chose to dye it a beautiful blue, [which is used in] Young Amleth's hat in the opening scene.

RIGHT Amleth (Alexander Skarsgård) holds his sword Draugr in one hand and the heart of his stepbrother Thórir the Proud in the other. **OPPOSITE** Coarse fibers and few visible embellishments define Amleth's clothing once he becomes a slave on Fjölnir's farm. Concept illustration by Linda Muir.

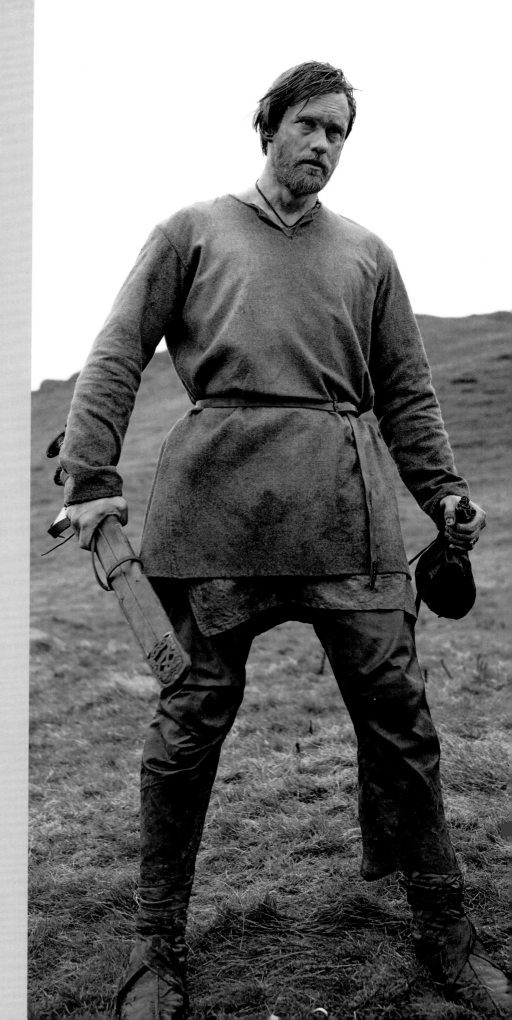

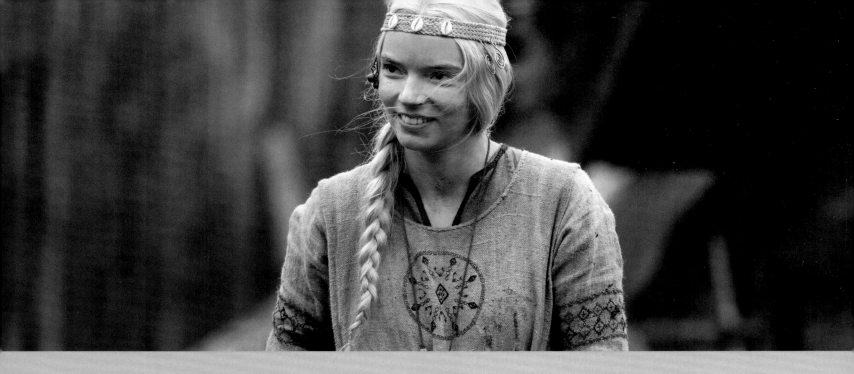

OLGA OF THE BIRCH FOREST

ABOVE Anya Taylor-Joy between takes during the village raid scene.
OPPOSITE Olga's costume tells her character's story, particularly her headband's cowrie shells (to encourage fertility) and coral beads to indicate her relatively high status within her Slav community. Concept illustration by Linda Muir.

Linda: Slavic women wore a headband with metal temporal rings (imagine massive pieces of jewelry, like an earring) suspended from the headband, one on either side of their head and hanging from the temple in front of the ear. We made spiral-shaped temporal rings in a few sizes with which to dress all the Slav village women. Often, cowrie shells were sewn to the headband between the temporal rings to encourage fertility, and coral beads reflected high status for the Slavs. I learned that the Slavic word for *embroidery* was, in the past, apparently the same as their word for *writing*, so these women "wrote" their hopes for the futures of their family and themselves, [such as] plentiful crops, many children, and health [using] embroidered motifs—straight lines, circles, wavy lines, *alatyrs*, and all sorts of patterns that repeated in lines around a garment's neckline, wrists, hems, and laps. Sacred codes with power [were] embroidered on the chest and on the upper arm to keep evil out, and black wool [was used] to guard against infertility. Crosses [were believed] to split or eliminate negative energy; their trinity was the mother, father, and child. Really, what [the Slavs] were doing was similar to the Vikings and their tablet weaving, but with even more passion. [Their embroidery served as] a sort of "call to the gods"—though very different gods than those of the Vikings—[and represented petitions such as] "I want this for my husband; I want this for my son or daughter."

> "[THEIR EMBROIDERY SERVED AS] A SORT OF, 'CALL TO THE GODS,'—THOUGH VERY DIFFERENT GODS THAN THOSE OF THE VIKINGS—[AND REPRESENTED PETITIONS SUCH AS] 'I WANT THIS FOR MY HUSBAND; I WANT THIS FOR MY SON OR DAUGHTER.'"

—LINDA MUIR

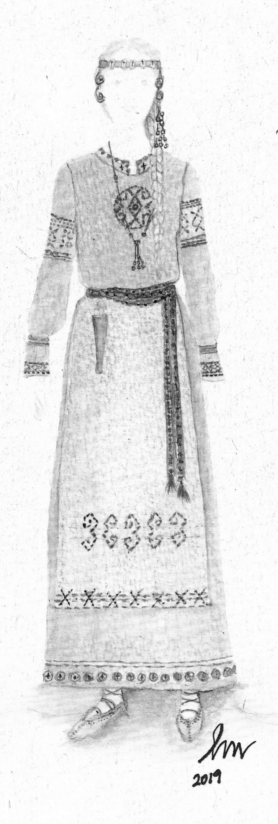

2019

· SEE BELTS

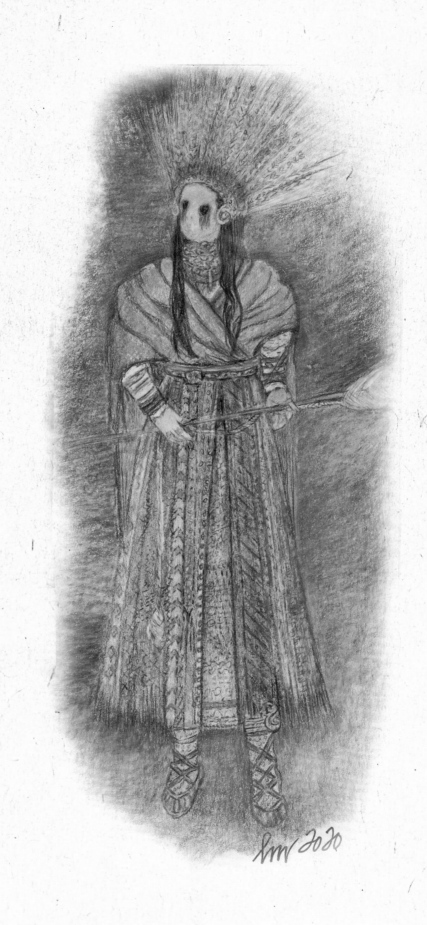

SEERESS

Linda: If the Slav women essentially "wrote" about health, fertility, and prosperity for their families' futures, then a seeress would be the über-writer responsible for her village, so her shift and skirt, or *poneva*, had to be completely covered with embroidery. The Seeress appears at night in her temple, which was destroyed in the raid, and she is lit only by moonlight from above, through the ruined roof. Jarin creates beautiful moonlight using filters that sort of replicate what our eyes see at night. As I understand it, our rods and cones don't see color at night, so Jarin attempts to drain everything of color during night scenes meant to be moonlit. The challenge, then, was to design costuming for the Seeress that reflected her Slav community. [We first see the Slavs] during the daytime raid, [and] they are dressed in undyed linen with red embroidery. But the nighttime lighting for the film affects the color red. And most of the reds were appearing on film as black, devoid of the meticulous detail. After much thought, some discussions with Jarin, and tests using a black-and-white setting on my cell phone, I [decided to use] shades of pink and gray that allowed the embroidery motifs to still read. So, my costume sketch for the Seeress is in pinks, which on the page really does not have the same punch, power, or cache as red. But in the end, it works, and Björk is, and looks, phenomenal. We see embroidery, a barley headdress, huge temporal rings, multiple necklaces, and cowrie shells and bells hanging in front of her empty eye sockets, [and they] tell the story.

RIGHT The Seeress (Björk) reminds Amleth of his obligation to avenge his father, King Aurvandil.
OPPOSITE The costume of the Seeress is covered in embroidery to reflect her status as an "uber-writer" among the Slavs. Concept illustration by Linda Muir.

HE-WITCH

Linda: I'd gleaned from information in one of Neil Price's books and from a description of a *völva* [a Viking seeress] in one of the sagas that there was perhaps gender fluidity in dressing that would be appropriate for the He-Witch. The choice of garments available from the closets of men and women in the Viking Age was very limited—a shirt, a shift, a dress, a pair of trousers, a tunic—so I tried to think about how to convey the image of a man dressed in women's clothing at that time. I arrived at the notion of using a garment that is both distinctly female *and* Viking, the apron dress. Women would wear an apron dress on top of a linen shift, or on top of both a linen shift and a wool dress. The apron dress was suspended from shoulder straps, secured onto very large metal brooches called tortoise brooches, or boss brooches, because of their domed shapes. These brooches are, as far as I'm aware, only seen on women in the Viking

Age. I thought that it would be very feminine for our He-Witch to wear an apron dress, but highly individual for him to wear his on its own, without the requisite long linen shift beneath, to reveal his masculine body. His uncovered arms and legs that poke out from underneath and the brooches would read as feminine, because up [to] this point in the film they have been seen only on women. He also wears a brown faux–Arctic fox hat lined with chamois that features the Helm of Awe symbol at center front, which is branded onto white birch bark. Birch is a sacred tree for both the Vikings and the Slavs, and I brought the piece we used as an offering from a magical forest I love in Ontario, Canada. His deep-blue cloak has thirteen different stones set in copper plates engraved with runes along its edges. He wears serpent arm rings, is barefoot with toe rings, and his belt holds objects needed for his magic.

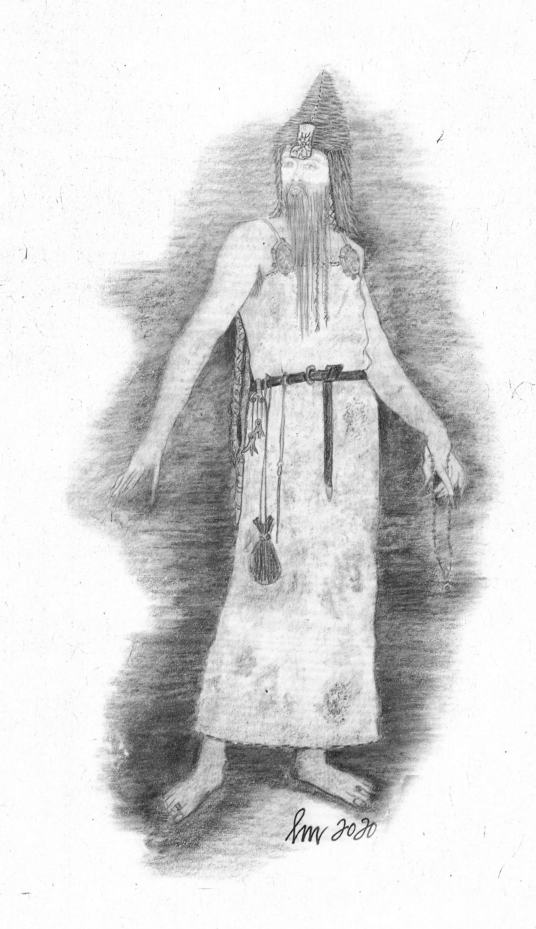

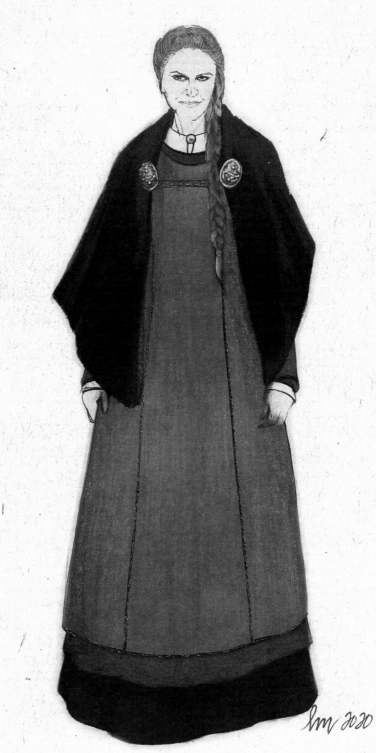

QUEEN GUDRÚN

Linda: Color and texture are important when trying to distinguish one character from another and to indicate their position within Viking society, and during the Viking Age it would have taken a good deal of time to create both these elements. Weaving a pattern into wool fabric, such as diamond or broken-diamond twill, would make the textile worth much more than plain-woven wool. Most free people wore plain-woven wool in dull or muted colors, or they utilized the natural color of the sheep. It was extremely hard to achieve rich, deep colors because a large amount of dye was required, which was expensive. Therefore, garments in reds, blues, marigold, or greens were reserved for high-status individuals. The Vikings used madder root for reds, and if you wore a voluminous red cloak of finely patterned wool, trimmed with lynx fur [with] a red wool-patterned dress with a generous train; a ginger-colored wool apron dress with multiple trims; a marigold-colored fore cloth on top suspended from heavy golden boss oval brooches [with] glass beads and totems; and were laden with fine gold and silver jewelry, you'd look and feel like a queen. Whereas the Hrafnsey costume designs for Queen Gudrún illustrate "a prize," or a "queen," her Freysdalur designs reflect the clothing of a happy, confident, and high-status wife. Her finery for the Knattleikr outing uses the same lynx trim brought from Hrafnsey and sewn onto her coat, which incorporates an extravagant amount of demurely colored wool. But, the lynx fur piece has been shortened and combined with cuffs of rare cream-colored tog.

BELOW Queen Gudrún (Nicole Kidman) rules with an iron fist and advises Fjölnir (Claes Bang) to show no mercy to their slaves.
OPPOSITE The clothing used in Queen Gudrún's Fresydalur outfits indicate her relatively high status. Concept illustration by Linda Muir.

"WHEREAS THE HRAFNSEY COSTUME DESIGNS FOR QUEEN GUDRÚN ILLUSTRATE 'A PRIZE,' OR, A 'QUEEN,' HER FREYSDALUR DESIGNS REFLECT THE CLOTHING OF A HAPPY, CONFIDENT, AND HIGH-STATUS WIFE."

—LINDA MUIR

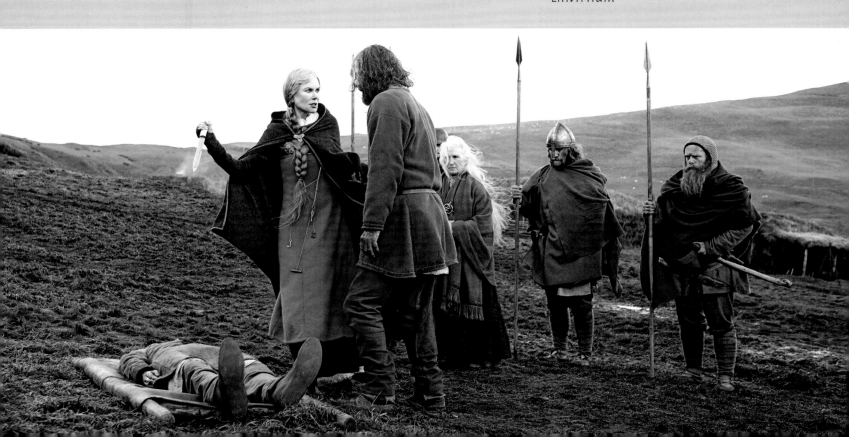

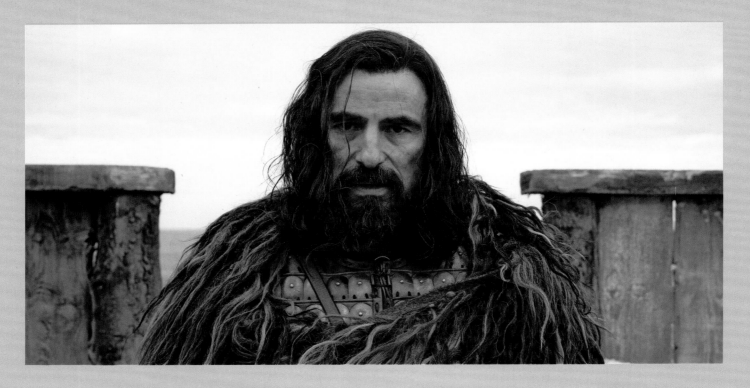

FJÖLNIR THE BROTHERLESS

ABOVE Claes Bang catches his breath before shooting the murder of his character's brother, King Aurvandil. **OPPOSITE** Fjölnir wears an elaborate woolen cloak. Concept illustration by Linda Muir.

Linda: Fjölnir is King Aurvandil's poorer half-brother, and while he has retainers, he and his men have visibly less than Aurvandil and his men. Not only are [Fjölnir's men] positioned further down the line of men in the homecoming march [scene] returning to Hrafnsey, but they are also not wearing the same amount of [chain] mail. King Aurvandil and his retinue wear high-status colors, but compared to Aurvandil, Fjölnir wears subdued dark colors. The only concession to his standing is his blue cloak, and he wears little jewelry. In considering the outfit that Fjölnir wears for King Aurvandil's assassination—when he and his men ride in wearing strange, scary, wool-felt masks and dark cloaks so that their identities are obscured—we thought that Fjölnir might wear lamellar armor and a

helmet with a drape that he could have taken off somebody in a raid sometime in the past. I think that one of the most beautiful costumes in the entire film is in this scene [with] Fjölnir's shaggy cloak, which is called a *varafeldr*. It is a truly unique Viking piece. *Varafeldrs* were made from a combination of two lengths of Icelandic sheep's wool. Our cloak was woven on a vertical loom, and every six inches or so down its length, long tufts of tog were woven or tied into the textile. If you really wanted to stay warm and dry on board a ship, you'd get yourself a *varafeldr*, because water shakes right off of it, unlike animal hides. It's both a massive cloak and a blanket, and in the Viking Age it was sold or traded outside of Scandinavia as a commodity.

> "I THINK THAT ONE OF THE MOST BEAUTIFUL COSTUMES IN THE ENTIRE FILM IS FJÖLNIR'S SHAGGY CLOAK, WHICH IS CALLED A *VARAFELDR*. IT IS A TRULY UNIQUE VIKING PIECE."
>
> —LINDA MUIR

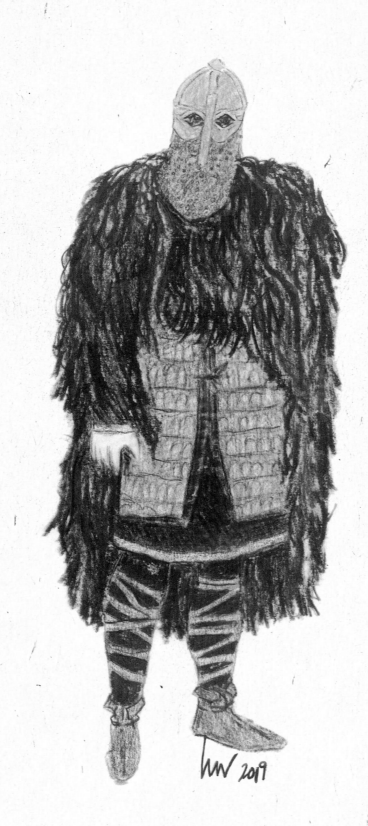

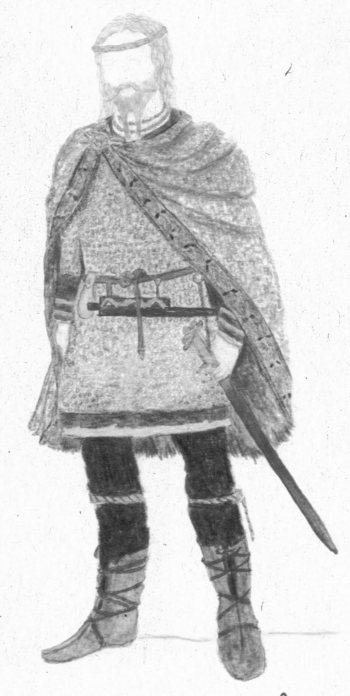

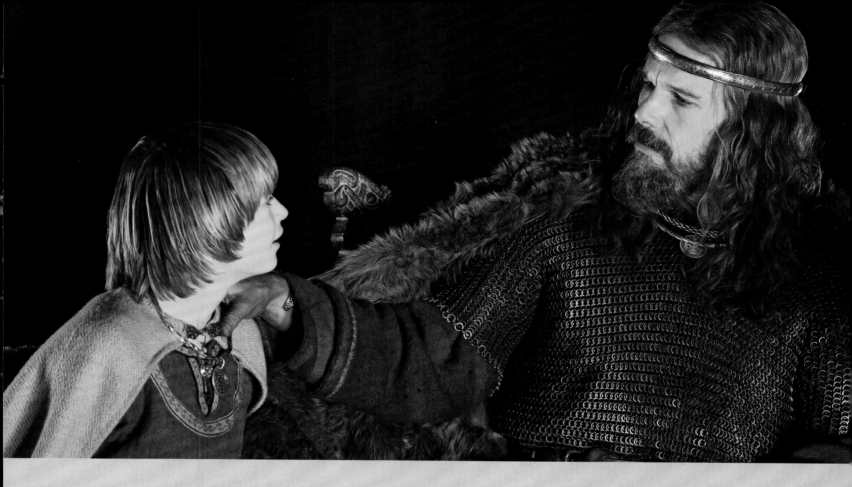

KING AURVANDIL WAR-RAVEN

Linda: There weren't "kings" at this time. [Instead,] there were jarls, who didn't have the same vast amount of territory that we tend to think of [today] in terms of kingdoms. There also weren't "crowns," per se, at this time. Men had precious metal in the form of coiled threads that were integrated into tablet-woven bands and worn as headbands. So, King Aurvandil wouldn't have had a crown; he would have had a tablet-woven headband with gold in it. But when Robert and I talked about this, he said, "I really think that it's important that King Aurvandil have a gold headband, which the audience will perceive as a crown." I agreed. I wanted it to look like stamped metal from items from the Sutton Hoo archeological find, and I eventually found a photograph of a drinking horn from the period. We inverted the image and used it as inspiration for the jeweler who made King Aurvandil's coronet.

As with Queen Gudrún's outfits, excess says it all for King Aurvandil, especially an excess of thick, warm, pat-terned, wool lined in fur. He wears a durable linen shirt under a madder-red tunic trimmed with gold-infused tablet-woven trim. On top there is [chain] mail edged in gold and a massive cloak of undyed, gray, handwoven diamond twill. The cloak features a wide band along its edges of gold and silk thread hand embroidery. This piece is based on the King Canute [archaeological] find and is lined with dozens of red pine marten. King Aur-vandil is accessorized with penannular pins, [with] one showing a large carved raven; gold brooches; a helmet with a gold brow and drape edged in gold; huge arm-bands; multiple gold necklaces and bracelets; and gold rings on virtually every finger. Yet, this king is a working Viking who rides and raids with his men, so he wears thick, serviceable wool trousers with tablet-woven gar-ters, held with gold clasps, and leather boots with spurs. From the waist up, he's all gold, jewelry, and an excess of fabric, fur, and color—but he's still a guy that goes out and does part of the work himself, too.

ABOVE King Aurvandil (Ethan Hawke) advises Young Amleth (Oscar Novak). **OPPOSITE** The design of King Aurvandil's cloak was based on items from the King Canute archeological find. Concept illustration by Linda Muir.

HEIMIR THE FOOL

Linda: I had previously worked with Willem on *The Lighthouse*, so I knew that he would be up for anything, and he was. Heimir is sort of the court fool, or a *þulr*. An archaeological find called the Orkney Hood greatly influenced the design of Heimir's costume. It's a funky piece of clothing that was entirely and incredibly well preserved in a bog. It's thought that it was actually made from pieces of two different garments [that were] recut and joined to make a child's hood. Again, this is an example of Viking economy. Heimir wears a wool hood lined in rough linen that sports ram's ears—a gelded ram indicated a foolish person, or an ass—and a red leather coxcomb, [which is] a medieval reference to cuckolding. I originally wanted to make the coxcomb out of fish leather (a product I had been totally unaware of until my Viking research), but it wasn't supple enough for our leather master Giampaolo Grassi to shape. Giampaolo and the armory team made all the principal characters' helmets, in addition to The Mound Dweller and the Valkyrja's. He also fashioned a large, red, leather phallus and scrota mounted on a leather cup and crotch strap. Heimir uses his overly large phallus prop to punctuate his bold statements, and he exposes his bare arse for emphasis. Therefore,

his costuming was in constant motion. Heimir is without trousers. His legs are covered with thick, thigh-high gray stockings made by a technique called *nålebinding*, which are held up by a thin leather belt and garters of tablet weaving. His nether regions are partially covered by his linen shirt—typically a man's shirt ended just around the knee. I used a re-creation of the wide band of tablet weaving seen on the Orkney Hood and repositioned it along the bottom edge of Heimir's tunic. The arms of the tunic are cut from a thick, handwoven woolen textile called "cotton" (though made from wool) in a pale woad-dyed blue, and the body is made of natural russet that is cut in a crossover Vendal style, like the tunic of The Mound Dweller. The tunic is worn open and unbelted, but Heimir's linen shirt is belted, with its length and fullness tucked up into the belt to help accommodate his movements yet cover the phallus when it was not wanted in the action. We manufactured two styles of tiny bells that were incorporated into the Slav costuming, and some of these bells hung from Heimir's hemline and on the ankle cuff. He has handmade leather boots, like all the principal characters, [which were inspired by] one of four or five styles based on Viking finds.

BELOW Heimir (Willem Dafoe) wears a hood crowned with ram's ears to indicate his foolish nature. **OPPOSITE** Heimir's thigh-high leggings were created using a technique called *nålebinding*. Concept illustration by Linda Muir.

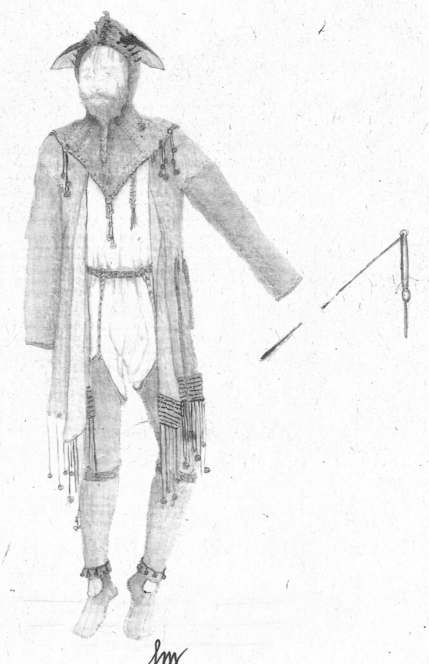

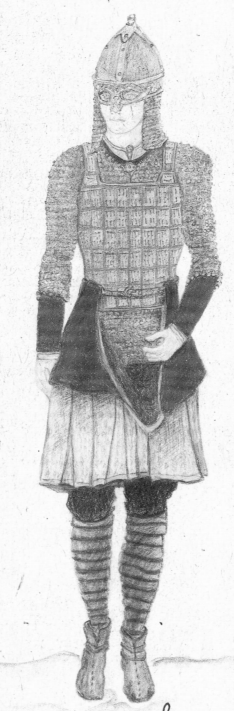

SHIELD MAIDEN

In addition to the Principles Workroom, Crowd Workroom, and Breakdown and Dyeing Workroom, the Costume Department also housed the Costume Armoury, in which Linda Muir was also responsible for the characters' helmets, lamellar, chain mail, bracers, and grieves. She worked closely on a daily basis with Costume Armour Master Giampaolo Grassi and his team to create memorable armour. In addition to the armour, Giampaolo fabricated the headdress for the Berserker Priest, fine-tuned the Berserker fur head-dresses, and made a huge array of items in leather, such as belts, tunics, caps, and all the "metal" pieces needed to show the history of Prince Amleth's dead ancestors. Linda recalls, "From the outset, Robert was adamant that the helmets had to fit properly, and it was an ongoing source of information to further develop appropriate choices for each character. We worked with an illustrator familiar with Viking Age armour who offered a selection of suitable styles and foil motifs from which to choose. The Costume Armoury created helmets in both metal and, when required for stunt work, their safer duplicates in leather, which were expertly painted to look like metal by colorist Amy Wright."

Linda: During filming, the body in [archeological site] Birka Grave BJ 581, which had long been thought to be that of a female warrior, was confirmed through DNA testing to have been a woman, a shield maiden, and this information was at long last more publicly discussed. Inspired by her existence and by iconography that exists on tapestries and metalwork, our Shield Maiden sports a mix of both Rus and Norse designs: gold-colored lamellar, chain mail with gold edging, and an elaborate helmet with a gold-edged drape.

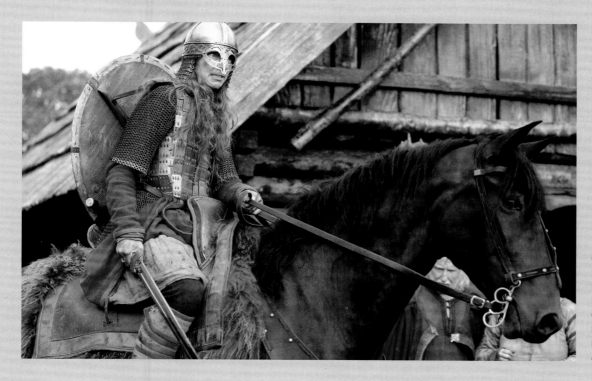

OPPOSITE The Shield Maiden's gold-colored lamellar, chain mail, and helmet are emphasized. Concept illustration by Linda Muir. **LEFT** Shield Maiden (Katie Pattinson) during the village raid.

THE VALKYRJA

BELOW Valkyrja (Ineta Sliuzaite) rides to Valhöll.
OPPOSITE The Valkyrja's armour represents the ideal warrior armour. Concept illustration by Linda Muir.

Linda: Seen against the night sky, the Valkyrja has many light-reflective costume components—a highly polished silver helmet with a gold swan motif and a gold chin strap; white "swan" feathers in three sizes (a reference to shape-shifting abilities) that line her massive red cloak; golden lamellar (made of hundreds of tiny gold-embossed plates); golden chain mail; gold jewelry; and golden bracers. She is strong and fierce, yet her armour does not have to be functional. She does not fight, but she is dressed as the ideal warrior when she carries the chosen fallen warriors to Valhöll.

[We needed] intentional duality in costuming [with] evocative beauty that [had to] repeatedly perform take after take, and the Valkyrja (both actress and stunt rider) wears such a costume. Throughout the film, the Viking cloaks in general required intricate, interior, and invisible engineering to achieve the simple look seen onscreen. Since the Valkyrja's blood-red cloak incorporated about four times the wool than any other cloak in its length and fullness, in addition to the weight of the feathers, it demanded a sturdy and infallible system to secure it through the layers of lamellar, [chain] mail, and clothing to a harness worn underneath. The cloak had to remain in place, falling elegantly from the rider's shoulders, while horse and rider galloped and jumped into the abyss.

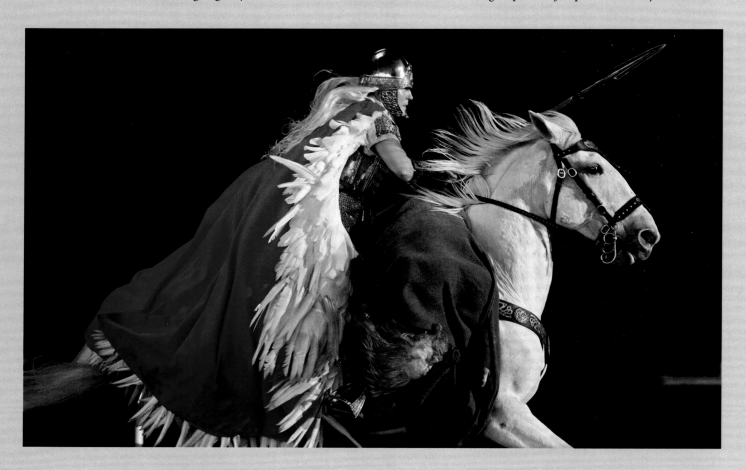

"[THE VALKYRJA] IS STRONG AND FIERCE, YET HER ARMOUR DOES NOT HAVE TO BE FUNCTIONAL."

—LINDA MUIR

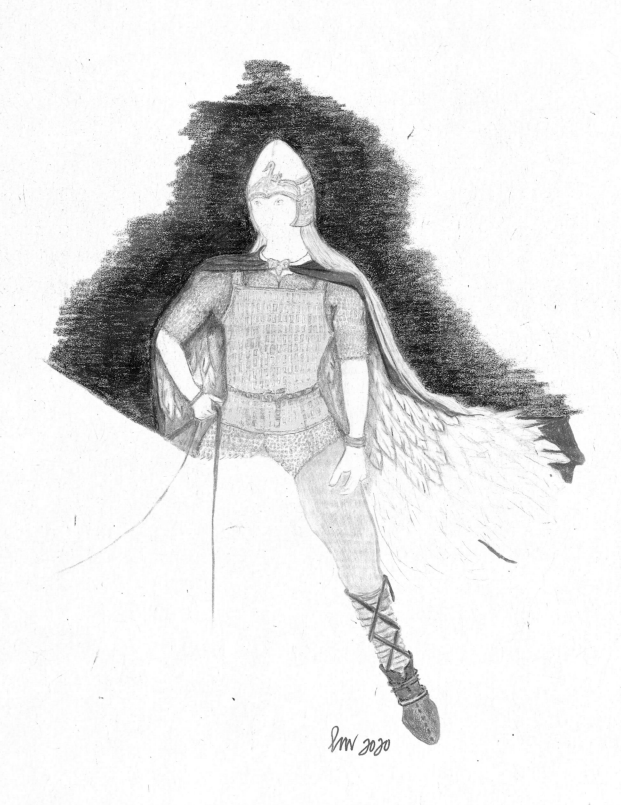

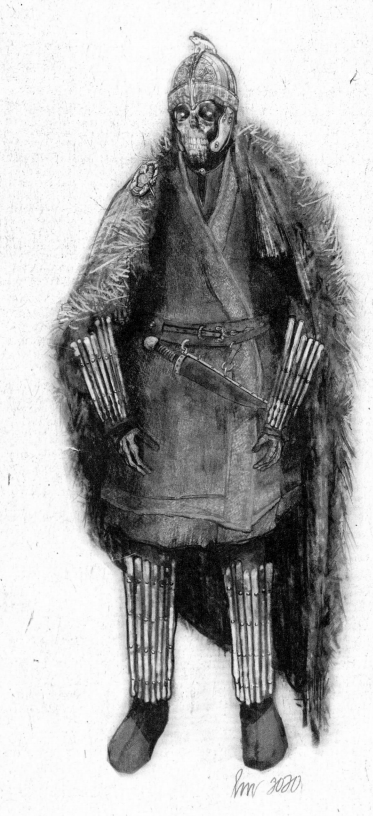

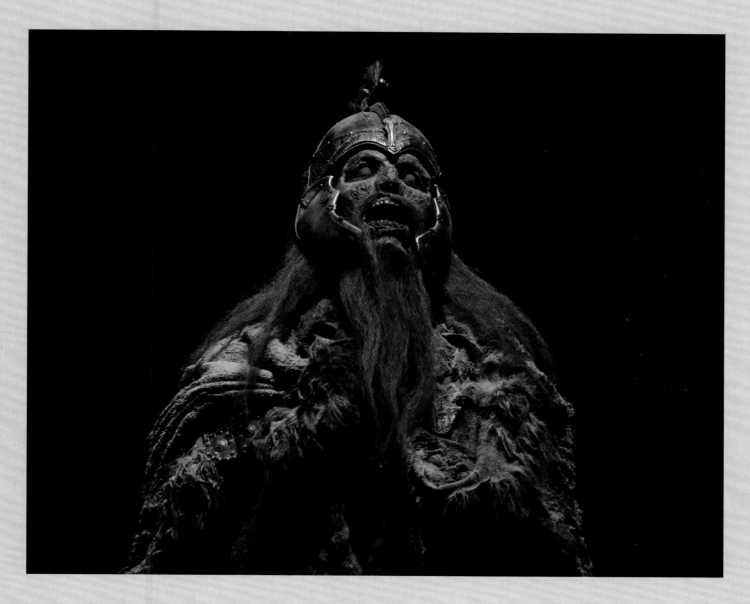

THE MOUND DWELLER

Linda: A long-dead warrior king and owner of the magical sword Draugr, The Mound Dweller had to appear to be a formidable challenge for Amleth. Ian Whyte, who portrayed this character, is seven foot one inch, and to further enhance that height he wore an elaborate Vendal/Valsgärde-inspired helmet topped by a large "golden" boar, complete with a boar-hair spine. To further increase his silhouette and to emphasize The Mound Dweller's skeletal remains beneath his rotted finery, we decided in an early fitting that shoulder, elbow, and knee bones needed to register through the costuming. Therefore, Giampaolo created an under layer which featured these bones.

Additionally, we exaggerated the proportions of The Mound Dweller's golden arm bracers, leg grieves, wide, leather belt, and pouch to further increase the appearance of a big size. The Costumes Department had to create a [a couple of] costumes, since the final shot tracks from the defeated warrior, headless on the floor, back to the [seated warrior who is ready] to fight all over again. All armour and costume pieces had to work together to allow Ian freedom to fight over the course of several shooting days while the sequence was filmed. [It was] important to design costuming for the character that reflected an earlier period of the Viking Age.

ABOVE The Mound Dweller (Ian Whyte) wakes up.
OPPOSITE The Mound Dweller's armour and costume pieces had to reflect an earlier Viking Age period. Concept illustration by Linda Muir.

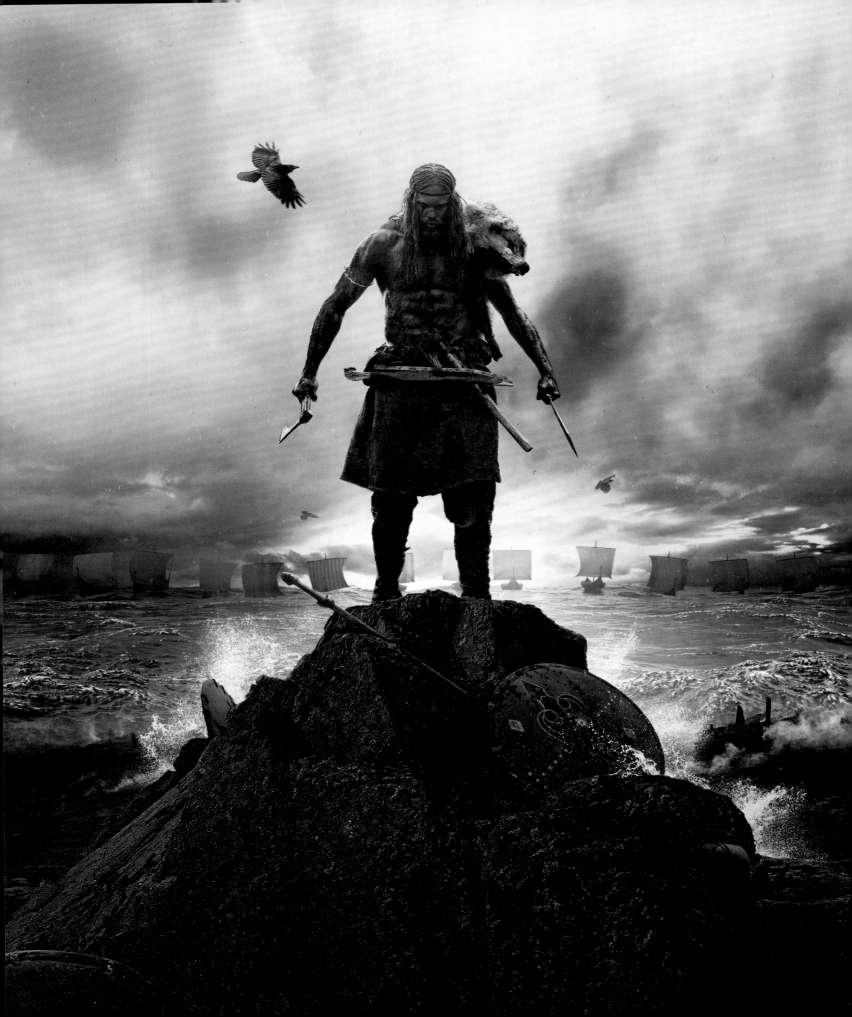

WEAPONS MASTER
TOMMY DUNNE

Weapons Master Tommy Dunne and his team made every weapon from scratch. Working closely with Craig Lathrop and the art department, Dunne and his crew created swords, shields, spears, and axes out of wood, leather, steel, and other materials that would have been available to Vikings living around the movie's central locations. Dunne and his team also worked hard to make sure that the rubber prop swords that the actors used in key scenes, like the Slav village raid, looked realistic enough to match the metallic blades used in other scenes. "We did a lot of intricate paint work to make sure that these prop swords looked like the real weapons we made so that we didn't have a beautiful steel weapon one minute and then one that looked like something you [pulled] out of a lucky bag."

OPPOSITE Photography by Aidan Monaghan; artwork by Focus Features. **BELOW** Amleth steals a weapon from Freysdalur's blacksmith. Concept illustration by Philipp Scherer. **NEXT PAGE LEFT** Amleth's sword Draugr, which Weapons Master Tommy Dunne created from scratch. Concept photo by Nick Ainsworth. **FOLLOWING PAGE TOP** King Aurvandil's sword. Concept photo by Nick Ainsworth. **FOLLOWING PAGE BOTTOM** Fjölnir's sword. Concept photo by Nick Ainsworth.

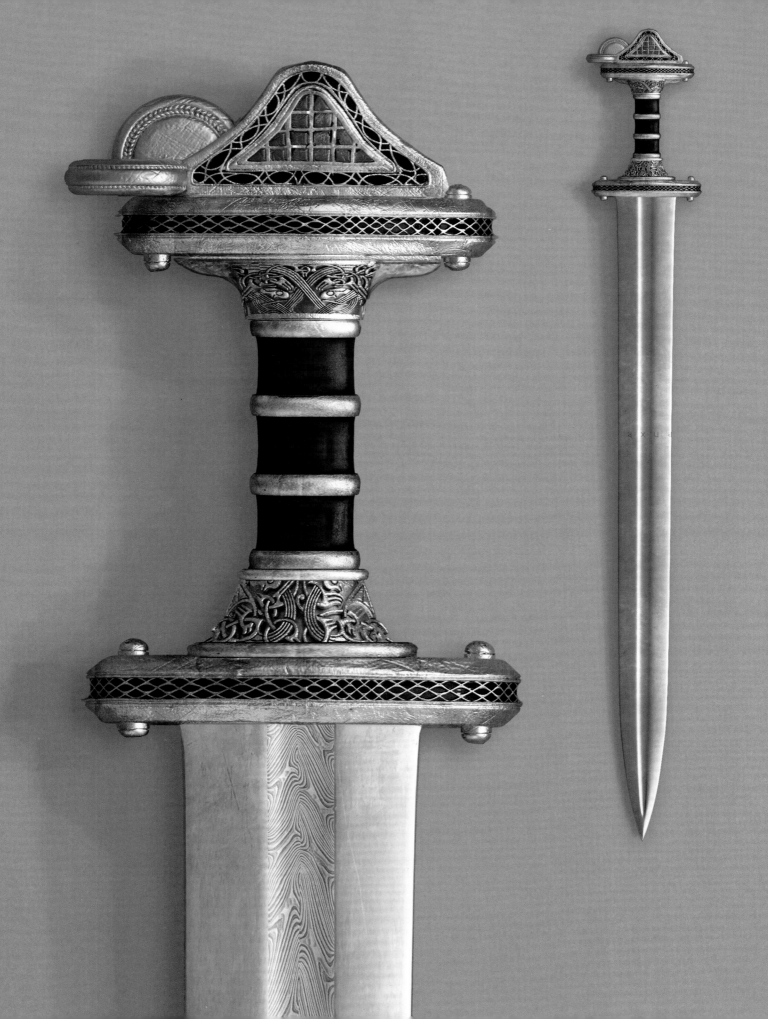

INSIGHT EDITIONS

PO Box 3088
San Rafael, CA 94912
www.insighteditions.com

Find us on Facebook: www.facebook.com/Insight Editions

Follow us on Twitter: @insighteditions

Published by Insight Editions, San Rafael, California, in 2022.

ISBN: 978-1-64722-777-7

Publisher: Raoul Goff
VP of Licensing and Partnerships: Vanessa Lopez
VP of Creative: Chrissy Kwasnik
VP of Manufacturing: Alix Nicholaeff
VP, Editorial Director: Vicki Jaeger
Managing Editor: Maria Spano
Executive Editor: Chris Prince
Art Director: Allister Fein
Senior Editor: John Foster
Editorial Assistant: Grace Orriss
Production Manager: Joshua Smith
Senior Production Manager, Subsidiary Rights:
 Lina s Palma-Temena

ROOTS of PEACE REPLANTED PAPER

Insight Editions, in association with Roots of Peace, will plant two trees for each tree used in the manufacturing of this book. Roots of Peace is an internationally renowned humanitarian organization dedicated to eradicating land mines worldwide and converting war-torn lands into productive farms and wildlife habitats. Roots of Peace will plant two million fruit and nut trees in Afghanistan and provide farmers there with the skills and support necessary for sustainable land use.

Manufactured in Turkey by Insight Editions

10 9 8 7 6 5 4 3 2 1

ACKNOWLEDGMENTS

Thank you to the incredible team at Insight Editions, particularly John Foster and Chris Prince. I'm also very grateful for Sam Hanson and Lars Knudsen for setting up interviews, as well as to the amazing interview subjects for their contributions: Robert Eggers, Alexander Skarsgård, Anya Taylor-Joy, Jarin Blaschke, Craig Lathrop, Naomi Liston, Linda Muir, Neil Price, and Jóhanna Katrín Friðriksdóttir. Finally, a big thank you to my family—Daphne, Dad, Mom, Nana and amazing friends—especially Bill, Steve, Alex, Alan, and MZS—for your support and advice.

CREDITS